CASTLES
OF NEW YORK

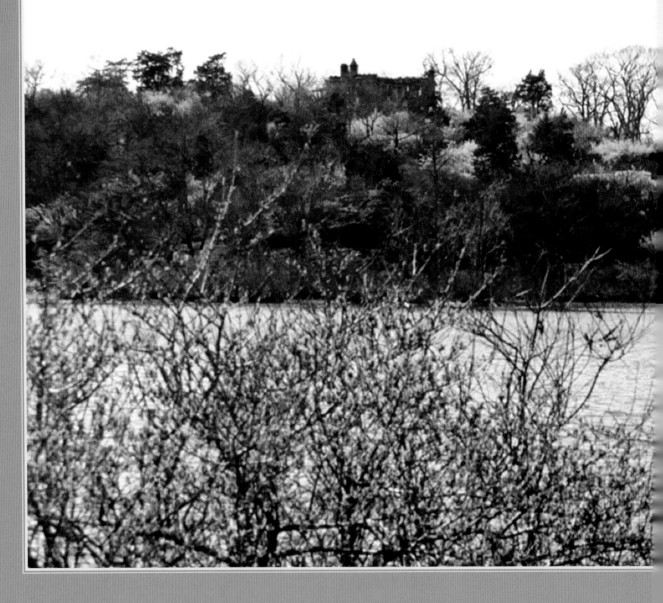

excelsior editions

AN IMPRINT OF STATE UNIVERSITY OF NEW YORK PRESS

CASTLES
OF NEW YORK

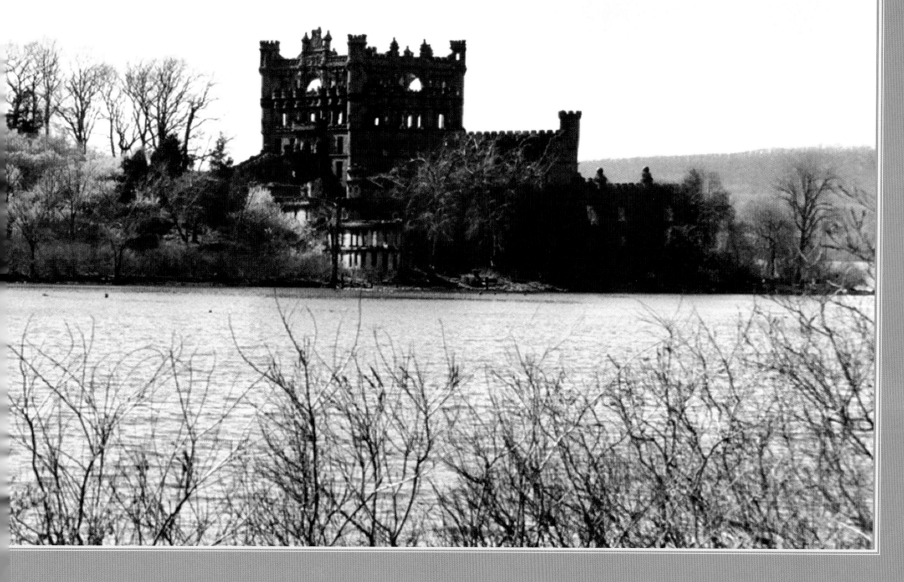

SCOTT IAN BARRY

Published by
STATE UNIVERSITY OF NEW YORK PRESS, ALBANY

Printed in the Singapore

For information, contact
State University of New York Press, Albany, NY
www.sunypress.edu

Production and book design, Laurie Searl
Marketing, Fran Keneston

LIBRARY OF CONGRESS CATALOGING-IN-PUBLICATION DATA

Barry, Scott.
Castles of New York / Scott Ian Barry.
p. cm.
ISBN 978-1-4384-3397-4 (hardcover : alk. paper)
1. Historicism in architecture—New York (State)
2. Historic buildings—New York (State) I. Title.
NA730.N4B37 2010
720.9747—dc22
2010010222

10 9 8 7 6 5 4 3 2 1

CONTENTS

HUDSON VALLEY

MOHAWK VALLEY

ADIRONDACKS AND NORTH COUNTRY

ACKNOWLEDGMENTS

Castles of New York would not have been possible without the generous assistance and invaluable contributions of the the following people: Aleta of the horses—the only one who knows that "the rest of the world wears bifocals" and that there's a "Quazi" in all of us; my longtime friend and agent Joanne Michaels, who, despite the accepted laws of the universe, *can* get blood from a stone; James Peltz of SUNY Press, whose professionalism and humanity is only matched by his great sense of humor; my Spanish "partner-in-crime," Alfonso Moral "Lugh" Cervantes, for white-knuckle rides in boats no bigger than a Volkswagen Beetle; my "Highland brother," Peter Morrison, for all our adventures, past . . . and our adventures, yet to come . . . *Thirteen!!!*; George Mason, for summer afternoons with the ladies, and the collies, down by the stream—and for snowy days at the chateau; George Maouris, for his assistance in helping me complete *Castles of New York*; and my brother, Harmon Glen, for his decades of support and his unwavering belief in my lifelong goals (*Yo Pat!*).

I would also like to acknowledge—with great appreciation—the following "castle folk," who were so generous with their time and attention toward the making of *Castles of New York*: Peter and Toni Wing, of Wing's Castle—*Keep'on building, Peter!*; Gilbert Baeriswil, manager of the spectacular Castle on the Hudson, for his graciousness and for letting me have "the run of the place;" Irene Villaverde at Leland Castle, the College of New Rochelle, for her wonderful assistance and support; Allison Hubbard and Dave, for their amiable dedication to helping me discover the castles of the Sands Point Preserve and for the spooky ghost tour; Tom Weldon, general manager of Singer Castle, for dodgy boat rides and for his great hospitality that allowed me to capture the venerable castle on film; Susan Phemister (and of course, Pumpkin the golden retriever), for her detailed guided tour of Amsterdam Castle; Hank Osborn IV of Cat Rock (Osborn Castle) in Garrison, for helping me in every way possible to create my images of his magnificent family homestead; Trudy Hanmer, assistant head of the Emma Willard School, with its "Potteresque" array of sublime castle structures; Lee, the security guard at Reid Hall Castle, Manhattanville College, for his genuine, warm, and efficient manner that helped clear the way for my photo shoots . . . *and last but not least*, the entire staff and management of Panera Bread in Kingston, New York, for helping make it so easy for me to go to my "second office," and write *Castles of New York*.

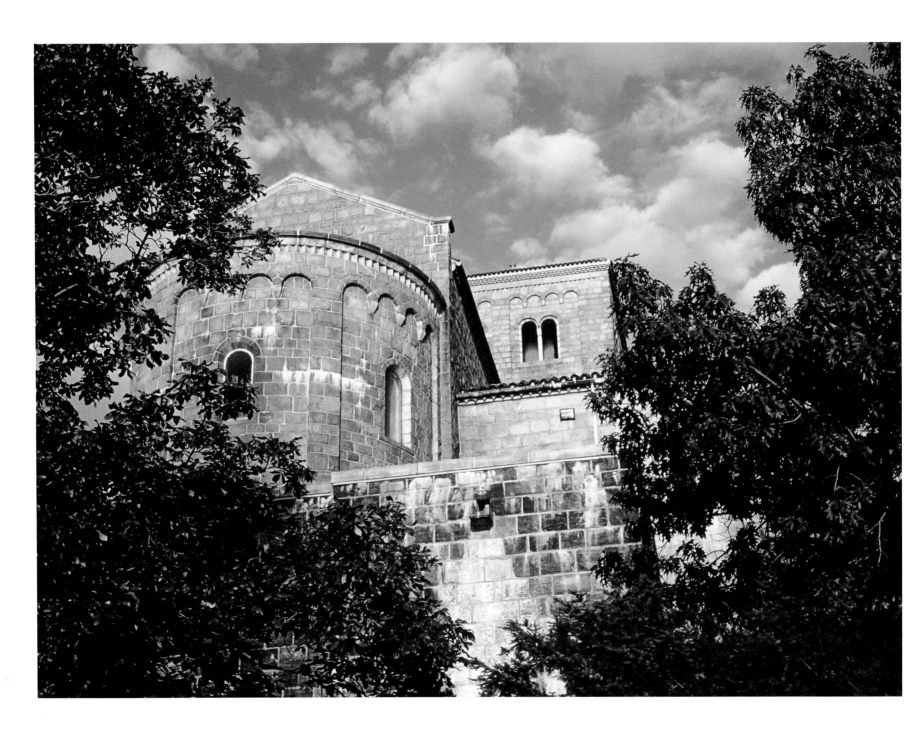

INTRODUCTION

I cannot, in all honesty, claim to be a believer in reincarnation. I am neither for nor against the concept, though I find the entire notion of having lived on this Earth in other forms fascinating. I *want* to believe in it; but having no clear proof that I have, in previous lifetimes, been a cow, a wolf, a cockroach, or a king, I prefer to tell myself, "I do not know."

And yet I cannot explain why, since my earliest recollections, I've found myself inexorably drawn to old stone structures—to stone houses, old bridges and monuments, colonial-era walls, and, most of all, to castles.

Of course, the irony of these early childhood memories is that I was born and raised in Flushing, Queens—a place not immediately associated with ancient armies and soaring ramparts. I simply knew that whenever I was in the presence of any historic site, I felt a powerful, secret connection to that structure. Something welling within my subconscious would stop me in my place: "Yes," my inner voice would tell me, "this is correct; this is where I belong."

On school field trips to the famous Cloisters, in Fort Tryon Park, Manhattan, I would quietly slip away from my teacher and classmates and walk reverently toward the huge central tower, with its expansive perimeter walls. I would make my way to the west-facing stoneworks and gaze out at the Hudson River below, then across to the rising cliffs of the Palisades, in New Jersey. I'd let myself drift away, pretend I was one of my childhood heroes, the legendary Spanish knight Rodrigo Diaz de Bivar—known to history as "El Cid Compeador," the Lord Champion. I could see the legions of elite Moorish troops, cloaked in black, against the setting sun, marching ominously toward the walled castle-city of Valencia. I could hear the steady, sardonic drumbeat—the thumping, pounding rhythm—that powered the enemy's undaunted approach to my courageous soldiers.

Admittedly, my imagination was shaped by the Hollywood epic *El Cid*, starring Charlton Heston and Sophia Loren. In fact, most of our modern impressions of castles are shaped by Hollywood images of great stone fortresses that feature damp, dark chambers and cold, brooding ramparts (which are based on the Norman castles or "keeps" of the eleventh and twelfth centuries), or "Cinderella" castles with fairytale towers and soaring spires (which take their inspiration from Neuschwanstein Castle in Bavaria, a nineteenth-century palace commissioned by Ludwig II). In

reality, however, there are many different types of castles, from the basic "motte and bailey" (mound and palisade) of the earliest Norman castles, which were built strictly for defense, to majestic structures built to house entire households and retinues. There are even castles in Asia such as the majestic Edo Castle in Tokyo, a fifteenth-century, seven-story pagoda that was the residence and military fortress of the shogun. One thing that all castles seem to have in common, though, is that they were intended as showpieces: enormous, often intimidating landmarks that told the local peasantry (or prospective invaders), in effect, "We're in charge . . . and you're not."

It was not until the invasion of England by William the Conqueror in the eleventh century that what we think of as the stereotypic castle really took hold as a building type. In the beginning, just after William's resounding victory at the Battle of Hastings in 1066, Norman castles were simply strongholds or stockades made of wood, which could be erected quickly from the raw materials found in surrounding forests. After William's decisive victories in England's north, however, he and his nobles began to erect more substantial and permanent structures out of stone. Again, they served two purposes: to establish superiority and control over the peasantry, and to stave off potential attacks from invading armies.

The first Norman castles shared several common features: a tall central tower or keep, which provided a high vantage point from which soldiers could rain down arrows, boulders, or boiling oil onto enemies below. These towers were built on earthen mottes, which would further raise the height of the keep and force enemies to scramble up a steeply angled slope to attempt an assault. They were generally surrounded by a ditch, which provided the earth for the motte. The battlements on top of the tower were composed of alternating merlons (raised square projections) and crenels (squared depressions), producing a type of up-and-down, zig-zag pattern known as crenellation, which gave the Norman castle its signature profile.

As castles became more elaborate and the nobles' power (and households) grew, courtyards, or "baileys" were added outside the ditch, and buildings and stables were erected within these to provide living and working space for all the people necessary to sustain castle life: blacksmiths, tanners, swordsmiths, armorers, cobblers, coopers (barrel-makers), troops, servants, and so forth. If there were multiple baileys, invading troops would be forced to advance through the castle's outer baileys and through its increasingly smaller inner ones. Narrow vertical spaces—called "loopholes"—in the interior walls and towers allowed for a deadly crossfire of arrows from defending forces, and hot tar and boiling oil could cascade down from above as the enemy tried to pass through a series of gates called "portcullises," constructed of heavy wood or iron, which could be raised (to let friends in) or lowered (to keep enemies out). They could be raised to let an enemy in, then lowered behind them as archers fired from the walls and loopholes at the trapped soldiers below. In the event that invaders took control of the outer and inner baileys, there was always the central keep to retreat to as a last line of defense.

Knowing these things as I prepared to take the photographs for this book, I had to ask myself, "Exactly what *is* a castle? For the purposes of this book, what makes a castle a castle?" I had to form my own criteria for judging whether a building qualified as a castle, yet at the same time

get across to my readers that there are, in fact, many types of castles, not all of them following the familiar Norman design. I decided upon three main physical features that I felt all the featured castles should share: a prominent central tower, the use of merlons and crenels to give the impression of battlements, and a thick wooden or iron main gate or door. I did not include baileys because the earliest Norman castles (like Sky Top at Mohonk Mountain House) were in fact just simple towers. Indeed, unlike my Spanish friends Juan Manuel "Fin" Montero and Alfonso Moral "Lugh" Cervantes, both of whom were spoiled by childhoods exposed to the enormous medieval fortresses of Alcazar and Alhambra, I have a quiet appreciation for the smaller castles and castle-towers, which are structural gems in themselves. Indeed, my favorite castle in the world is Eilean Donan in the Scottish Highlands.

Sadly, one of the castles featured in this book is in serious danger: the weathered and austere Bannerman Castle on Pollopel Island in the Hudson River, between Beacon and Cornwall-on-Hudson. Despite valiant efforts over the years to maintain the structural integrity of this well-known phantom of the Hudson Valley, Bannerman continues to fall (literally) into disrepair: on December 26, 2009, a little over a month after I had submitted my final manuscript to the publisher, a thirty-foot-long section of the castle's southeast wall collapsed, leaving a gaping hole in the perimeter.

Having visited the island itself as well as photographing the castle from the shore, I had long suspected, and even predicted to my friends, that such a collapse was imminent. I was truly saddened to learn that my prediction had come true, for it is my belief that we need to preserve our precious historic structures. I cannot envision the Metro North commute from Poughkeepsie to New York City without the anticipation of seeing Bannerman Castle between Beacon and Cornwall-on-Hudson; nor Tarrytown, New York, without Lyndhurst or Castle on the Hudson; nor the town of Hudson without Frederic Edwin Church's Olana. The recent collapse of Bannerman Castle's south face was as much due to the community's lack of will and desire to preserve it as it was due to lack of funds to maintain it.

Too often, we only appreciate something when it's gone. For my part, I think a New York without the awe and majesty of Singer Castle in the Thousand Islands Region or the imposing strength of Castle Gould on Long Island or the mysterious ruins of Bannerman Castle in the Hudson Valley would be a diminished state. Even if I cannot visit every castle or castle-like structure in the state, it is enough to know that they are out there, among us, enriching our lives and the lives of our children. Sometimes they are hidden, off the beaten track or behind the gates of some large estate, but more often they are hiding in plain sight, like the New York State Capitol in Albany or the New York State Military Museum in Saratoga. It is my hope that this book will help us open our eyes to see these castles and to preserve them for generations to come.

LONG ISLAND

HEMPSTEAD HOUSE

The three castles at Sands Point Preserve on Long Island—Hempstead House, Castle Gould, and La Falaise—are bound by location, history, and ghosts. . . . Yes, ghosts.

I arrive at Hempstead House to the comical din of honking Canada geese on the front lawn of the estate. It's a glorious afternoon, and I am in heaven: there are no cars, no telephone poles or electrical wires, and no people to flitter into my camera frame and destroy the pristine aesthetics of this powerful castle.

Squatting low in order to shoot up at the three-layered main towers, I instantly know that there is cover-shot potential here. Little do I know that Hempstead House is considered a haunted place. By day, there is no hint of spiritual or paranormal activity,

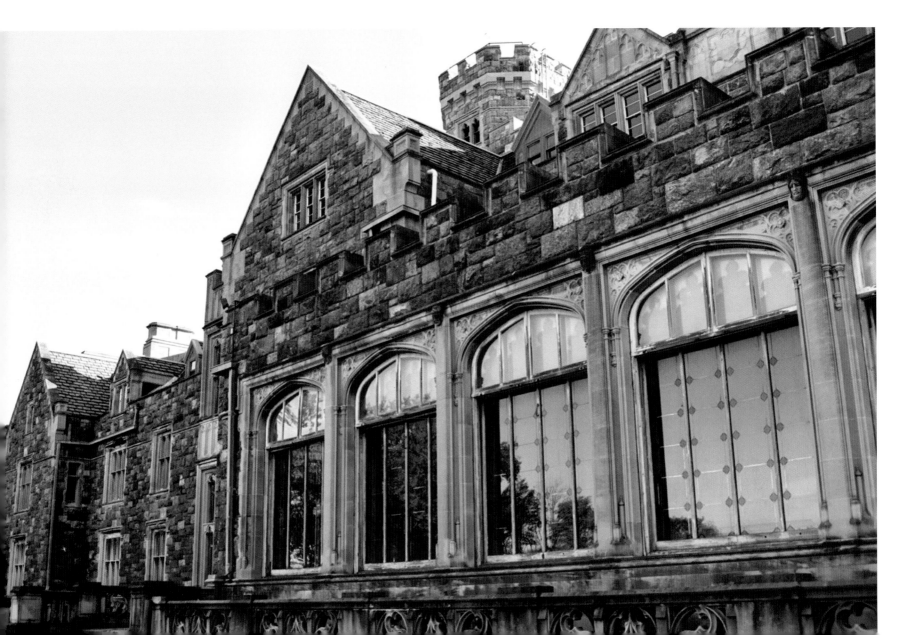

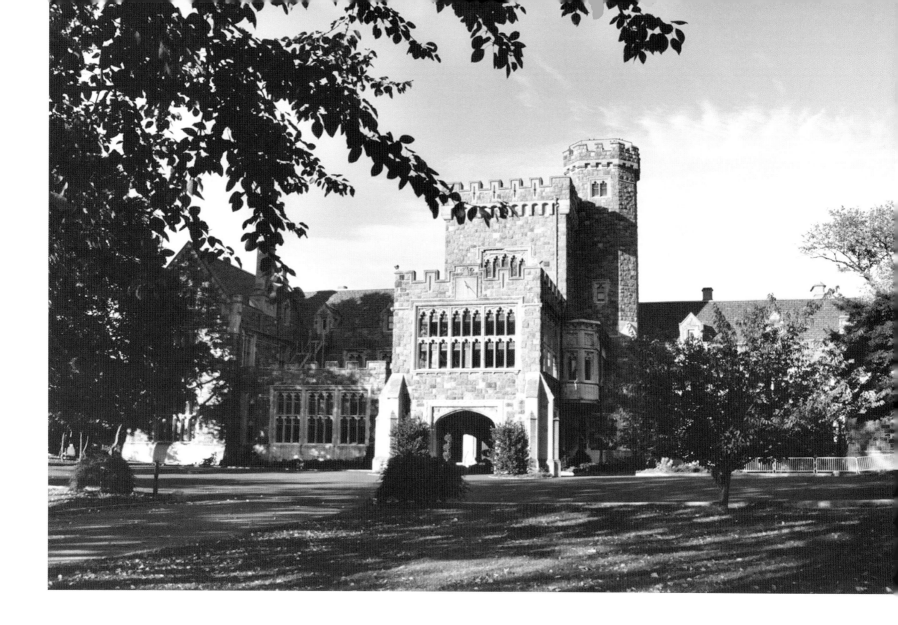

either in or about the beautifully crenellated structure. There is, however, much history, not to mention a steady schedule of film shooting, from Victoria's Secret lingerie spots to location shots for Martin Scorsese's *Boardwalk Empire* series for HBO. There are also a host of first-class weddings.

Completed in 1912, Hempstead House was designed in the architectural style of a castellated Tudor manor house. Its exterior combines local granite and Indiana limestone, which was used for the more decorative elements of the building's façade. It is both densely-packed and large, but deceptively so, for when I finish shooting machine-gun bursts of film at the front, I work my way around the west wing to the cinematic panorama

of Long Island Sound that inspired F. Scott Fitzgerald to write *The Great Gatsby*. After admiring the view, I turn slowly to my right and am stunned by the sheer size of the place and the gaping visual disparity between the south façade, which faces the entrance, and this long, rambling collection of peaked stone towers and tall, arched windows—all dominated by the two main towers, one octagonal and elegant, the other very square—very no-nonsense and austere.

Hempstead House is 285 feet long and 135 feet wide. It features three stories, a full complement of forty rooms, and that all-impressive central tower, climbing eighty feet into the air. It was the brainchild of Howard Gould, son of famed financier and

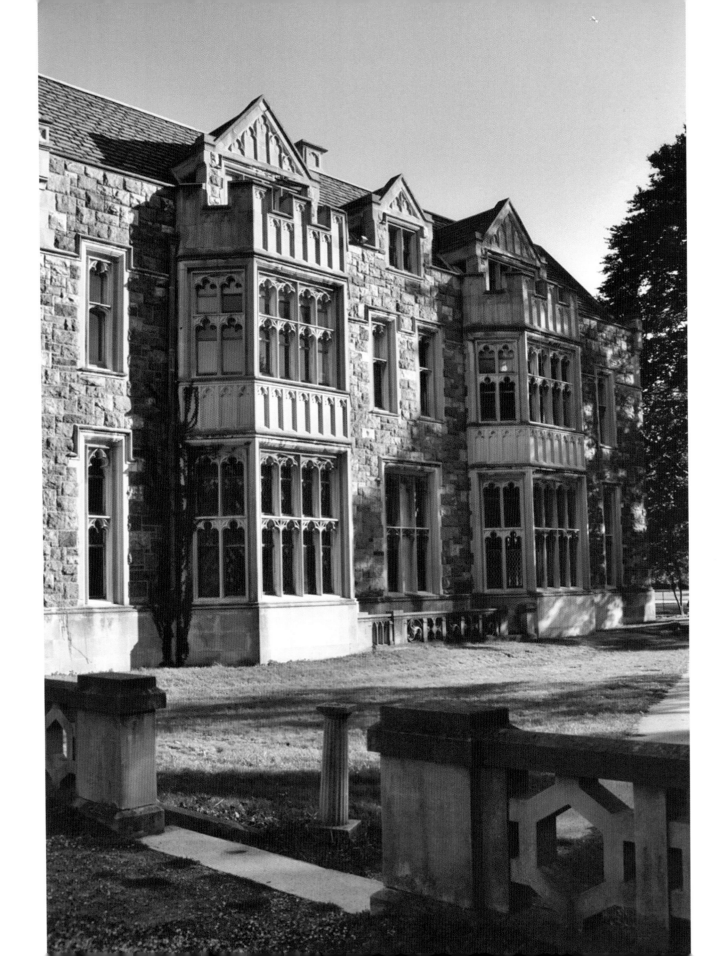

railroad tycoon Jay Gould, who bought the land between 1900 and 1901. Sixteen years later, in 1917, Howard Gould sold the estate to Daniel Guggenheim. Daniel then gave ninety acres of the estate to his son, Harry F. Guggenheim, who built his new home in the style of a thirteenth-century Norman manor house and dubbed it "La Falaise," or "The Cliffs."

Dave Hubbard, the caretaker of the historic structures at Sands Point, invites me to come back after dark for a tour of the interior, and I'm happy to take him up on his offer. It is with a decidedly pronounced sense of anticipation that I return several hours later and follow him through the thick oak entrance door into a scene that I could never have imagined, especially when I consider some of the brooding, narrow castle entrance halls I have seen. What stretches before me is a literal palace—an expansive chamber of marble floors, smooth granite walls, bleached-stone columns that support vaulted arches—with both stained and leaded glass windows, allowing in the radiant moonlight.

To my right stands a baby grand piano of rich ebony wood. Just across from it, the original pipe organ, of oak, defies the ravages of time. When I look to my left, the centerpiece of the

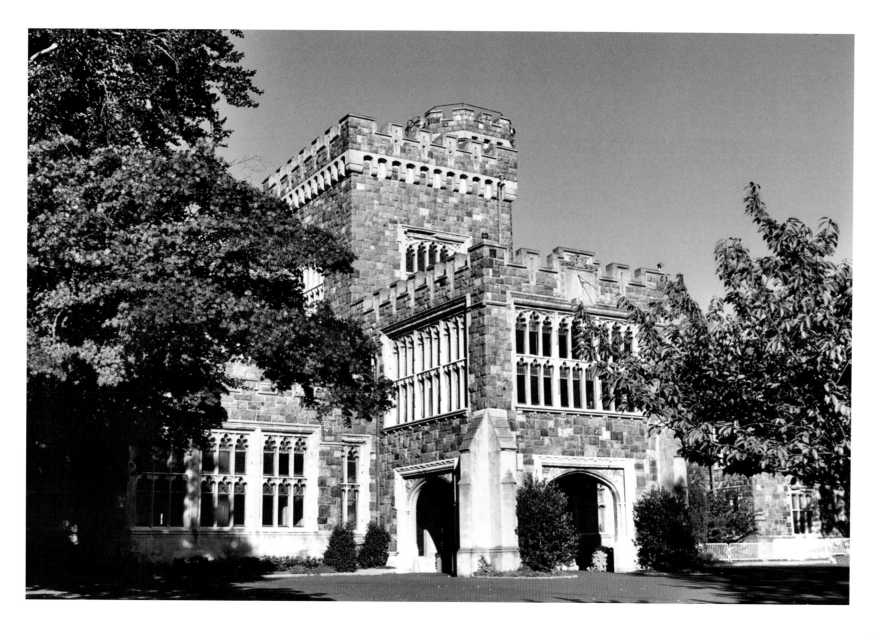

chamber reveals itself in a combination of classical Roman and Victorian-era splendor: the Palm Court. With its border of in-laid mosaic tiles, stone columns, and amphorae, the Palm Court once contained 150 species of rare orchids and other plants, as well as an aviary of exotic birds in tall cages among the flora. But my favorite part of the visit to Hempstead House is when Dave takes me on the grand tour, leading me into the dimly lit library with its dark walnut paneling. The moment we step across the threshold, I get a very strange sense of something that, to this day, I still cannot explain. I stare at the long bay-window seat ahead of us, beneath the very faint glow of a small wall lamp; "I *feel* something," I tell Dave.

Dave does not respond right away. "Like what?" he finally asks.

"I'm not sure," I answer back. "But I feel something . . . at the window."

He leads me out of the library and continues our tour: "It's down these halls," he says, "that most of the sightings occur."

"Sightings . . . ?" I say.

"Ghosts . . ." says he.

I swallow, hard. "Lovely."

Add to this the fact that not only the entire atrium area but each hallway we slowly walk down is decidedly cold. It's no wonder I have the sense that a "sighting" could occur at any moment . . . that is, until Dave informs me that Hempstead House's furnace is being replaced and that there is no heat in the place.

Ghosts, indeed . . . but it was a deliciously stimulating tour.

When we close the castle up and stand outside in the driveway, I gaze up at the battlements atop the hulking central tower, which is dimly illuminated against the dull, ashen clouds of the night sky. The superstructure projects an ominous presence, where the thought hangs in the air that, here, anything can happen. The building takes on a sense of being alive.

Home to unearthly spirits? Or proud bastion of American history?

Go to Hempstead House yourself. You be the judge.

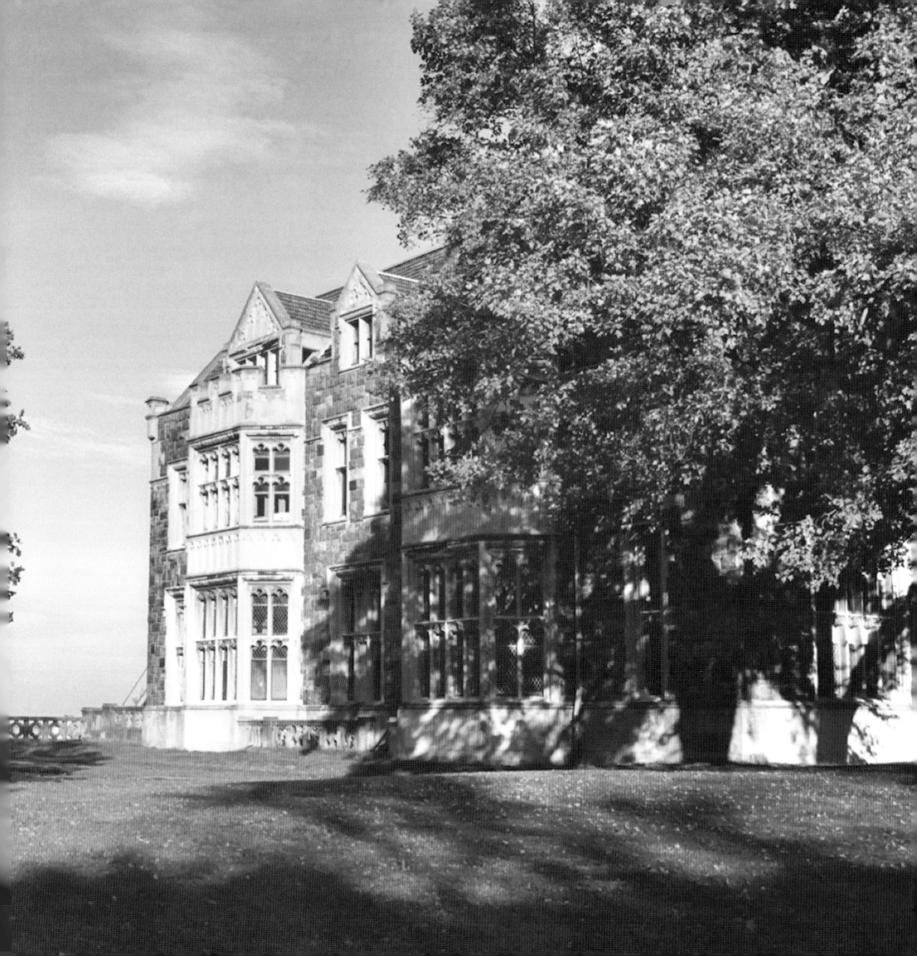

CASTLE GOULD

I pull my van into the parking lot at Castle Gould, having just swapped ghost stories with Allison Hubbard, events coordinator, and her husband Dave, caretaker, at Sands Point Preserve on Long Island.

Of all the castles I've visited for this book, Castle Gould most evokes the sweep and scale of the grand castles found in Europe, particularly in Spain. Mind you, Spanish castles, like Alcazar and the Alhambra, are immense in scope, like small cities. But there is something about Castle Gould—perhaps its two huge wings that extend far out from its massive, fortress-like central clocktower—that is imbued with power and intensity.

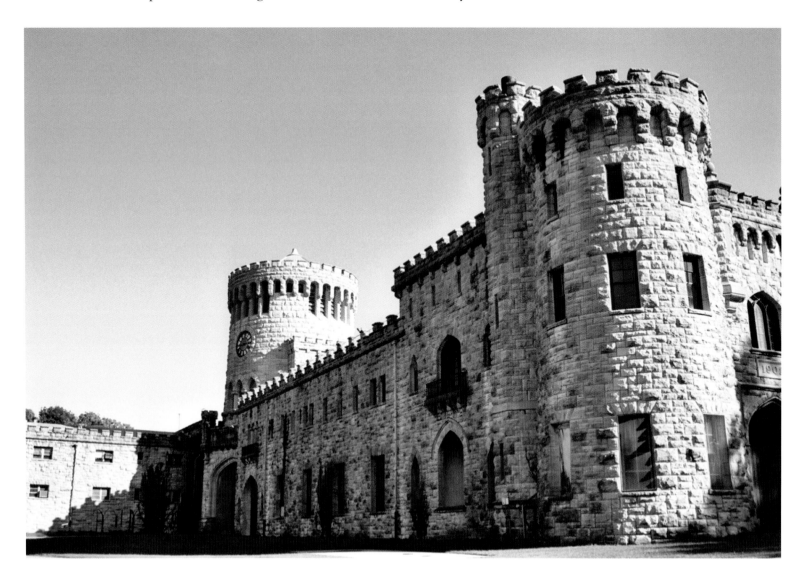

Made of white limestone—you can actually see the fossils of prehistoric shells in the surface of the brick—Castle Gould appears precisely as true historic castles were designed, bathed in a bright white wash, to be showpieces for the nobleman who lived there. Based on Kilkenny Castle in Ireland, it was originally intended to be the main place of residence for Howard Gould and his wife upon its completion in 1904. Mrs. Gould did not like it, however, and Howard then built Hempstead House for her and turned the limestone Castle Gould into a stable and servants quarters. In an ironic twist, the Goulds were separated before Hempstead House's completion in 1912.

The castle has seen several incarnations, from restaurant to museum to its current status as a visitor center and gift shop. When I stand before its rotund central clocktower and allow my eyes to wander the length and breadth of this architectural triumph, I see that it is endowed with nearly every aspect of castle design. While its east wing displays more traditional merlons

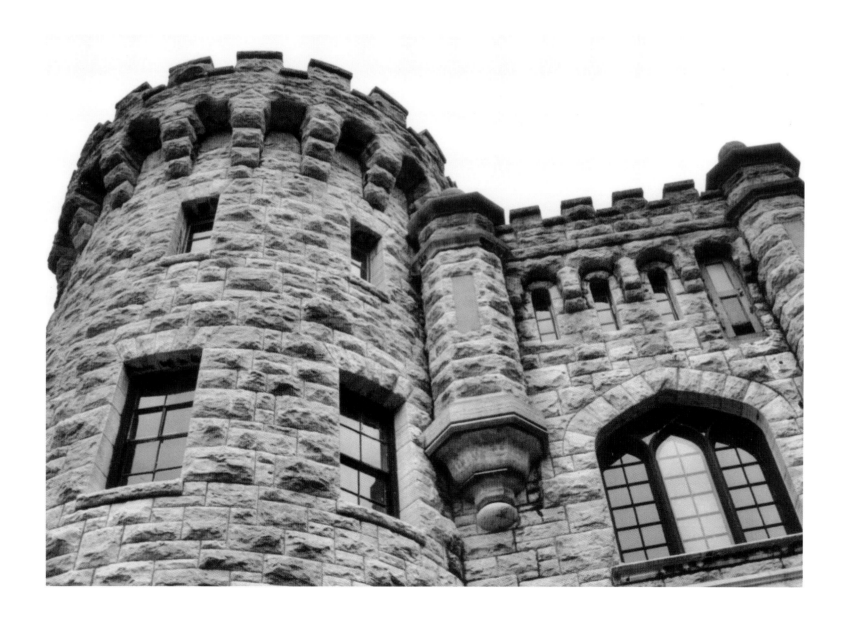

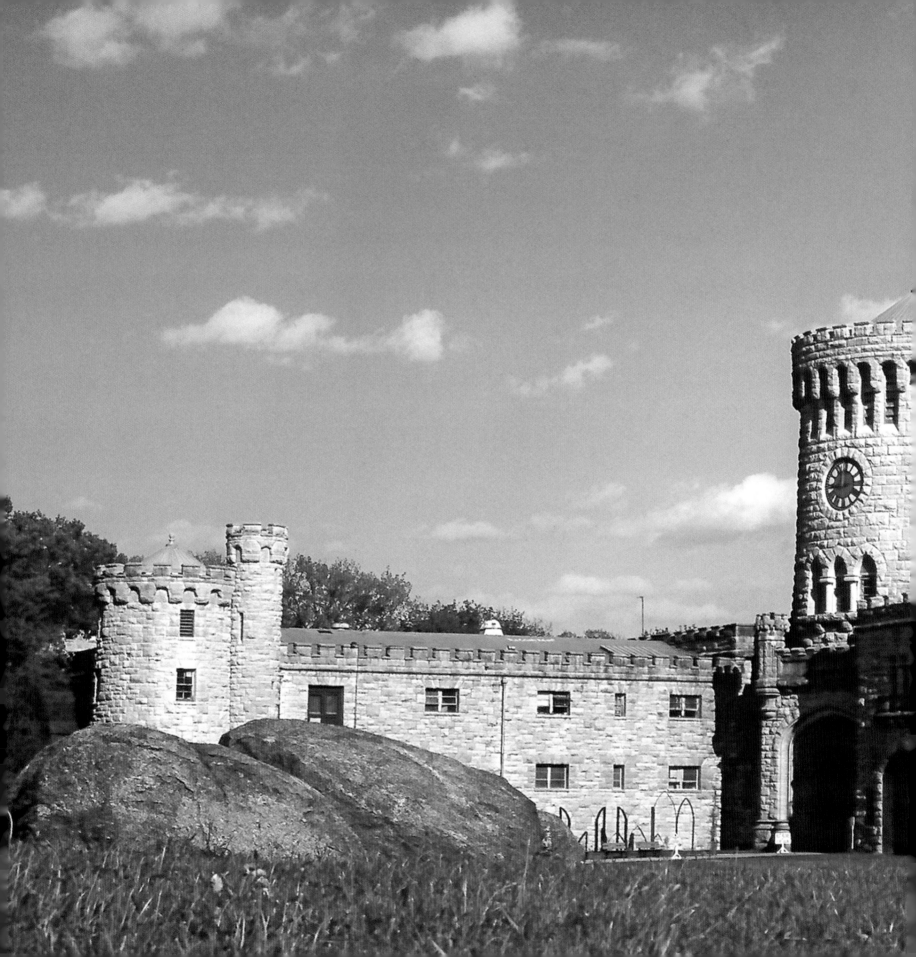

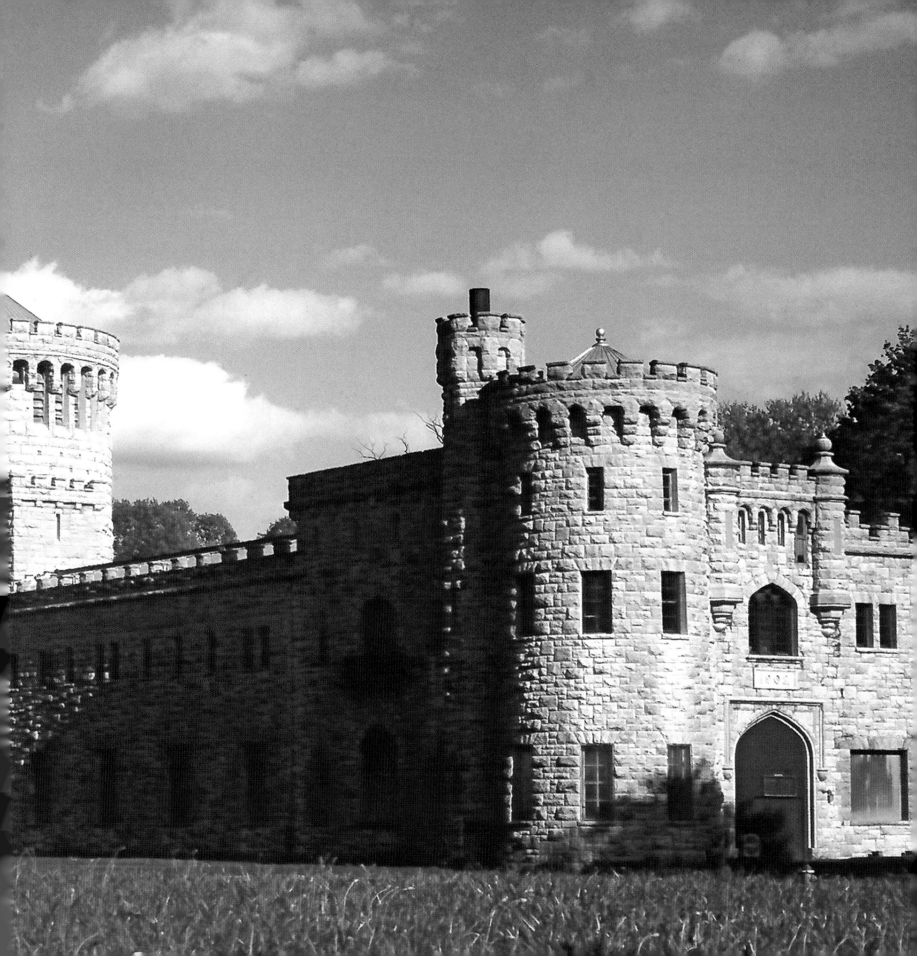

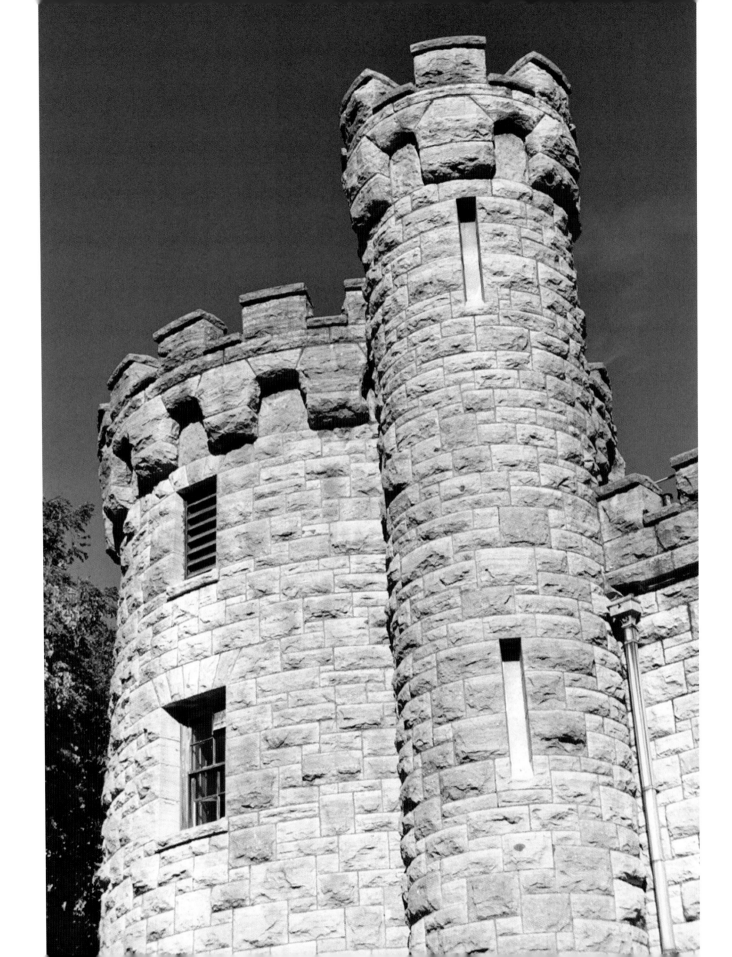

and crenels along the battlements, its longer and grander west wing features more stylized crenellations. The central clocktower supports a rudimentary surface-tower, also crenellated, with vestigial forward loopholes along its west side. The archway of the main entrance gate is capped off by a crenellated border and a corner turret that is faceted and castellated. Hulking square towers surround the main structure on its eastern side. And in an uncommon architectural twist, the great central tower is capped off with a robust peaked roof of tent design.

I ponder to myself: What has transpired here, over the decades? What has taken place between the walls of this erstwhile stable, beneath that big peaked roof?

We do know that the Guggenheim servants lived out their lives at Castle Gould, and that, as with all human endeavors, there were friendships, rivalries, loves, and hatreds. Some say that the spirits of these servants move in and about the halls, and that, like the murmurings at La Falaise (next on my tour), "voices" can be heard, soft voices—and from time to time, the plaintive whinnies of Harry's horses.

I suppose we'll never know for sure if the stories are true, but come each Halloween celebration at Castle Gould, it would not be hard to believe.

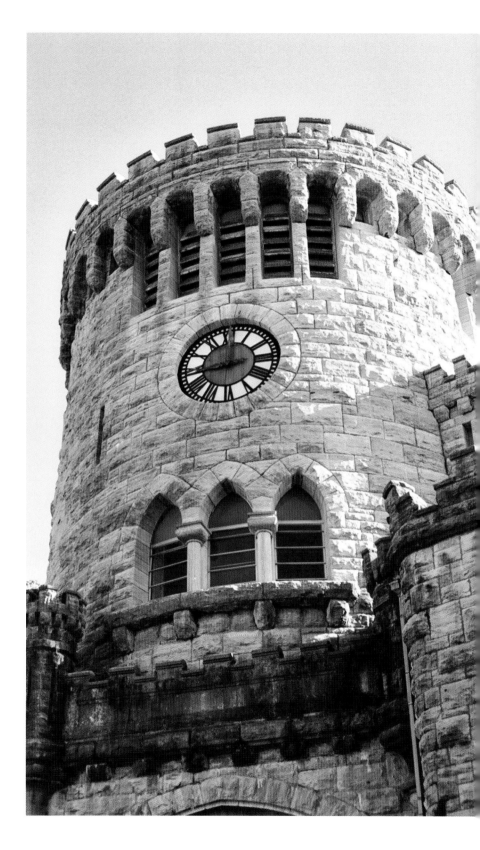

LA FALAISE

I'm on my way to La Falaise, and Allison Hubbard, the events coordinator at the Sands Point Preserve, leads me in her truck down the bucolic, winding road that takes us past a magnificent stone stable used by the Nassau County Police. We pass through a set of stone pillars and into a walled cul-de-sac. The feeling here is very medieval, with diagonally patterned red-brick outer walls, bay-window turrets, and a unique tile-roof construction, called "bread and butter" for its smooth, tight, overlapping fit.

La Falaise, which means "the cliffs," is one of the few remaining historic structures from Long Island's Gold Coast period. Built specifically for famed businessman, philanthropist, and horseman Harry Guggenheim and his wife, Caroline Morton, in 1923, its architectural style is referred to as "French eclectic" and takes the form of a thirteenth-century Norman manor house.

Allison's husband Dave, caretaker of the historic buildings at Sands Point Preserve, appears from a door in La Falaise's east

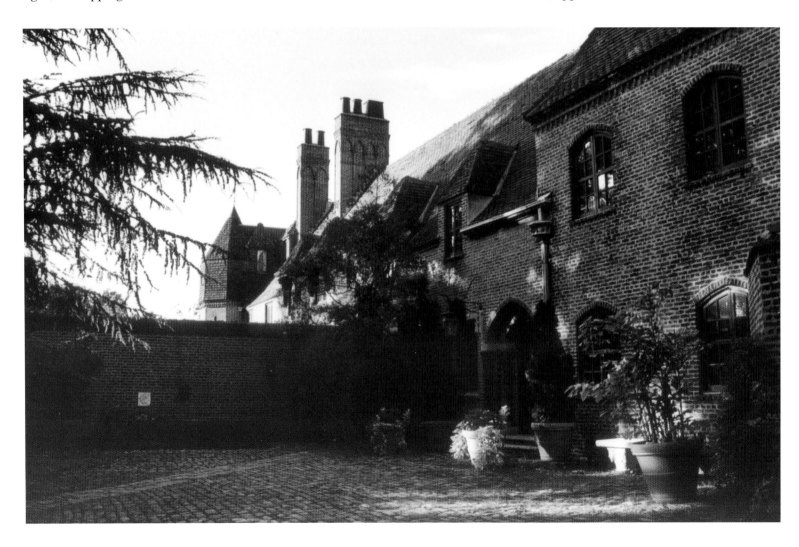

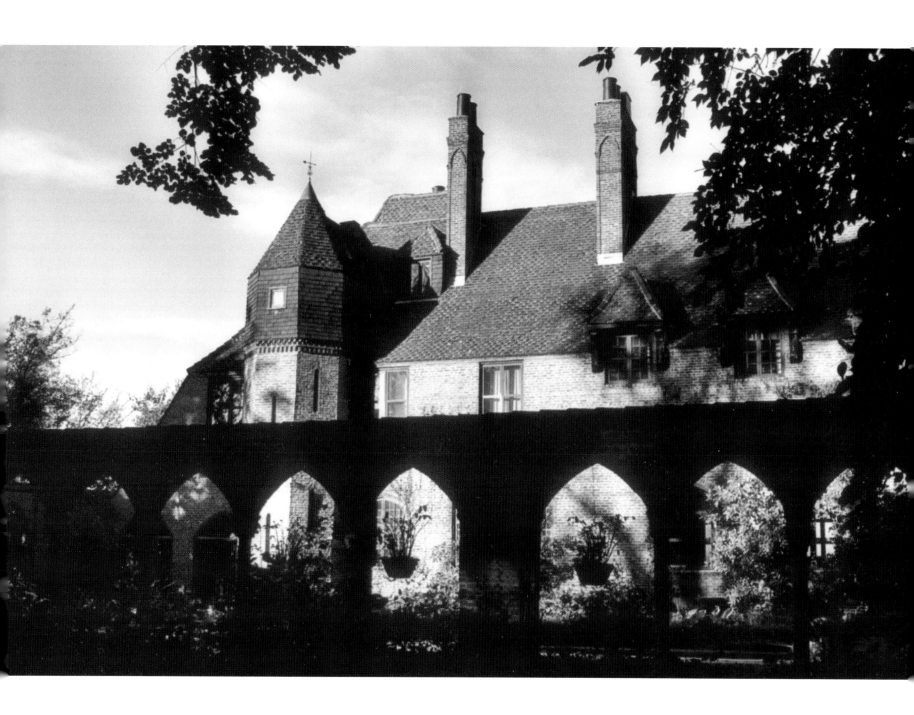

wing and leads me past the long southern-boundary wall to a gated and enclosed courtyard of sublime cobblestone construction. Just behind me, a row of arched stalls—along with the fan-shape of the cobblestone courtyard—strongly suggest that this was a place for horses (which makes perfect sense, considering the fact that Harry Guggenheim bred and owned racehorses and helped found the New York Racing Association). Dave then leads me down a short series of steps and through a wrought-iron gate to the most picturesque swimming pool I've ever seen. At each corner of the pool, highly detailed stone fish spray water from their gaping lips—fountain style—into the pool. Dave informs me that these fish go back to China's Ming dynasty. I am amazed to learn that Harry Guggenheim sat by this very pool with his good friend, the heroic aviator Charles Lindbergh, many times. Added to this prestigious company was none other than the "father of modern rocketry,"

Robert Goddard, whom Harry consistently funded with large sums of money from the Daniel and Florence Guggenheim Foundation.

I stand by the entrance gate to the pool, snapping carefully composed frames and marveling at the flowers, potted plants, and rippling pool water. There is life here, peaceful yet dynamic. I see Harry, Charles, and Robert—three giants of their time; three giants of American history—sitting, casually talking, exchanging genius thoughts from genius minds.

"This," says Dave "is where Charles Lindbergh came after his son was kidnapped and murdered. He came here to get away from the press . . . to get away from the world."

I gaze around the pool area, dominated by the west tower and the multiarched, stone perimeter-wall. Yes, I tell myself—I would want to come here, too, in times of distress. I too would feel safe here.

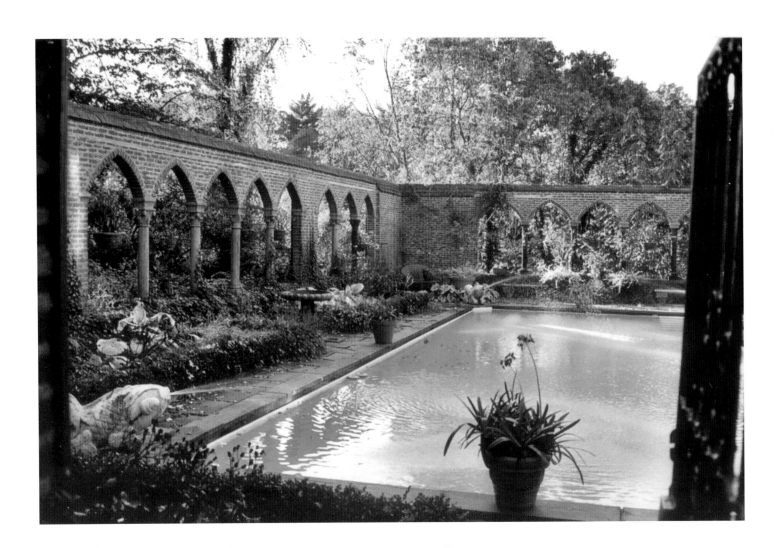

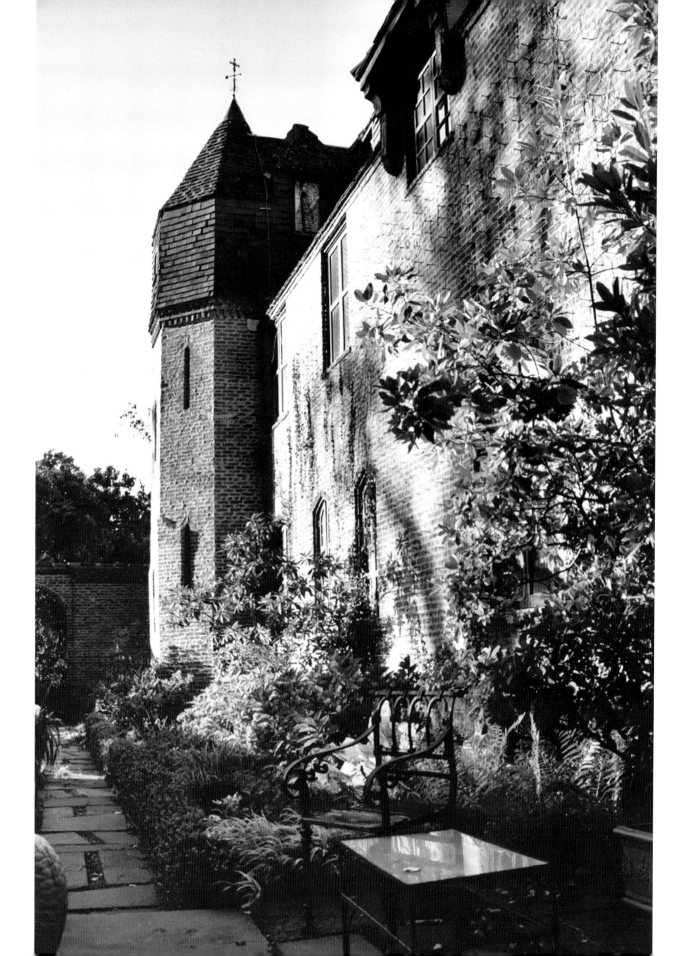

Just around the bend, on the north side of the building and down below the seawall, stretches Long Island Sound—a natural barrier to prying eyes and ears.

"Did Lindbergh stay here for a long time?" I ask Dave.

Dave nods his head: "He stayed for quite awhile. And nobody knew where he was. Nobody knew he was at La Falaise, with his friend Harry Guggenheim, talking into the wee hours of the morning."

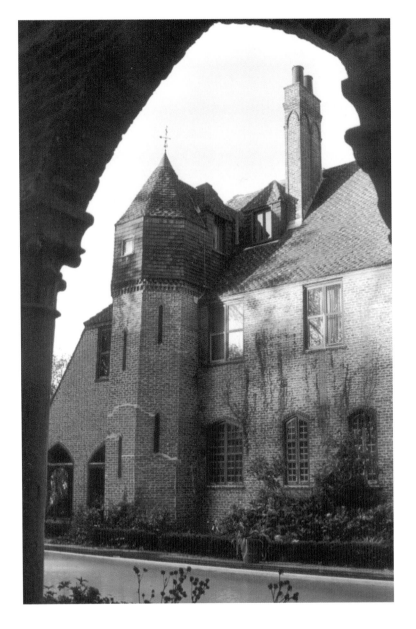

Back inside now, Dave and Allison take me on a personal tour. The medieval ambience continues, with thick wooden beams and arches of oak, textured-plaster walls, sixteenth- and seventeenth-century antiques, and various relics on hand-carved stone mantels. But if Harry had his own particular pride and joy, it was surely the Trophy Room, with its photos, paintings, sculptures, wood carvings, and, of course, trophies, all featuring—what else?—horses.

As we move through the rooms, I feel compelled to ask the operative question: "Okay," I say to them. "I gotta ask you this: any ghosts here?"

"One day," says Allison, "Dave and I were about to go up the stairs into the tower." She points down the hall, ahead of us. "Our sheltie-mix was with us; he's a tough guy." She gives a faint little smile. "Well, he bolts up the stairs, barking and barking—staring straight at the corner, with fur raised—growling and bearing his teeth."

"And what happened?" I ask Allison, excitedly.

"Suddenly," she tells me, "he came running back down the stairs, whimpering. When he stood by me and Dave, he stayed on the bottom step, looking up the stairs, whining and barking the whole time. Whatever he thought he saw, he didn't like it a bit."

"Also," says Dave, chiming in brightly, "people have said they hear voices—a voice—mumbling words. The voice of Harry Guggenheim." He shrugs his shoulders. "That's what they say."

"Have you guys heard anything?"

"Not quite sure," Dave says, leading us all back to the east-gate cul-de-sac.

"Ghosts or no ghosts," I tell him, "La Falaise is an incredible place."

I thank my wonderful hosts, hop into my van, and temporarily take leave of them as I wind back down the entrance road to photograph the magnificent Castle Gould a second time. A strong breeze off Long Island Sound sways the trees, making their dried leaves hiss and whisper in the wind. But the sun is bright and crisp, and the sky is gemstone blue. I have the feeling it's going to be another good shoot—like taking candy from a baby.

NEW YORK CITY

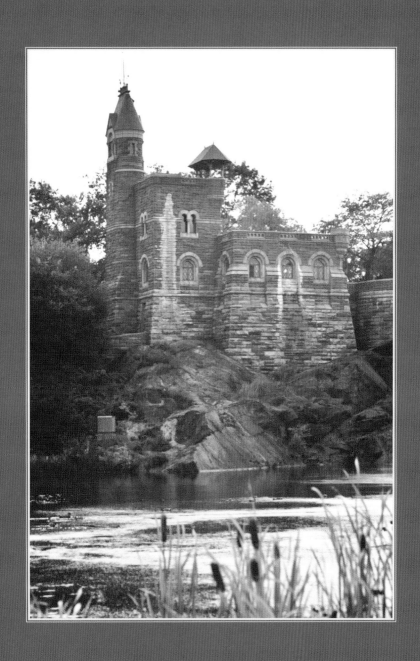

BELVEDERE CASTLE

In the heart of Manhattan's Central Park stands a tall, gray-stone tower surrounded by sweeping curtain walls at its base, crenellated battlements, square-granite entrance halls, and rows of stone arches, turrets, and loopholed windows. Belvedere Castle is an international mecca for tourists to come and gaze at a "pastoral-urban" panorama that includes everything from imposing apartment complexes to skyscrapers to the expanse of Turtle Pond, where there live not only turtles but also a flock of squawking mallards and no fewer than ten industrious yet comical raccoons, who come for their daily ration of food from the "Peanut Man."

I maneuver around the terrace of the south landing, preparing a side-view, profile shot of the castle. Within the course of one minute, I hear Russian, Chinese, Japanese, Arabic, French, Italian, and Spanish—and, oh yes, English—spoken all around me. Tourists and lovers dutifully line up against the castle's curtain walls (appearing to my mind like penguins in the Antarctic, huddling together before a storm) to have their pictures taken.

Although Belvedere Castle was originally designed by Frederick Law Olmstead and Calvert Vaux as a Victorian "folly," or fantasy building, the tall tower shows characteristics of fifteenth-century castles, while the secondary rectangular and square towers contain thirteenth- and fourteenth-century design elements.

At its conception, the castle was merely a shell—a Hollywood-like façade that lent power and atmosphere to its immediate surroundings. Its window frames and doorways were open, its vacant interior an erstwhile home to the various wild animals of Central Park.

Today, however, Belvedere Castle has real windows and doors and provides a home for the Henry Luce Nature Observatory, managed by the Central Park Conservancy. The interior now features simple educational displays on the everyday tasks of naturalists and how they translate their findings to

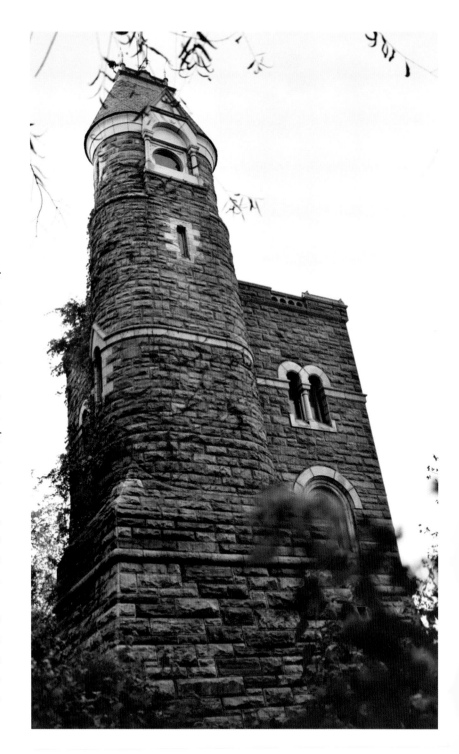

the public. Telescopes, microscopes, skeletons, and feathers all serve as interesting educational tools for young students and adults.

The castle's second floor houses papier-mâché reproductions of the nearly two hundred species of birds that can be found in Central Park throughout the year, many of which can be seen or heard in the Ramble, the thirty-six acres of woodland walk directly south of the castle. Within the building, discovery kits containing binoculars, a guidebook, maps, and sketching materials are offered to children ages six and up, on a year-round basis.

I head down the series of stone steps from the south terrace and wind my way across the paved path, where I stop at the Turtle Pond's boulder-strewn, tall-grass shoreline. Just across the water, the entirety of Belvedere Castle rises straight out of Vista Rock as though it were a seed, planted there centuries ago. I am taken aback to hear the plaintive notes of a bagpipe, the ancient instrument of my people, lilting through the air in the not-too-distant woods. The mallards are whipping up the pond with the fervent flapping of their wings and their crash landings onto the surface of the water. The raccoons—those jesters of constant ambition—are chattering and grasping at the air for yet one more peanut. This is a special place, where life flourishes, where wild animals as well as the people of Manhattan—and the

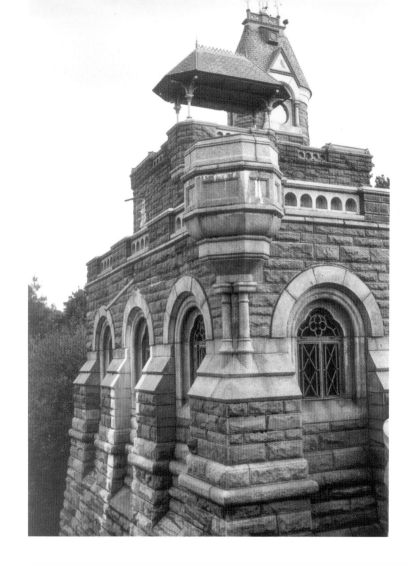

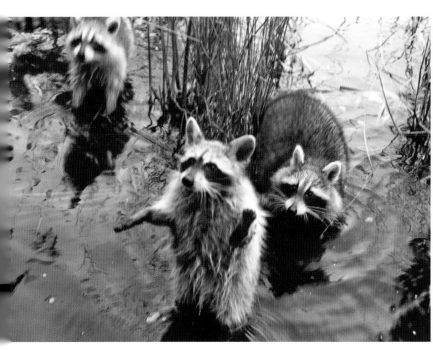

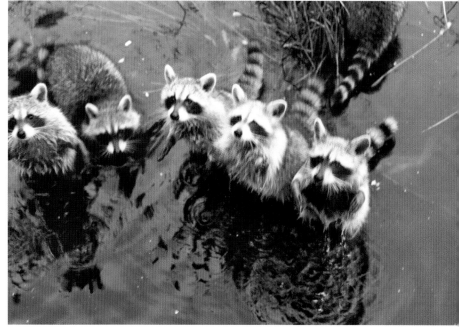

world—"do walk about and recreate themselves," in the words of Shakespeare.

Yet, for me, Belvedere Castle has taken on a life of its own, for it is the one castle out of all those I've visited that has defied my efforts to capture a satisfying image on film. This is no less than my seventh attempt to get the photo I am looking for. Why? Because the castle rests in a topographical depression, or bowl. It is also ringed on three sides by trees, which block the sun. So the castle remains in the shadows much of the time, and this, combined with its brooding gray-stone surface, makes for an image that often lacks the depth, contrast, and grandeur that only the sun can provide when it washes its orange glow across the east face of the building. This would mean photographing it at dawn, which would mean leaving my home, two hours away in the Catskill Mountains, well before that time. And frankly, I am not a morning person. Thus, I have to concede that this shadow image is the correct way—the faithful way—to present Belvedere Castle.

After all, some of us were not meant to "shine in the sun," only to "grace the shadows."

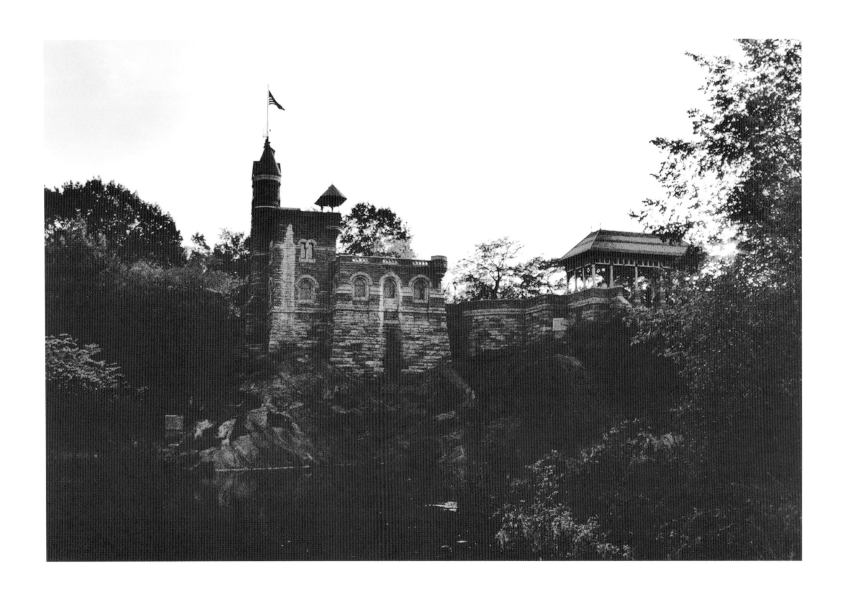

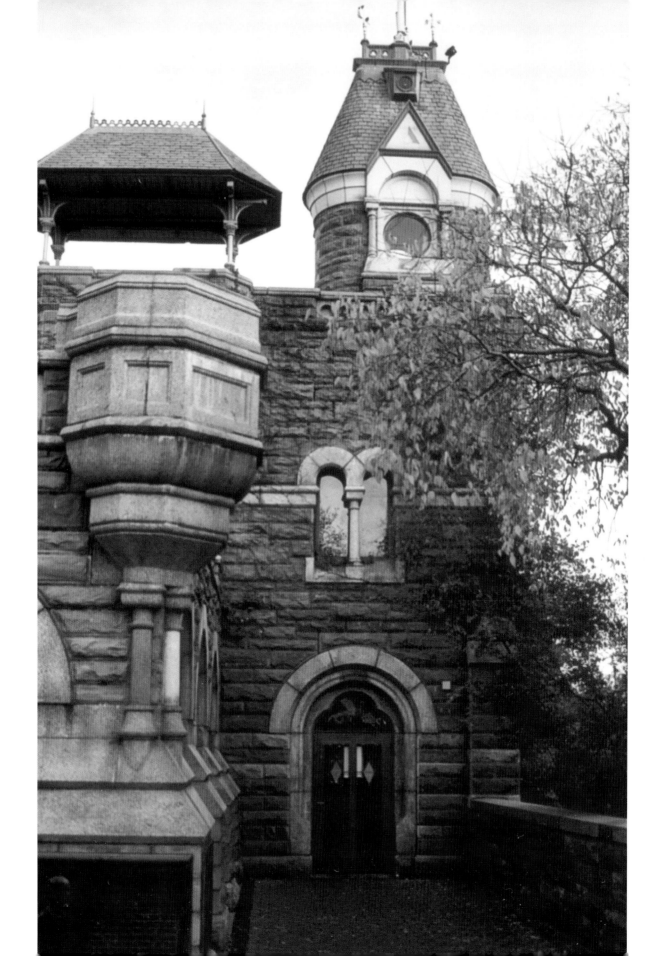

THE CLOISTERS

I stand before the raised battlements of my shoreside castle, watching, listening for the foreboding drumbeat of my enemy, for the disjointed clatter of armor and the uncertain whinny of horses. I am Rodrigo Diaz de Vivar, known to the people of Spain as "El Cid Campeador," the Champion, and to the Arabic world as "al-Sayyid," El Cid, the Lord, and this is the Battle for Valencia, in the year of our Lord 1094 . . .

Here, at the famed Cloisters, located in Fort Tryon Park in upper Manhattan, it is decades since I had that beautiful daydream as an eight-year-old: the dream that I was El Cid himself, defending my country from foreign invaders.

The moment I enter the building, from the eastside Froville Arcade entrance, I get the palpable impression that I have stepped back in time. Once inside the lower level, I am hit by the sensation of cool stone walls and the distinct, otherworldly smell of silt. I mount the long set of stairs to the main level, feeling every step of the way that I am in a true medieval fortress.

Ironically, the Cloisters was originally intended to be a classic twelfth- to thirteenth-century Norman castle, but the Rockefellers, who were Quakers and wanted no hint of fortresses or war to be part of the structure's theme, mandated that it take the shape of a medieval monastery. With an endowment grant from John D. Rockefeller Jr., sections from five medieval French cloisters—Saint-Michel-de-Cuxa, Saint-Guilhem-le-Desert, Bonnefont-en-Comminges, Trie-en-Bigorre, and Froville—were disassembled and then reassembled in Fort Tryon Park between 1934 and 1938, along with historically accurate medieval gardens. The Cloisters collection, now a branch of the Metropolitan Museum of Art, contains approximately five thousand works of European medieval art, with an emphasis on pieces dating from the twelfth through the fifteenth centuries. Much of it was purchased by Rockefeller from American sculptor and art collector George Grey Barnard and subsequently donated to the Met, along with a number of significant pieces from his own collection.

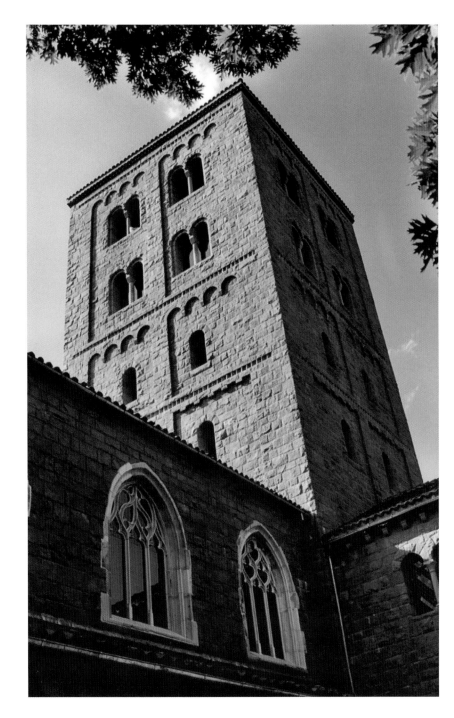

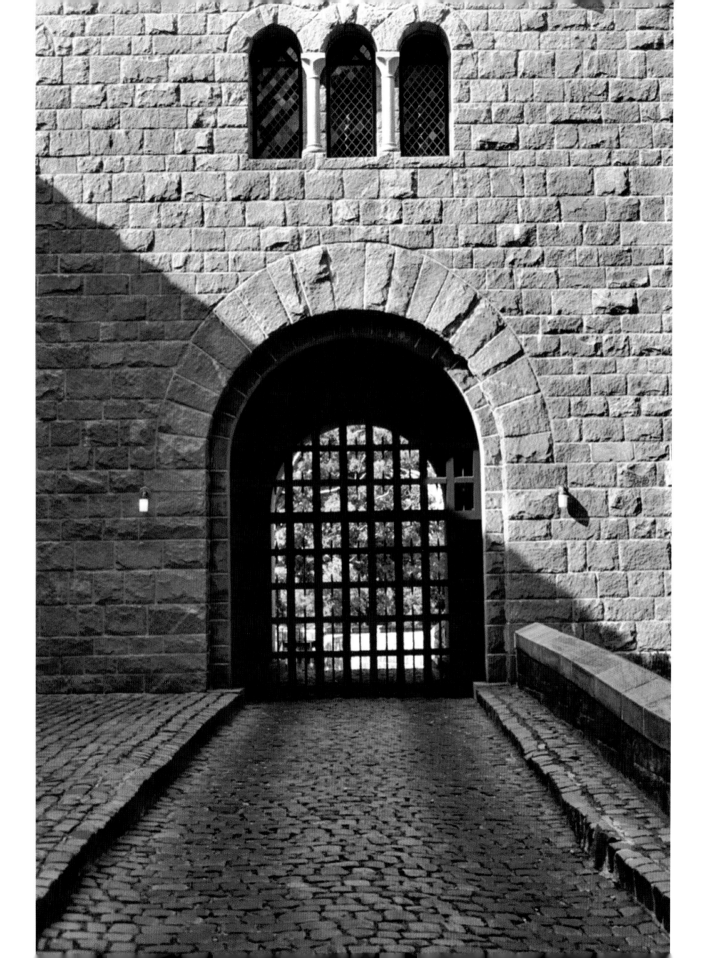

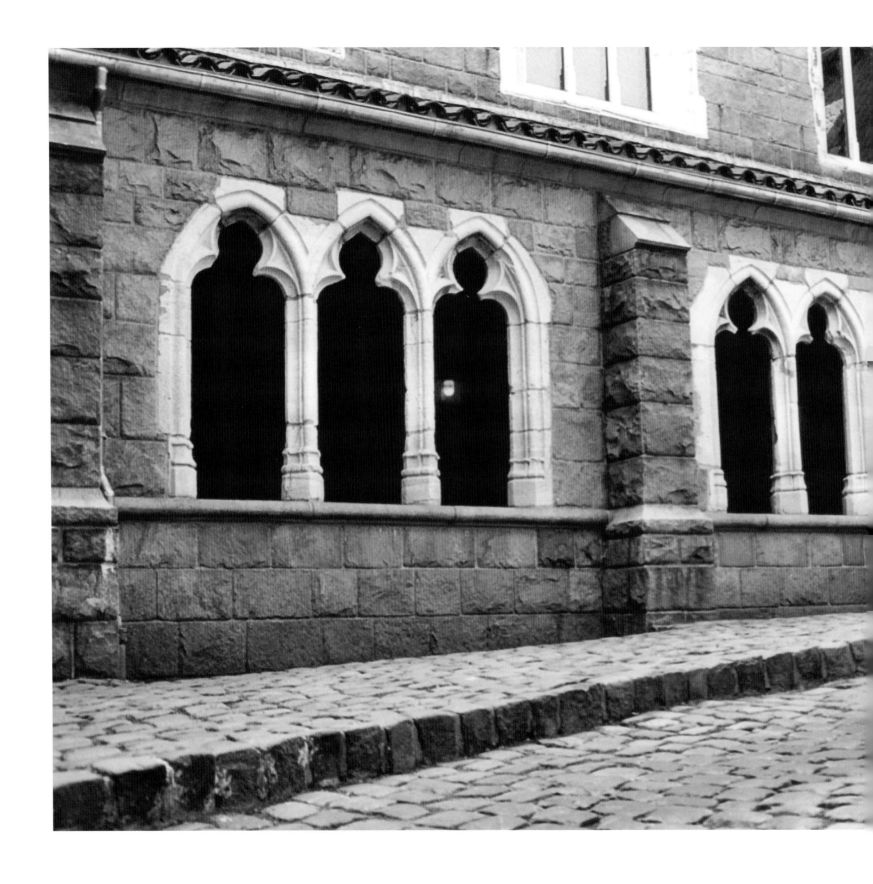

I, for one, am grateful for these spectacular gifts. Where else, I ask myself, can someone enter a room and stand just inches away from the *original* tapestries of the mythical unicorn, born of the sixteenth-century Flemish school of tapestry making?

Sadly, the artistic theme of the seven unicorn tapestries is the struggle of the unicorn to evade the capture, cruelty, and death brought upon it by humankind. And even though the unicorn uses his magical horn to remove snake venom from Man's drinking water, as seen in the second tapestry, "The Unicorn at the Fountain," he is still pursued and imprisoned by human beings, which has led to speculation that he is, in a fashion, a Christ-figure, saving us from the snake's—or Satan's—poison.

But surely the two most emotionally powerful and disturbing unicorn tapestries at the Cloisters are tapestries six and seven, "The Unicorn in Captivity," in which the unicorn has miraculously come back to life (again, a Christ image), only to be taken prisoner and then forced into a small, circular corral and chained by the neck to its wooden gate. He is an unwilling participant in his own destruction.

The Gothic Chapel, however, displays death in quite an opposite perspective. Graced with funerary effigy-tombs, individual knights and lords are captured, in some of the finest artistic expressions of their time, with a combination of sophisticated "living" detail and idealized aspects of virtue, piety, and courage.

The center of the chapel features an effigy of the French crusader knight Jean d'Alluye. He is shown as a young man protected by chain mail, with a trusty, sidearm sword attached to a broad belt, and a stout shield. His eyes are open, contemplating, while his hands are joined in prayer.

Rivaling the artistic majesty of Jean d'Alluye is the effigy-tomb of the Spanish nobleman Ermengol X (1254–1314), Count of Urgel, who is shown wearing decidedly pointed shoes—perhaps not uncommon to his native area of Catalonia, near the Pyrenees Mountains—called "poulaines."

The builders of Gothic chapels strived in general to bring light into the naves; the light of Heaven, as it were—God's grace. Yet although the ambience of the Gothic Chapel is indeed rarefied, I am moved and even awed by the unearthly light that

angles into the Romanesque Fuentiduena Chapel, centered directly in the north portion of the Cloisters. There is a stillness and an almost challenging eeriness to the curved apse of the room, which is dominated by a great wooden cross made of red pine (with the body of Christ upon it, made of white pine) that hangs on a heavy metal chain.

Some might say that the Cloisters is not a true castle, since it is a composite of medieval monasteries. In reality, though, it has all the elements that comprise bona fide castles: a prominent, tall central tower; inner and outer courtyards; vaulted ceilings; high, stone-wall battlements; and one of the finest examples of a true portcullis gate, which rises and lowers onto the east cobblestone drive, that I've seen to date.

I approach the battlements of the west-face terrace and gaze out at the Hudson River below. To this day, I can hear the drumbeats of the enemy; the disjointed clatter of armor, the uncertain whinnies of their horses. Am I El Cid? Is this the walled, fortress-city of Valencia? I think not. But in this ultimately special place, where the past comes palpably alive, you can feel yourself living it.

Who knows, I tell myself. Maybe, maybe not . . . I consider the possibilities.

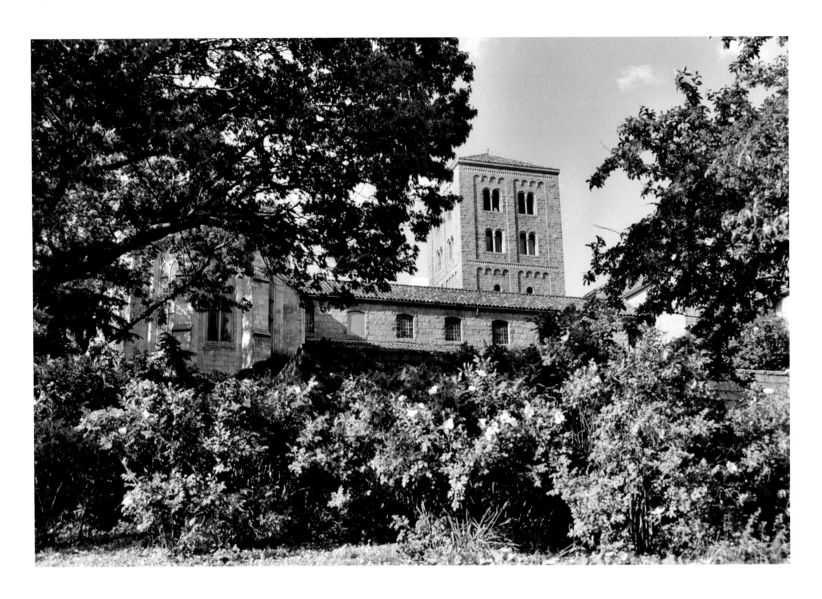

FONTHILL CASTLE

onthill Castle, which sits in a topographical bowl at the west end of the College of Mount St. Vincent, can be described as a perfect castle—in miniature. Its classically formed towers, of varying heights and widths, display deeply carved merlons and crenels along faceted, cylindrical rooflines. They are grouped in effective defensive clusters of two and three, with either hexagonal or octagonal configurations. Long, narrow windows, which mimic castle loopholes of the Middle Ages, appear ready to rain arrows down on an enemy below.

But here, in Riverdale, the Bronx, raining down arrows could not be farther from the intended purpose of the Sisters of Charity, who own the castle.

Initially, the castle was located in the Bronx neighborhood of Kingsbridge, which is now part of Riverdale. It was the brainchild of the well-known Shakespearean actor Edwin Forrest, who purchased farmland overlooking the Hudson River in 1847. He built the castle, as was so often the case, with the prevailing desire to please a loved one—his wife, Catherine. Apparently Edwin's great gift fell somewhat wide of the mark: he and Catherine achieved modern, tabloid-like notoriety in a messy "knock-down-drag-out" divorce in 1850 that was the culmination of their official separation the year before, when Edwin had moved back to his hometown of Philadelphia. After the divorce, Fonthill Castle was sold to the Sisters of Charity and the College

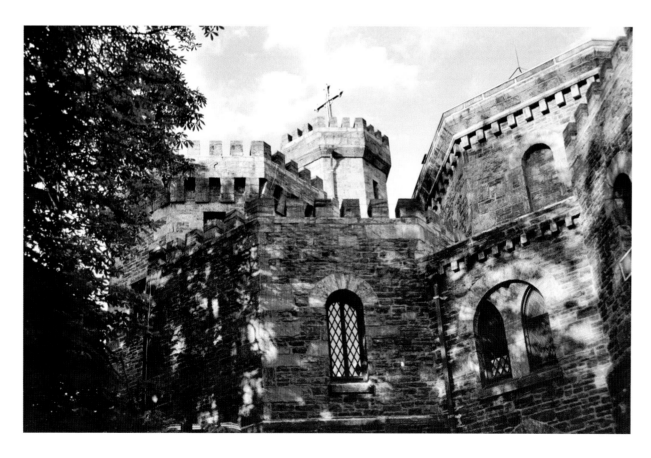

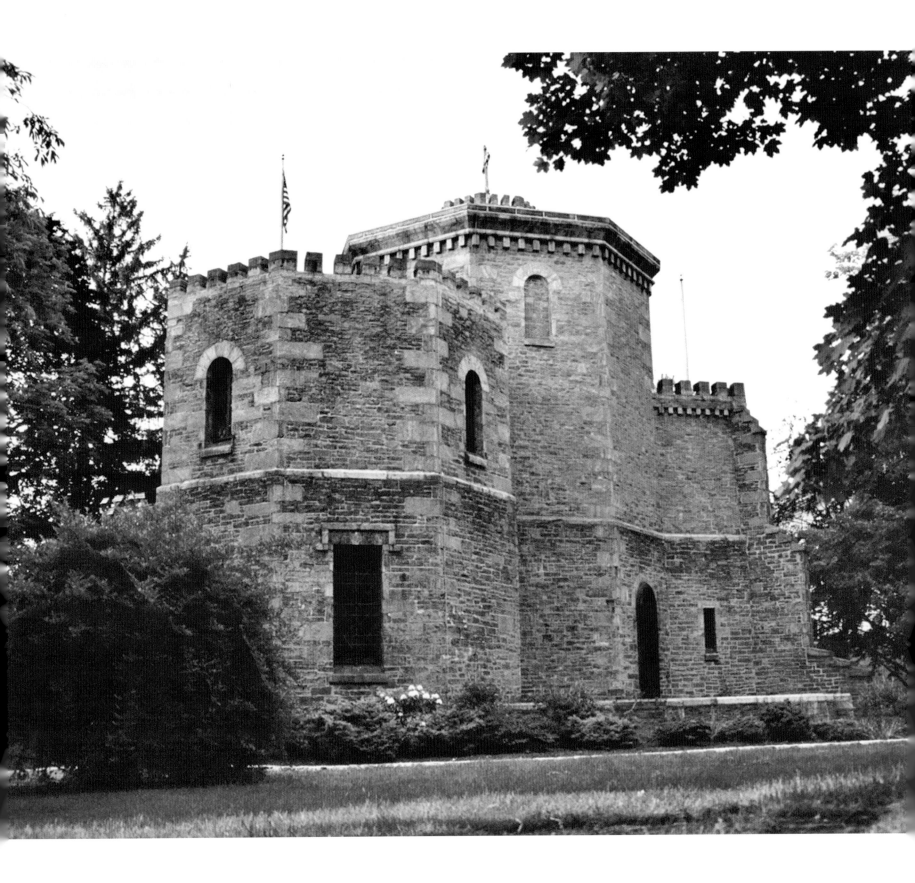

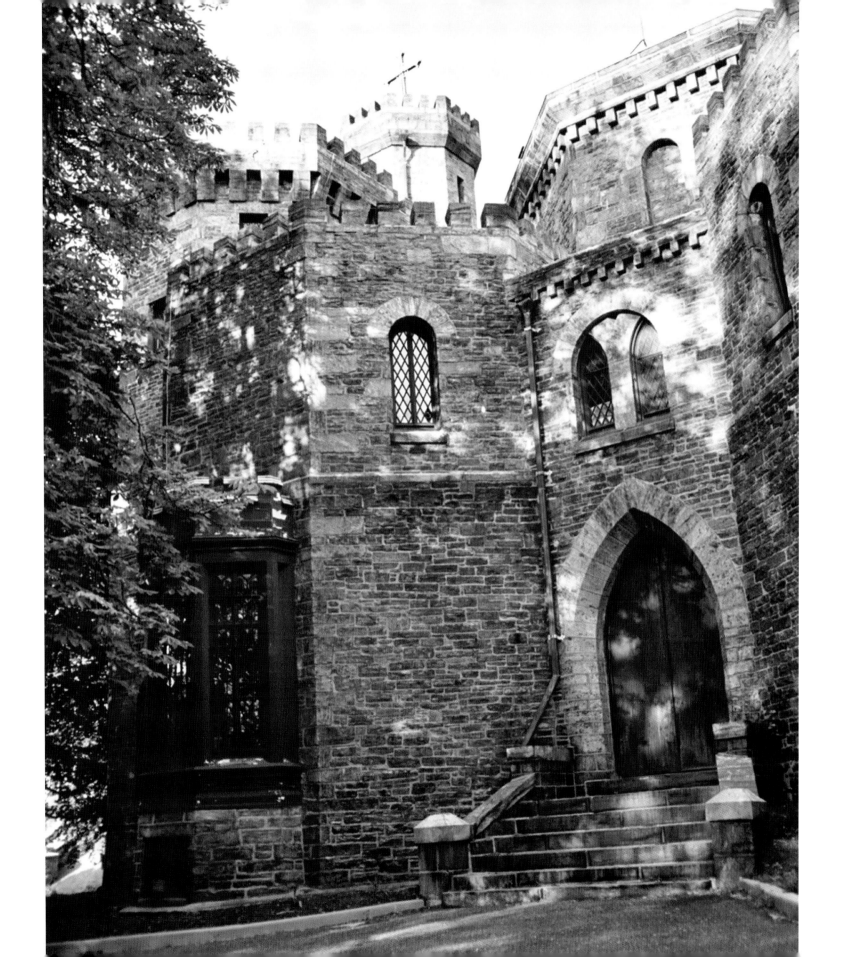

of Mount St. Vincent, and by 1912 it was doing triple duty as a chaplain's residence, library, and museum. Today the castle serves as the Office of Admissions and Financial Aid and is the architectural symbol of Mount St. Vincent College.

I lie on my stomach, along the upslope of a lush, grassy knoll. The setting sun is creating swatches of shadow and light across the width of the Hudson River. At the same time—due to the rise of the land—it casts a warm, golden-orange glow over the south and west faces of the castle. Did actor Edwin Forrest see the same glow, experience the same tranquility, when he named his new castle after writer William Beckford's Gothic Revival country house, Fonthill Abbey, in England? Surely he was well aware that the original Fonthill was nicknamed "Beckford's Folly," perhaps because Beckford lived there, alone, in one of the twelve bedrooms, while the monumental three-hundred foot tower of the abbey collapsed and had to be rebuilt not once but twice.

Fortunately, Fonthill was not built on such a grand scale. This might be disappointing to some, but to my mind Fonthill Castle is beautiful because of, not in spite of, its compact profile. Like my favorite place in the world—Eileen Donan Castle,

in Kintail, Scotland—Fonthill makes a statement of power and grace in a small package. With its massive oak entrance door—which serves as a portcullis, of sorts—and interior complement of granite and limestone walls, hardwood furnishings, and leaded glass windows, it shares the best features of the neorevivalist castles that literally lined the slopes of the Hudson River at the turn of the twentieth century but were plowed into dust in the name of "progress" and development.

Here is one Hudson River treasure that will be preserved for ages to come.

The shadows creep rapidly over the surface of the castle towers now, and I'm shooting frame after frame of film with increased urgency, as my camera settings reflect the loss of light on my subject. Something deep inside wishes I could be here in the snow, warmed within the thick walls of the battlements, stroking the forehead of my great Highland hound. It is an image that is easy to conjure, here in this center of knowledge and faith. Let the snows come—Fonthill will be ready.

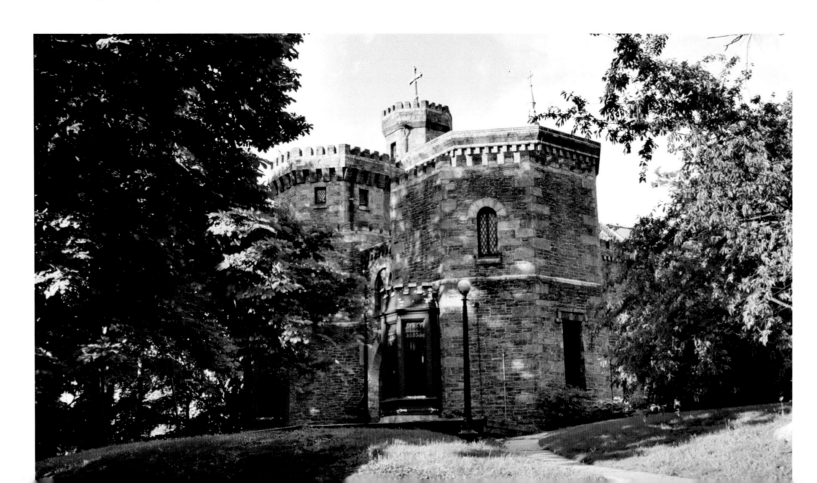

WESTCHESTER COUNTY

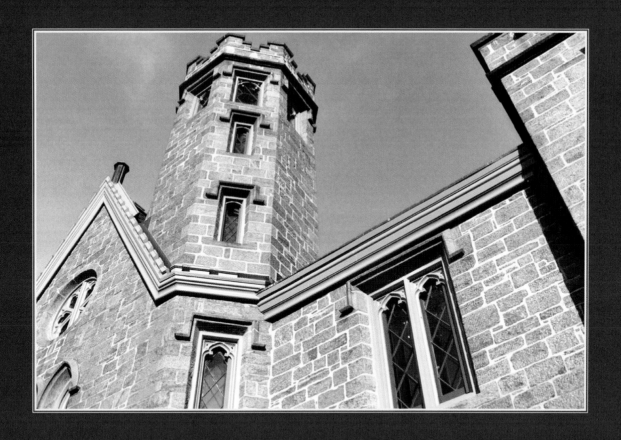

IONA CASTLE

It's my fifth attempt to find Iona Castle, which is allegedly tucked away on an island in Long Island Sound, just off the town of New Rochelle. I have heard about it and even seen pictures, but after much investigation—and to my growing chagrin—I just cannot find it. Gradually, my search for this heavily crenellated, multitowered little stronghold has taken on the proportions of a holy quest, and today I find myself driving up and down the same roads until I almost don't care anymore whether I find the place or not.

Finally, just when it seems that every inlet and marina will yield false leads and that maybe Iona Castle does not actually exist after all, I come to a stop at yet one more interminable traffic

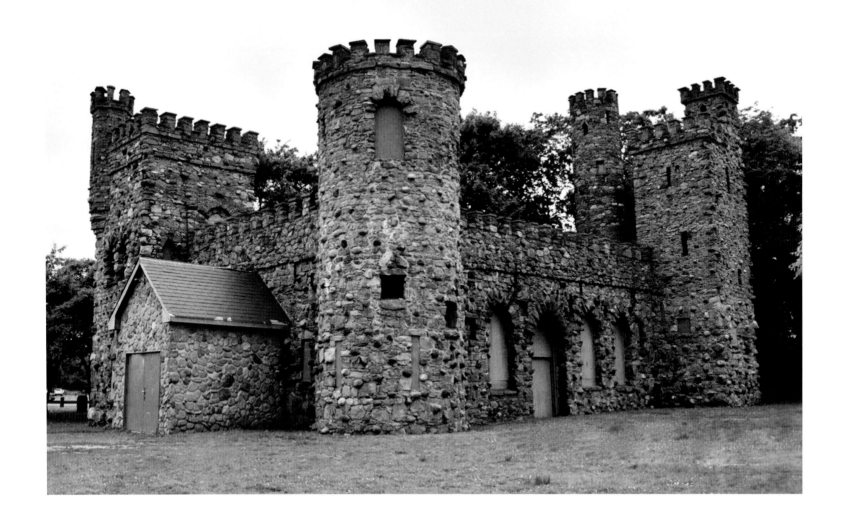

light. Weary and sighing, I tell my assistant, Aleta, that I'm ready to give up and go home. Then I glance up at the street sign to my right. In simple, clearly legible white lettering, the sign reads S BARRY AVE.

I turn to Aleta and ask the inanely obvious question: "Do you see that? *S Barry* Avenue?"

"It's a sign," she says reverently.

"I *know*," I shoot back at her.

"No," she insists, "This is literally a *sign*!"

"I *know*, I *know*."

She shifts in her seat and turns toward me: "Let's keep going."

"What?"

"*S Barry* Avenue," she says. "It's a sign that we should keep looking."

I shake my head. "I don't think . . . Okay, what the heck." Maybe this *is* some sort of sign, I think.

I continue driving south, past homes that go from modest to luxurious, all the while trying to keep us close to the water. After some more dead ends and backtracking, and just as I'm ready to pack it in again, we come across a simple but prominent sign that reads GLEN ISLAND PARK.

"Glen Island Park," I say, checking my notes. "That sounds familiar." We cross over the small drawbridge that connects the island to the mainland and follow the winding drive. Finally, out of the corner of my eye, I sense something tall, rising above the landscape.

"I see it," I tell Aleta, "I see the towers. You were right—it *was* a sign."

Like the last, remote outpost in a French Foreign Legion movie, Iona Castle seems so alone, despite the boats in the harbor behind it, the large parking lot next to it, and the families grilling hot dogs beside the picnic tables in front of it.

Perhaps it's this incongruity with the surrounding civilization that gives the castle its distinct character. The overall impression is not of elegance, grandeur, or enlightenment. Instead, Iona Castle speaks to a stark pragmatism, to a bulldoggish tenacity. Short and squat, it seems fully prepared to withstand a ground assault. Its five defensive towers offer a combination of

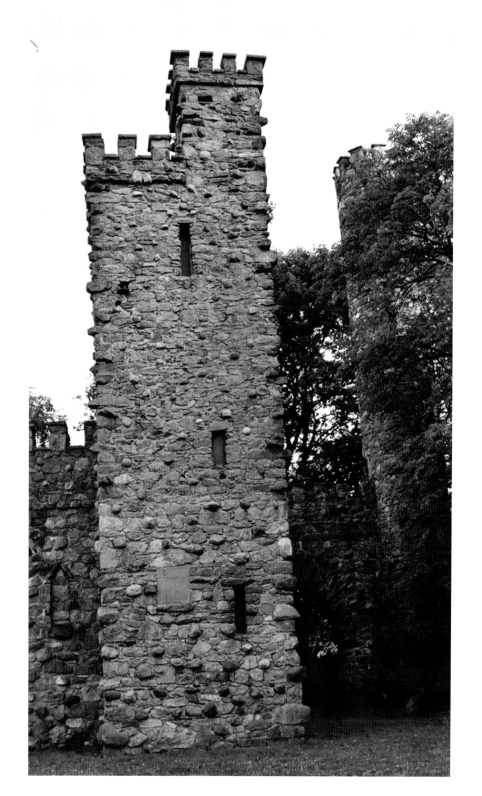

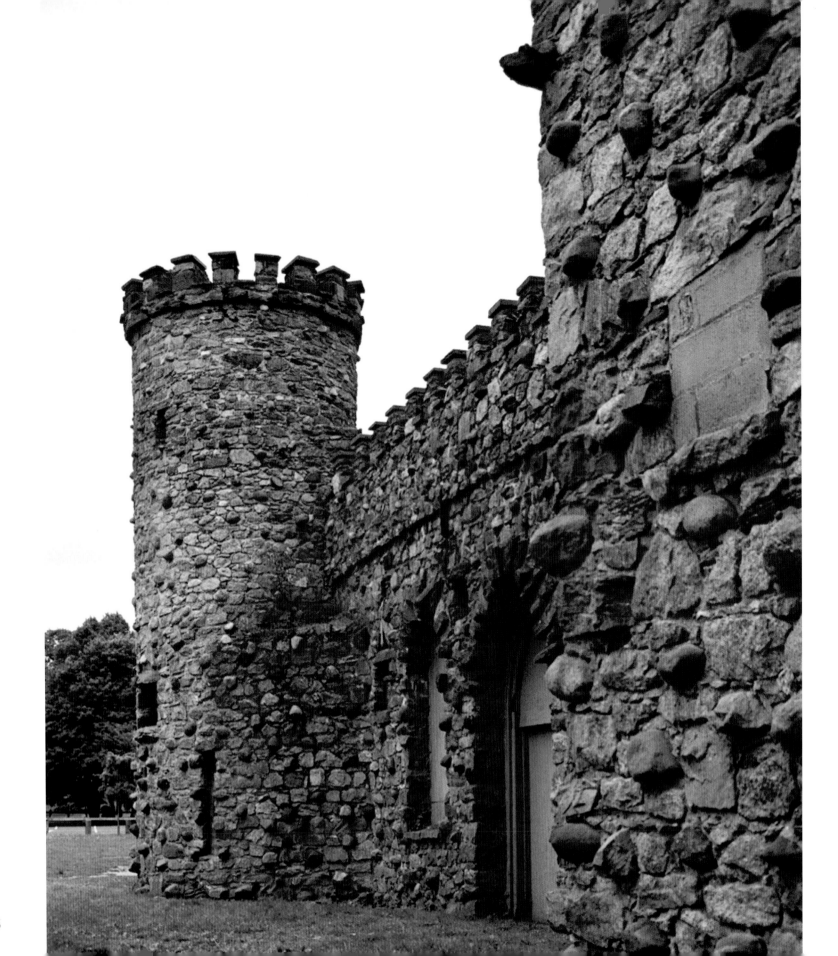

classic Norman cylindrical form with the hard-edged, squared configurations of the Middle East. Like Fonthill Castle, it is perfect in its austerity.

Iona Castle's origins, however, are not in Normandy, the Middle East, or even the United States, but in late nineteenth-century Germany, where it was built of coursed "rubble stone." In the 1920s, it was disassembled and shipped to New Rochelle. As I look at it, I find myself thinking of the many small castles that dot the Rhine.

There are actually two castles at Glen Island Park. Once the focal point of the 130-acre property when it was established as a summer resort in the 1920s, Iona Castle is the only one still in use—the second, even smaller castle, closer to the water, is now in ruins. As for Iona Castle, it now serves as the boathouse for the Iona College crew team, which shares it with the Sarah Lawrence crew team. It is the center of all Iona crew operations and is the hosting point for the Fall and Spring Metropolitan Regattas at Glen Island and Orchard Beach Lagoon.

As the waning sun quickly throws Iona Castle into the gloom of night, I fire off the last frames of my film. Then Aleta and I climb into the van and bid farewell to this last outpost on Long Island Sound. It may have taken forever to find this place, but I feel a sense of quiet comfort within me that finding it was partly due to S BARRY AVENUE.

LELAND CASTLE

Leland Castle at the College of New Rochelle is one of those photo shoots that I cannot say I chose to do in the rain; but shortly after I arrive, I begin to realize that the rain provides the perfect setting for this fourteenth-century English Gothic "kingdom." Spread before me is an exquisitely kept collection, if you will, of gray stone buildings enclosing a sort of expansive green courtyard within. There is a powerful sense of grandeur here, combined with intimacy—a deft achievement, considering that thousands of students attend this bastion of higher learning on a daily basis.

It began, though, in 1848, when Simeon Leland purchased forty acres of farmland in New Rochelle as the intended site of his weekend and summer home. Construction got underway in 1855 and was completed in luxurious style due to the success of Simeon and his four brothers—known as Simeon Leland & Company—and their intelligent leasing and able management of the six-story Metropolitan Hotel in New York City. Leland dubbed his new home with its square Gothic tower "Castle View" for its uninterrupted panorama of Long Island Sound, the surrounding countryside, and five lighthouses. He hired renowned architect William Thomas Beers and several artists to bring to life his dream of an "English castellated Gothic edifice."

In keeping with his reputation for combining the best of European artistry with the solidness of American comfort, Simeon Leland had his castle constructed of granite, some of which was quarried not far away in Tarrytown and some in the environs of New Rochelle itself.

Castle View contains a complement of sixty rooms. The rooms on the first floor support sixteen-foot ceilings, while the second floor rooms reach a height of fourteen feet. All rooms are finished in high-art frescos, with woodwork of solid black walnut. The stairs and household furnishings are of the same solid black walnut. Set off from the grand staircase, on the main floor's first landing, are the impressive billiard room and art gallery, which is home to rare works of art.

Individual rooms—the Gold Room, the Blue Room, the Pink Room, and the Tent Room—have been named for their specific artistic appointment. Each is adorned with rosewood and high-polished walnut, interwoven with ormulo and gold. Fine china, velvet carpets, thick hanging tapestries, and exquisite statues and caryatids complete the effect.

The rain falls in a gentle, showery mist now, dampening my face and the body of my Nikon FM10 camera. The windows of the castle glisten beneath the shroud of a deep gray sky that

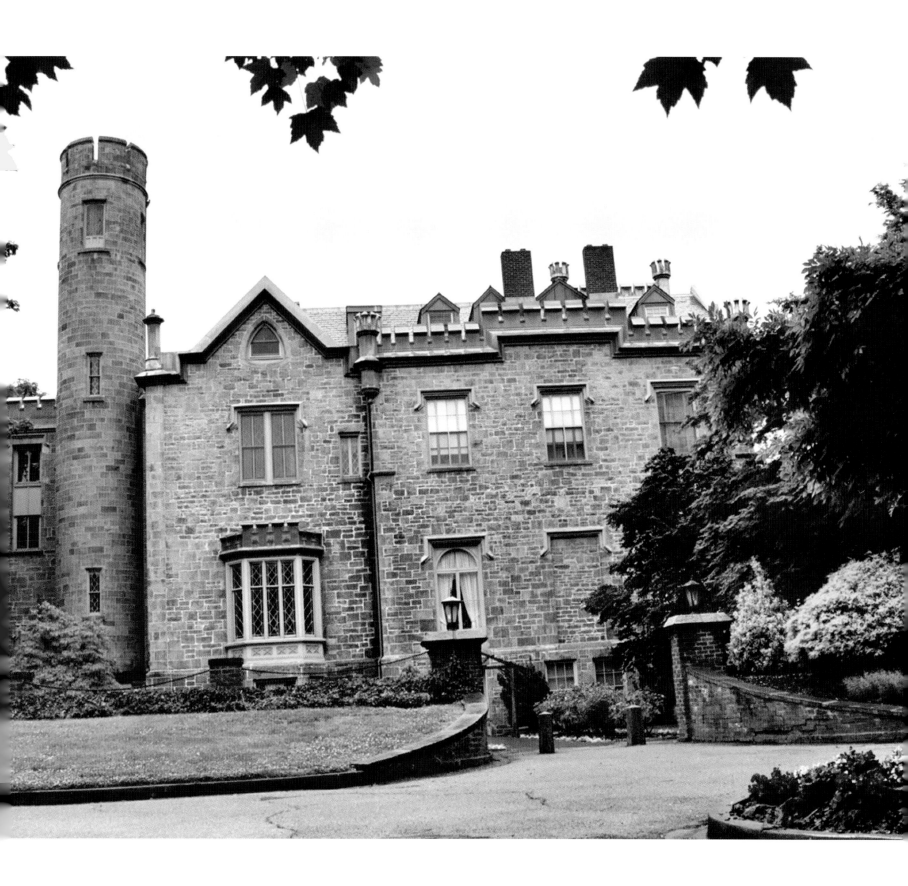

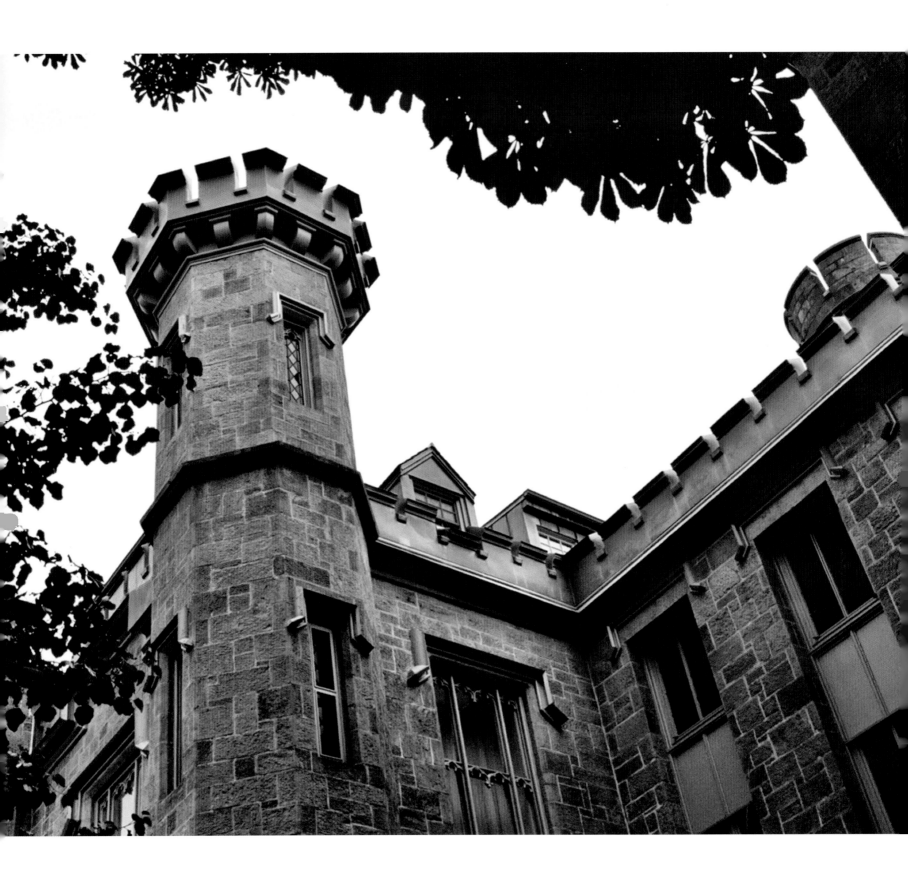

looks as though it has been carved from the same granite as the building. I cannot help thinking, among the hushed atmosphere (devoid of students, who have gone home for summer vacation): Is this the same tranquility, the same easy solitude, that Simeon Leland and his wife, Eleanor Moore, knew in the mid-nineteenth century?

Sadly, when Simeon Leland died on August 3, 1872, he, like so many of his peers, was deep in debt. Castle View had cost $35,000 to build (something on the order of $1 million today), and Eleanor had failed to pay the mortgage. The castle was soon taken over by the Manhattan Life Insurance Company, who allowed Eleanor Leland to live there until 1880.

Since then, the castle has had several incarnations. From 1880 to 1882 it was known as the Castle Inn, accommodating guests from the Queens County Hunt Club in the tradition of English roadside inns. In 1884, it was converted into a boarding house by its newest owner, Adrian Iselin Jr.

From 1889 to 1892, the building was rented by the New Rochelle Collegiate Institute as a boarding school for young boys. Iselin reduced the forty acres of the original estate to a

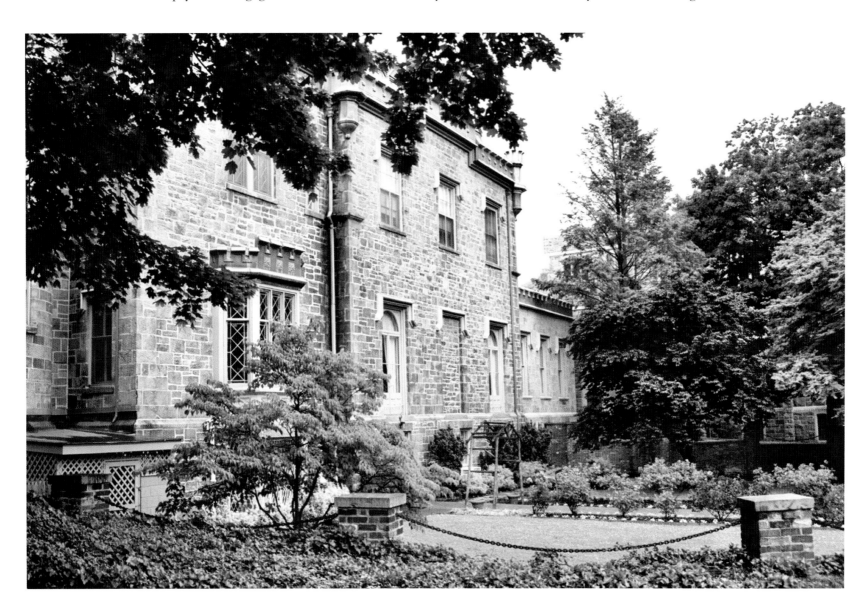

paltry two-and-a-half acres, turning the rest into one of America's first suburban developments, called the Residence Park.

In 1896, Leland Castle was transformed into a girls' boarding school when a Miss Morse of Boston rented the building for her academy. But on January 13, 1899, a fire broke out in one of the castle's main chimneys and caused extensive smoke and water damage to the building's roof, plaster, murals, and woodwork. Having no disaster insurance, Morse broke her lease and closed the school.

Coming to the castle's rescue was Mother Irene Gill, an Ursuline prioress and the principal of St. Teresa's Convent and Normal School, on Henry Street in New York City. Mother Irene told an agent of the Iselins that she would indeed buy Leland Castle if they would repair all areas damaged by smoke, water, or fire. Her request was quickly fulfilled by the local architectural firm of Peter Doern.

The nuns moved into Leland Castle during the summer, and in September of 1897 they opened the new Ursuline Seminary. The seminary did so well that by 1899 the nuns needed to build a larger chapel, which was constructed on the site of the original greenhouse as an extension of the drawing room. Delicate care was taken to match the windows, tracery, and stonework to the original building. Yet even this addition was not enough to accommodate the ever-growing student body. In 1902 a larger wing was added onto the north side of the castle, next to the old billiard room and picture gallery, also in the style of English Gothic architecture. It was here that Mother Irene's latest creation—the College of Saint Angela—began educating its first students.

In the following decades of the twentieth century, few changes were made to the original building—only the installation of an elevator in the north tower to replace a burned-out staircase and the replacement of wood surfaces over the bay windows with galvanized iron.

Today, the majestic avenue of elms that once graced West Castle Place is no longer there. But the fourteenth-century Gothic kingdom, as I like to think of it, with its classic battlements of merlons and crenels, its wrought-iron fences and chiseled stone figures, still presides over the immediate landscape.

The steady mist of the rain does not dampen the calm dignity of the castle; rather, it adds to it, enhances it. The attendant buildings do not appear foreboding; they invite us in, to be safe and secure and, within their walls, to breathe and think and learn—to fulfill our own quest for knowledge.

I stare admiringly at the cast-iron lion faces that grace the castle's entrance doors. How many faces have they seen? I ask myself. How many lives have they welcomed between these walls? The answer is clear: thousands.

REID HALL

Reid Hall at Manhattanville College is a five-story, eighty-four room granite structure with a prominent central tower, classic castle battlements comprised of merlons and crenels, and several portcullis gates. It is situated near the corner of Purchase Street and Anderson Hill Road in Purchase, New York, and is one of several castles that I had to visit again and again to get the images I envisioned for this book.

Each time I took the hour-and-forty-five-minute trip from my home in the Catskills to the college, either the flawless-blue morning sky would change to a bleached, glaring, hazy field—

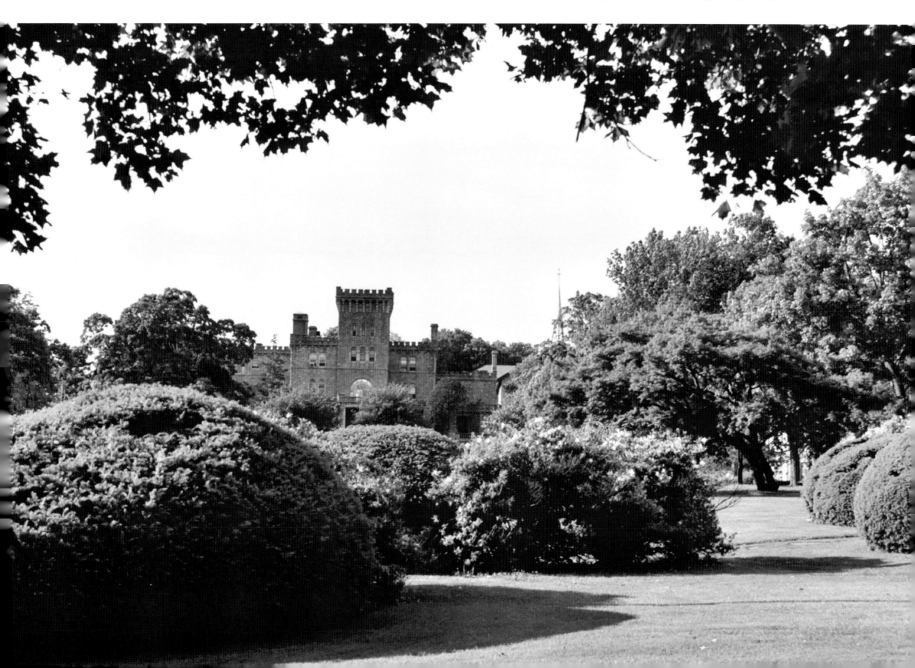

which is the worst kind of light for photography—or the sun would give way to rain; or I would find myself stuck in a monumental traffic jam on Route 684—which would get me there too late to capture the kind of shot I wanted of the main tower. And since one of my key goals with *Castles of New York* is to present my stone subjects in a natural, "organic" state, free of any vestiges of twenty-first-century life, I was continually striving to keep any cars, trucks, telephone wires, signs, or human beings from getting into my camera's frame.

The history of Reid Hall—or the land on which it now stands—dates back to 1661, when Chief Shanarocke of the Siwanoy Indians (a clan of the Mohegans) bequeathed the land to John Budd of Southold, Long Island. Although Budd built a gristmill at Blind Brook, he never filed a claim with the provincial governor to register the land, and toward the end of the seventeenth century, a second Indian—Pathungo—took claim of the land and then sold it for the equivalent of forty pounds to John Harrison of Flushing, Queens. After Harrison was granted an official patent for the land, it later became known as "Harrison's Purchase"—so named by a group of Quakers in the early 1700s.

In 1864, Ben Holladay, the "Stagecoach King," who created a huge financial empire through investments in the Pony Express and by winning the U.S. Mail contracts for the Overland Express, bought one thousand acres in the area and built a spectacular mansion of granite and marble. In an effort to bring a bit of the West to New York, he imported buffalo from Wyoming, elk from Colorado, antelope, and deer, along with speckled trout for the streams and trees, ferns, and wildflowers from western states.

Although early terrain maps designated the estate as "Buffalo Park," Holladay called his estate "Ophir Farm" after the Ophir Silver Mine in Virginia City, Nevada, of which he was a part-owner. He then added a chapel in the Norman-Gothic style, along with a coach house, stables, a root-cellar, and houses for the sixty servants he employed.

But the hand of fate would turn, and Holladay lost his entire empire in one day during the stock market collapse of 1873. He put the estate up for sale, but it wasn't until a full ten years later that John Roach, the shipbuilder who constructed

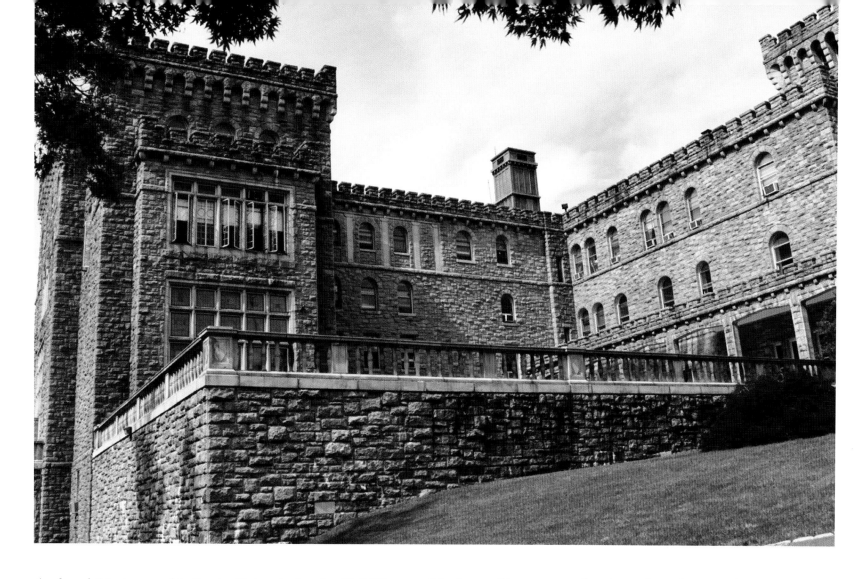

the famed *Monitor* warship for the Union during the Civil War, purchased it. In a second twist of fate, however, Roach lost his fortune before he had ever actually lived on the estate or in the old house. His son, Garret, immediately put the estate, which was now falling into ruin, up for public auction. In 1887 it was purchased by Whitelaw Reid, owner of the *New York Tribune* newspaper. Reid hired the architectural firm of McKim, Mead, and White to oversee the restoration, which included the latest appliances and innovations, including a telephone connection and electric wiring. But on the morning of July 14, 1888, only days after Reid and his wife, Elisabeth, had moved in, a fiery blaze swept through the house, and several hours later the mansion was reduced to rubble, with only the stone walls left standing. (Ironically, that same month the main building of the Manhattanville campus—then located on Convent Avenue in New York City —was almost totally destroyed by fire.)

Whitelaw and Elisabeth decided to rebuild on an even grander scale than before, adding a five-story tower and crenellated battlements. When they hosted a grand opening in 1892, the mansion was renamed "Ophir Hall" and was immediately proclaimed a "work of art."

The reception hall gleamed with two varieties of marble— yellow Namibian marble from Africa and pink marble from Georgia—perfectly blended in presentation. An original stained glass window that had survived the fire dispersed light from above the main staircase to the entrance room below. The two rooms to the right of the main entrance hall were imported from Poissy, France (Reid was appointed minister to France in 1889

and oversaw much of the restoration work by letter from Paris). The newer Jacobean Corridor offered a combination of the Elizabethan and Renaissance styles. The corridor was adorned with paintings from Gainsborough and Turner, all of which symbolized the Reids' affiliation with the Court of St. James.

In 1949, Manhattanville College of the Sacred Heart—which had been located in New York City since 1841—purchased the castle along with 250 of the estate's 900 original acres. Mother Eleanor O'Byrne, president of Manhattanville College, provided constructive ideas and great leadership in the designing of the new Academic and Music Building, as well as the library. In September 1952, with the opening of five college buildings, Manhattanville made its final move to Purchase, New York. Seventeen years later—in 1969—the main castle building was renamed "Reid Hall," in honor of Whitelaw Reid. And a short five years after that, on March 22, 1974, the U.S. Department of the Interior placed the building on the National Registry of Historic Places, in recognition of its cultural, architectural, and academic contributions to the legacy of New York State, and to the country as a whole.

Today, Manhattanville College is a nondenominational, co-ed community in itself of sixteen hundred undergraduate and twelve hundred graduate students from seventy-six countries and all fifty states.

On my fifth trip to capture the best aspects of Reid Hall, the weather has changed on me once again. The sun is gone, blue skies are nowhere to be found, and a quilt of gray has blanketed the heavens above. To add insult to injury, here in the off-season for classes, there is one vehicle—a beige Lexus SUV—parked just to the right of Reid Hall's main entrance, effectively ruining my shot of the castle's lengthy exterior. And when I call the security guard, Lee, on my cell phone to ask if the Lexus can be moved, the reluctant answer comes back: "Sorry, Scott—we don't know who the vehicle belongs to."

I am forced—as I have been many times—to work around this man-made impediment to the aesthetics of my shoot. I do this by getting low to the ground so that I can shoot up at my subject. I then use natural, surrounding objects: tree limbs, bushes, flowers and rocks, to frame the borders of my image and give it that special "postcard" quality.

When I am finished shooting, I drop in on Lee at the college security post. "I saw big birds," I tell him.

"Oh yes," Lee replies, brightly. "Hawks sit on the cross at the O'Byrne Chapel. They fly into the bell tower."

I nod my head appreciatively. "Isn't that where John Kennedy married Jackie? At the O'Byrne Chapel?"

A broad smile from Lee: "That's the place." He steps closer. "And we have ravens on campus."

My eyes widen. "Ravens? So far south?"

He bobs his head, affirmatively. "And coyotes come by, at about four in the morning." He glances at a security camera. "They walk by . . . They just walk on by."

"Man," I exclaim, "you guys have everything here. What a great place to go to school."

"Yes we do," says Lee, "And yes, it is." Another broad smile. "It certainly is. Quite a place."

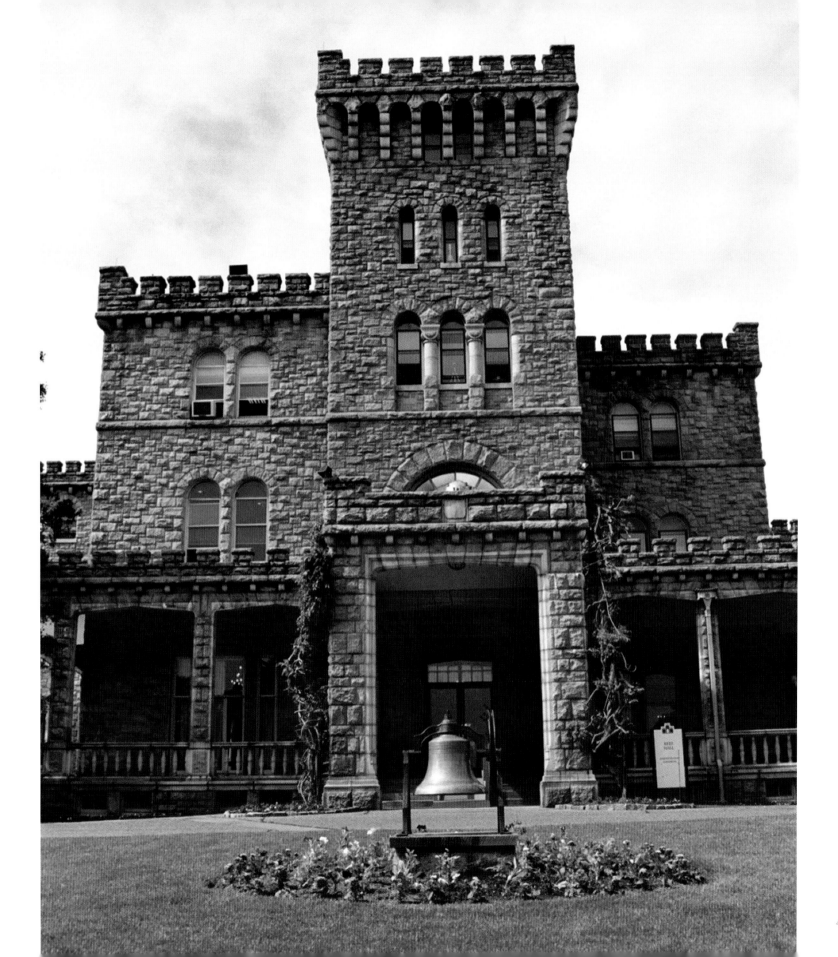

WHITBY CASTLE

I arrive at Whitby Castle late on a July afternoon in what can only be described as the most glorious lighting conditions imaginable. A crystalline-blue sky supports thin ashen clouds here and there. The air—pleasant and not overly warm—hangs silently around the castle, which is nestled in the heart of the Rye Golf Club, near the eighteenth green. As I approach the sweeping circular driveway of the golf club, I note the long, scalloped shadows created by stands of trees that bookend the structure on either side, which will lend depth and contrast to each photograph. Yes, I think, this will be a good shoot.

Ironically, this flawless, life-affirming setting and its bucolic sense of peace, so close to Long Island Sound, has a historic

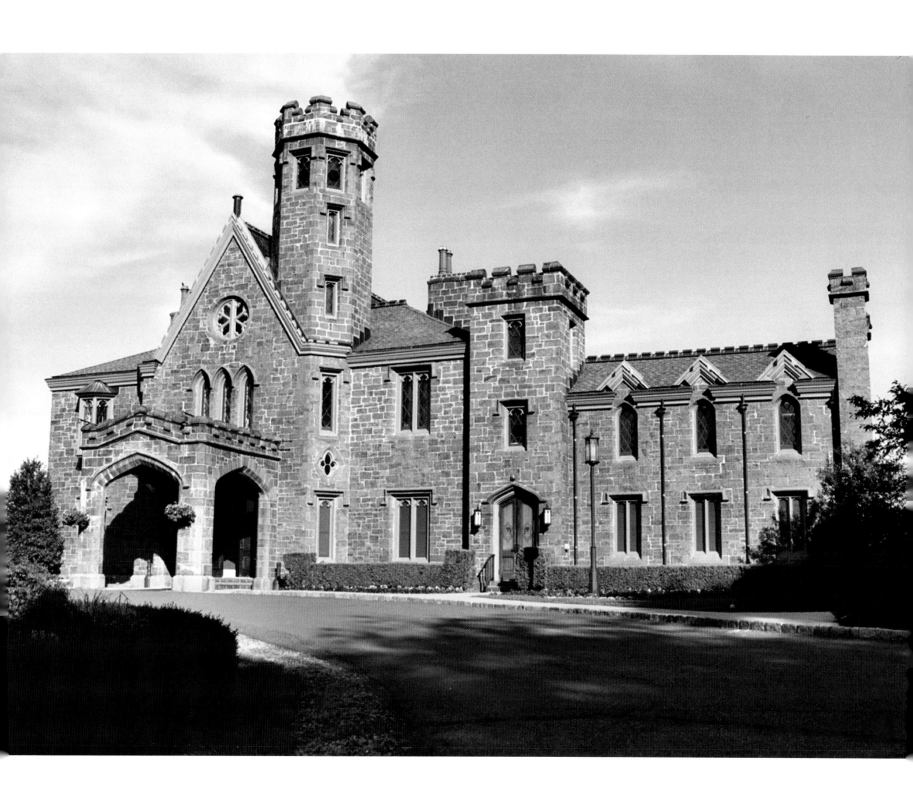

connection to the famed Irish author Bram Stoker and his classic horror epic, *Dracula*. When iconic New York architect Alexander Jackson Davis was hired in 1852 by Whitby's first owner, William Chapman, to build the castle, he imported stones taken from Whitby Abbey in England, the same abbey that forty-five years later was the setting for Lucy Westenra's first encounters with the Transylvanian count.

In 1886, thirty-four years after the castle's construction, the Chapman family sold Whitby Castle to the Park family, also of Rye, New York. The Parks lived there for the next twenty-five years. In 1921, the original 40 acres of the estate were combined with the adjacent 110 acres of the Allen estate to become the Rye Country Club. Eventually, the country club was sold and renamed the Rye Wood Country Club. In 1965 the city of Rye bought the property, changed its name, again, to the present one—The Rye Golf Club—and opened it to the public.

The interior of the castle features intimate restaurants with a solid hardwood bar, marbled floors, reception areas, bridal suite,

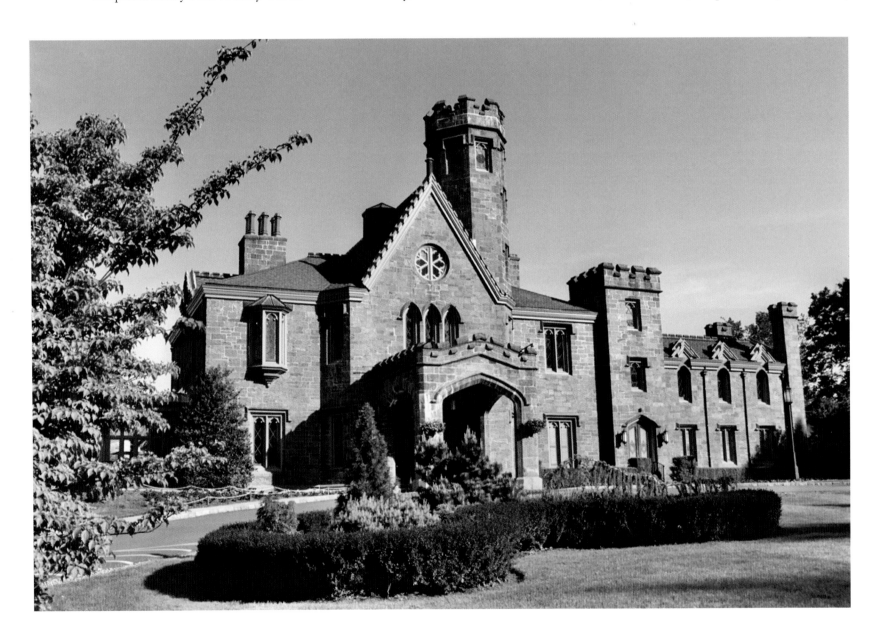

and beautifully appointed, spacious ballrooms. The castle offers two private reception rooms with elevator access on the second level for private family dinners, bridal showers, and smaller celebrations. Over the decades, hundreds of thousands of people have come to Whitby to play a grand eighteen holes of golf, get married, have a fine meal, or simply hang out at the bar.

I move around the castle, first walking, then stalking my prey commando-style, crawling along on my belly across the plush front lawn. As I suspected, each angle, each shot is a winner. The castle is a well-designed harmony of gray-stone brick, capped bay windows, crenellated towers, chimneys, and roof lines, with a lancet-arched main entrance door and a dominant but elegant central tower that stands out against the darkening azure sky. Impeccably maintained flower gardens and low hedge-rows trimmed to perfection border the castle's foundation, creating contours and depth-of-field to the estate grounds.

The sun sinks slowly in the western sky, turning the bright golden light to a warm orange glow. A silence seems to descend over Whitby's superstructure. I get to my feet and walk slowly—still stalking my prey—to the west wing of the castle where, mystically, the sun is now reflected off one of the tower's top windows, like a star, just below its battlements.

From this angle Whitby takes on a different persona, one that speaks to a dignity and strength through the passage of time. But in the midst of the silence, I suddenly recall Whitby's connection to Bram Stoker's *Dracula*, and I decide that maybe I should leave before the light is fully gone.

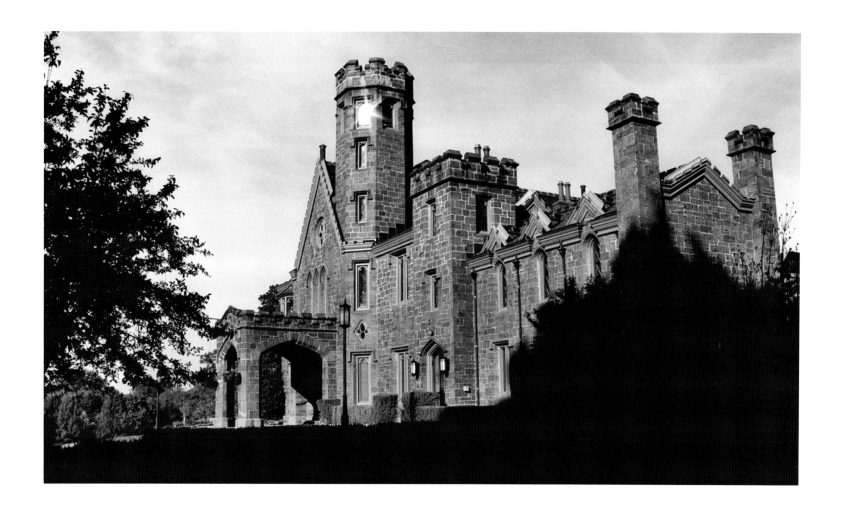

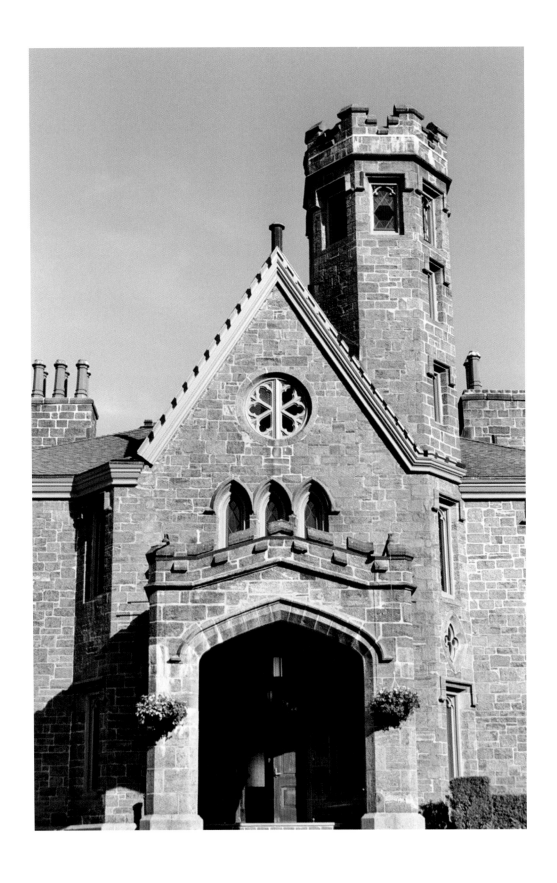

HUDSON VALLEY

BANNERMAN CASTLE

To my mind, Bannerman Castle—which lies between the New York towns of Beacon and Cold Spring—has always been the true phantom of the Hudson Valley. It is one of those amorphous entities of local folklore that relatively few members of the public get to visit, but which most of them seem to know about. It is "that place, just around the corner . . . just out of reach . . . somewhere, out there."

Although situated on six-and-three-quarter acres of rock known as Pollopel Island, the castle rises like a ghostly apparition over the Hudson River, just a thousand feet from the Amtrak and Metro North train tracks parallel to Route 9D. It is a New York mystery, wrapped in history and heritage that stretches back to fourteenth-century Scotland where, according to legend, a member of the MacDonald clan rescued the clan banner during the Battle of Bannockburn in 1314. Upon witnessing this heroic act, King Robert the Bruce proclaimed the brave MacDonald a "Banner Man," and it was this heroic Scotsman who reached into the future and inspired his descendant, Frank Bannerman VI, to construct his tribute in the form of a castle.

In its glory days, Bannerman Castle served as a storehouse for the tons of weapons and explosives owned by the Bannerman family, who by that time were America's largest dealers in surplus munitions. Bannerman purchased the island in 1900 and spent the next seventeen years constructing the castle and its surround-

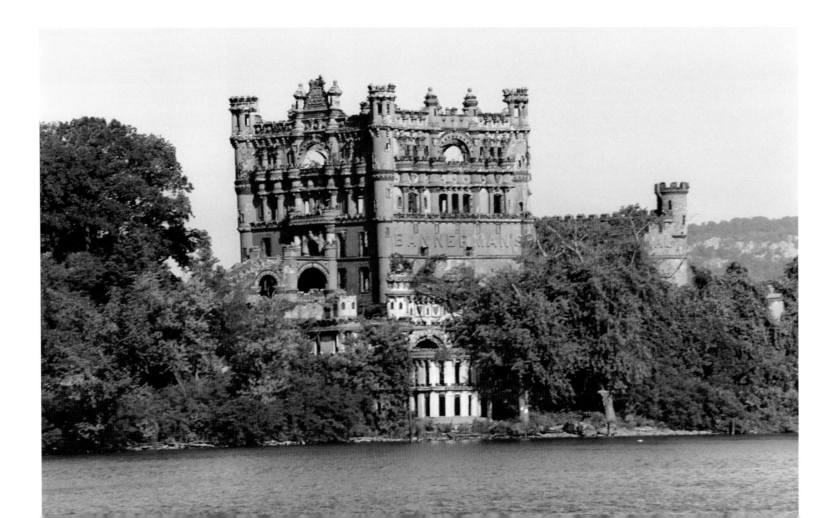

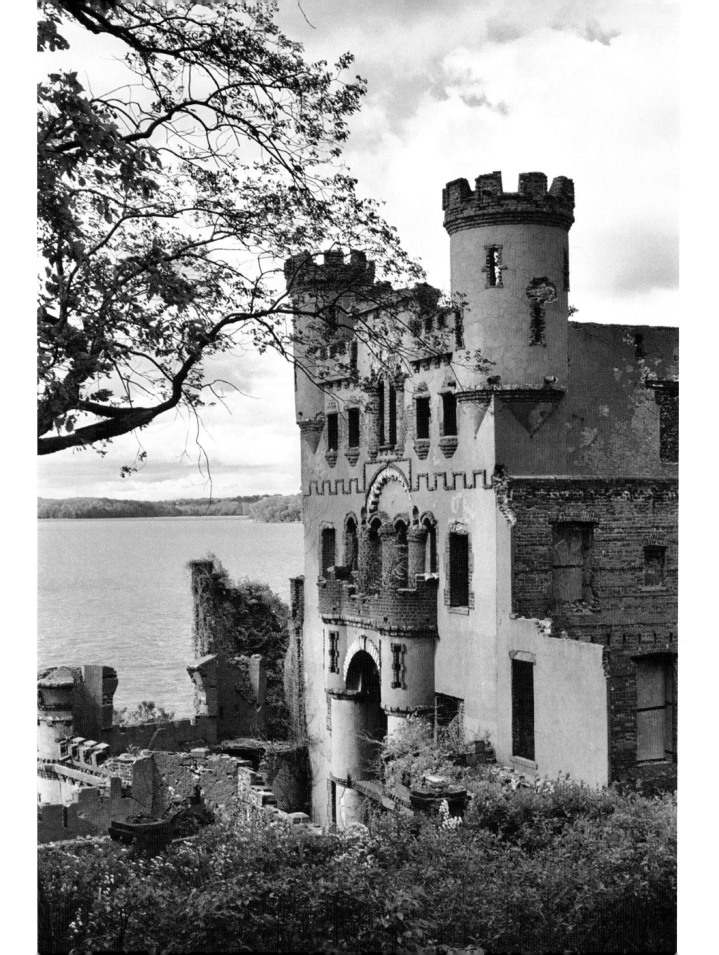

ing buildings, which included a smaller castle that served as the family home. The larger castle, which served as the main arsenal, features a huge main tower, battlements of raised merlons and sunken crenels, lone turrets, garden walls, and a moat. A large escutcheon (shield), emblazoned with the Bannerman coat-of-arms, and a wreath of Scottish thistle leaves with flowers are set in stone between the castle's towers.

Tragically, though, the failings of man and the ravages of nature have taken their toll on the proud castle and its attendant buildings. Despite the fact that Frank Bannerman had his construction crews reinforce the castle's walls with all sorts of military surplus debris—from old bayonets to screwdrivers, broken muskets, and whole bedframes—the mighty structure was no match for a huge gunpowder explosion in 1920, when a twenty-five-foot-long section of wall was blown clear across the river shallows to the Metro North railroad tracks.

Frank Bannerman passed away in 1918, and the island and buildings were gradually abandoned over the years. In 1967, the Bannermans sold the castle and island to the New York State Office of Parks, Recreation, and Historic Preservation. The state then took possession, and all the military surplus artifacts were removed and the more important pieces donated to the Smithsonian Institution in Washington, D.C.

New York State had intended to open the island as a public park, and in fact, for a short time in 1968, tours were taken through the foliage- and vine-strewn island. But a blazing fire of unknown origin (most likely vandals) lit the night sky on August 8, 1969. Bannerman Castle and its attendant buildings were engulfed in flames and gutted, and the Taconic State Parks Commission declared the entire island off-limits to the public, which only added to the castle's mysterious, larger-than-life reputation.

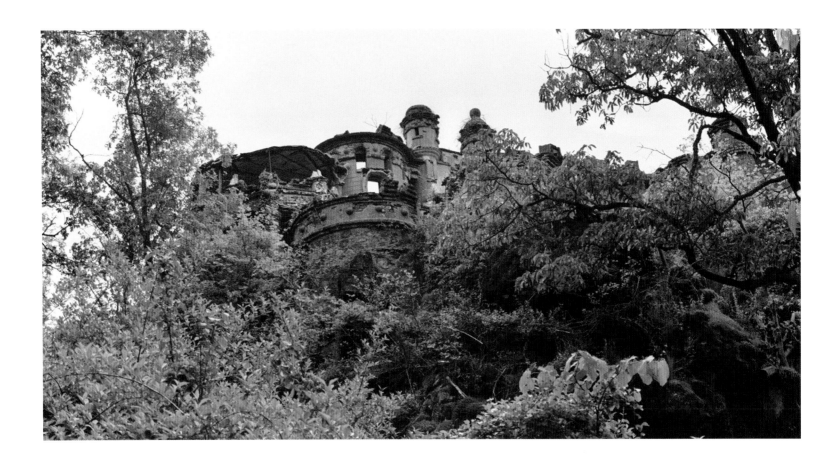

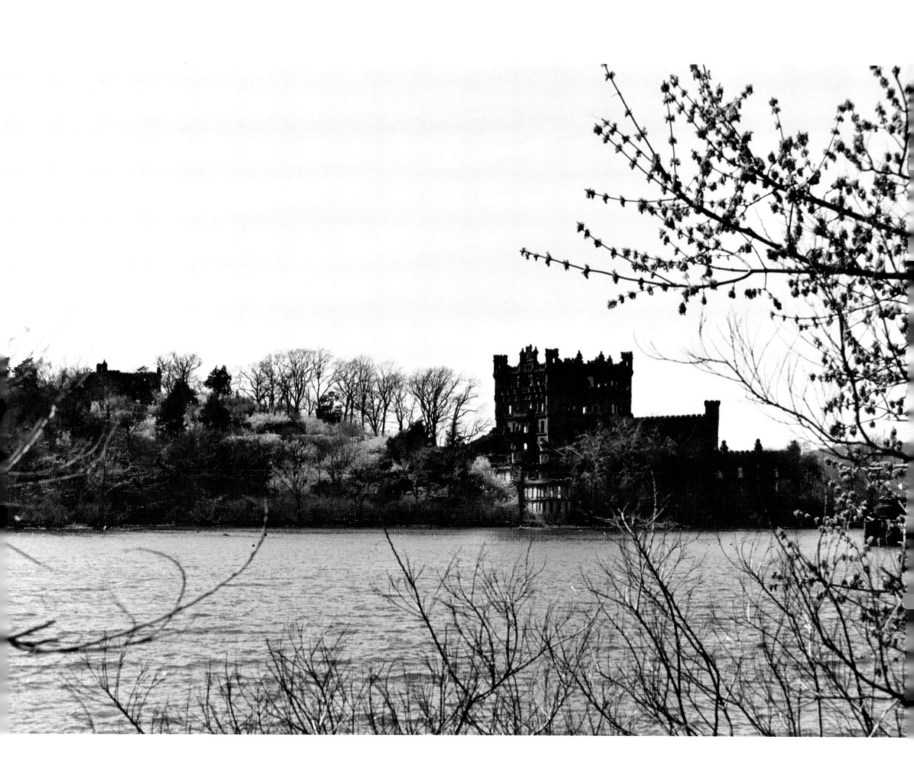

In 1993, the Bannerman Castle Trust was established in the hopes of raising awareness of the castle's history as well as the funds necessary to restore it, but it continues to deteriorate. Indeed, shortly after I submitted this book to my publisher, the castle suffered another blow when two-thirds of the eastern tower and part of the adjacent southern wall collapsed, most likely from the wear and tear of the elements. It is unclear as I write this whether the castle is salvageable or will ever be open to the public again.

But my goal as a photographer was not so much to document the castle up-close, from the island, but to show it in its slightly distant majesty, which is how most people have experienced it—in fleeting, enigmatic glimpses from a speeding Amtrak or Metro North train. Sounds relatively easy, I thought. Unlike wolves, which I've photographed extensively, castles don't move.

But "the best-laid schemes o' mice and men gang aft agley," as Scottish poet Robert Burns wrote, and I find myself taking more than a few trips to the castle to get the precise images and mood I'd envisioned. On one particular shoot, in fact, I nearly end up paying for them with my life. My assistant for the day is Susan Silverstream, of Rosendale. After walking along the gravel bed parallel to the railroad tracks and eventually getting the images of the castle from across its watery inlet, Susan and I decide to take the easier path back to my van by walking on the tracks themselves. Susan walks about thirty feet ahead of me. I keep my eyes down and forward, concentrating on the placement of my feet, trying not to turn an ankle on one of the gaps between the railroad ties. The midafternoon sun beats down on my head and neck, lulling me into a semi-drowsy state. All is calm and quiet, save for the music of the gently lapping waves against the shore.

Eventually I see Susan casually turn, then gaze past me: "Scott," she says in a calm but determined voice, "there's a train coming."

I glance over my shoulder, "Oh, yeah," then pivot right and begin walking down the short gravel slope away from the tracks. *Six seconds* later, the Metro North train comes hurtling past the very spot I was standing, blasting its horn. "Castles don't move," I remind myself, "but trains do."

CASTLE ON THE HUDSON

There is no mistaking the whereabouts or identity of the Castle on the Hudson. You need only drive along Route 119 and you will not miss this European-style structure, reminiscent of the grand castles of Edward I of England or Philip II of Spain, perched on eleven hilltop acres in Tarrytown, New York.

I guide my van toward Benedict Avenue, up and around the long entrance road. Like a monster made of stone, the castle sports huge, rough-textured walls with classic battlements of merlons and crenels running along their edges. Two equally crenellated stone towers rise high above the circular main drive, welcoming guests and visitors to the majesty of this nationally recognized historic landmark, which now houses a hotel and gourmet restaurant.

I step out of my van and stare up at the twin towers. "Now *this* is a castle," I tell myself, cataloging mental images of medieval siege towers, archers showering down arrows on their foes below, and fiery projectiles being hurled through the air by catapults.

But here, at Castle on the Hudson, that fantasy couldn't be further from reality. General manager Gilbert Baeriswil

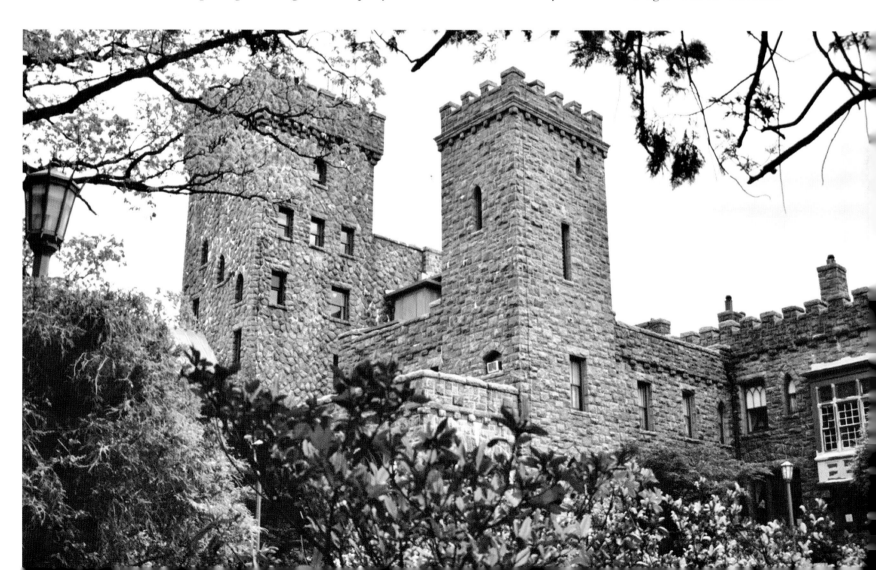

personally sees to every detail that has established the hotel and its renowned Equus Restaurant as an icon of tasteful splendor.

Originally a private residence, the castle was built by General Howard Carroll, who purchased the land in 1897. "Carrollcliffe," as it was appropriately called, was built in two stages between 1897 and 1910 by renowned New York architect Henry Kilburn, and was specifically based on classic Norman castles in Scotland, Wales, and Ireland. The finished structure, with a full complement of forty-five rooms, has seen few changes in the past hundred years. A high percentage of the original oak girders, beams, intricate woodwork, and handcrafted German furniture remain intact.

But Castle on the Hudson's roots go deep into history. The Oak Room, which served as the family dining room, had its wainscoting shipped over from a room in General Carroll's house in St. Germain, France, near Paris, a house that Louis XIV allegedly had given to James II of England after he had been overthrown and fled to France. It was in this very room that James's grandson, Prince Charles Edward Stewart of Scotland (otherwise know as "Bonnie Prince Charlie") and Scottish patriot Angus MacDonald of the Highlands planned the uprising of 1745 that led to the eventual destruction of the Scottish clans at the Battle of Culloden Moor in April, 1746.

In 1910 additions were added in the form of the Great Hall (the new dining room), an adjacent pantry, a formal ballroom, new servants' quarters, a garage, and stables. After General Carroll's death, in 1916, his wife and three children, Caramai,

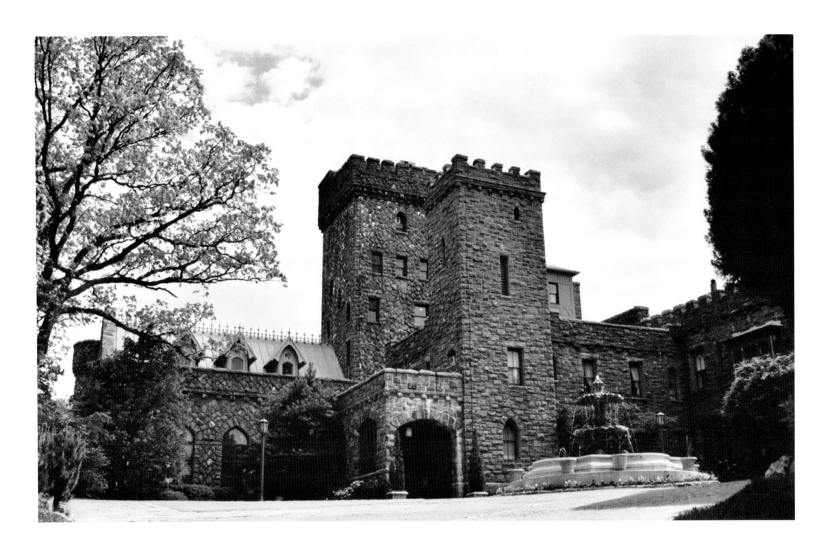

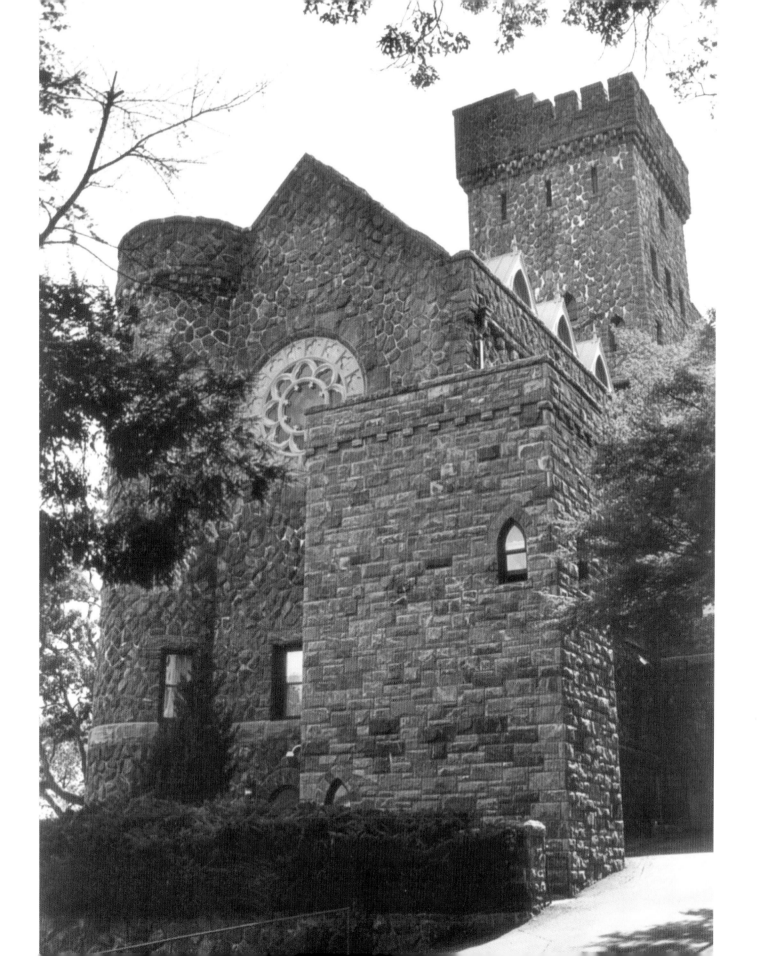

Arthur, and Lauren, remained in the castle until 1940, when it was briefly rented to a local school.

In 1941, Emerson and Ruth Axe bought the castle and sixty-four acres of land for $45,000 and made it the headquarters for their investment counseling firm, H. W. Axe and Company. The castle became known as "Axe Castle" or by its nickname, "High Finance on the Hudson."

During World War II, the castle's roof and seventy-five-foot tower (the highest point in Westchester County) were partially enclosed and served as a watchtower and listening post by the Tarrytown civil defense to monitor air traffic in the area. Volunteers served in three-hour shifts around the clock, searching for signs of German planes or possible U-boats in the Hudson River.

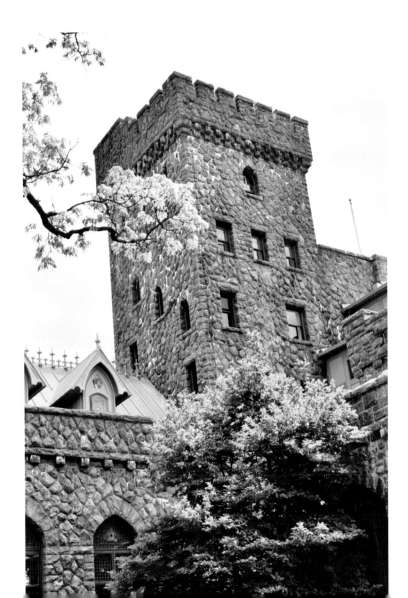

A decade later, in the 1950s, a far more pleasant role was found for the tower: a ten-foot-high, ninety-pound star, bristling with eighty white lights, was put up to celebrate the holiday season. The star could be seen for miles. Happily, this winter tradition was brought back in 1997.

By 1981 the castle's value to the community, along with its wide international appeal, earned it the designation of a historic landmark by the town of Tarrytown, which preserves the magnificent stone façade of the towers—along with the entirety of the landmark—forever. Any changes made to the building's exterior would have to be effected in the name of repairs, for the betterment of its structural integrity.

Since it became a luxury hotel, the Castle on the Hudson's superb service standards have allowed it to be entered into Relais & Chateaux, a prestigious and somewhat-exclusive association of 415 privately owned five-star hotels and restaurants in forty-two countries throughout the world. The restoration of its original suites—with their inspiring views of the Hudson, along with the Manhattan skyline on the distant horizon—makes a stay at the hotel something more than "just a stay." It is a respite, an escape, if you will, from the stresses and sometimes ugliness of modern life. Under Gilbert Baeriswil's guiding hand, the hotel and restaurant provide luxurious memories for guests, many of whom, once they leave, want to turn their cars around and come right back.

A new, twenty-four-room addition—fittingly named "Carrollcliffe"—puts a punctuation mark on recent innovations, which include a state-of-the-art fitness center; a spacious, heated outdoor swimming pool; and pro-quality tennis courts.

To me, this is all well and good, but I can still see my heroes of the past standing between the merlons and crenels of the massive battlements, shouting out commands to their determined troops. Of course, this is the product of my very healthy imagination, but it wouldn't be possible without the grandeur and romance of the Castle on the Hudson.

So if you are driving along Route 119 in Tarrytown, New York, take a look up, and you will see this medieval giant waiting to welcome you from your ride up Benedict Avenue. But be warned: you might not want to leave.

CAT ROCK (OSBORN CASTLE)

Whereas it is true that castles do not move, it is not necessarily true that they are easy to photograph. Half the difficulty in capturing them on film is simply getting there (at least for someone as directionally challenged as myself). Such was the case with Cat Rock (also known as Osborn Castle), where on my second attempt to begin my ascent up the wide, dirt-and-gravel road that leads to the castle, my van ended up stuck in packed ice and snow for an hour-and-a-half. I can laugh about it now, because now, in July, the ride is effortless.

I approach the quaint but affluent town of Garrison, where two castles share a name, Osborn, and an illustrious family history.

The one most visible to the public, Castle Rock, sits high above Route 9D, appearing to me like a vision out of fifteenth-century Transylvania conjured up by Bram Stoker. It is a solemn, serious-looking creature, with conical-peaked spires and a gray stone façade. The product of post–Civil War America, it was constructed by William Henry Osborn and his wife, Virginia Sturgess Osborn, in 1880. It is, for all practical purposes, the more well known of the two Osborn Castles because it can be easily seen, perched on its high hill, as motorists drive past the Garrison Country Club Golf Course below.

My destination—Cat Rock—is hidden from view, tucked away up Osborn Drive, off local Route 403. I begin my third ascent. The van breezes around corners and narrow twists in the driveway, finally to the top. I step out onto the circular entranceway and am met by a tall, neatly bearded man: "Hi, Scott," he says, extending his hand. "I'm Hank Osborn. Welcome to Cat Rock."

Hank, who I learn is actually Frederick Henry Osborn IV, leads me around the north side of the castle, where I am struck by a spectacular, sprawling view of the Hudson River and the United States Military Academy at West Point across the way.

I can practically breathe in the history as I imagine my hero, George Washington, or the infamous American traitor Benedict Arnold—for whom West Point ("Fort Arnold") was originally named—looking down from my vantage point, assessing his military options.

Just to my left, two imposing towers—one square, the other cylindrical—climb skyward, like staunch defenders protecting Cat Rock from harm. But the only sensation I get here is one of tranquility combined with the grandeur of a universe within itself, born in the bosom of the Victorian Era. Hank informs

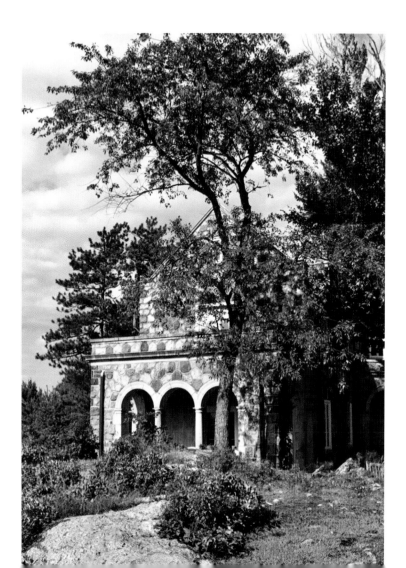

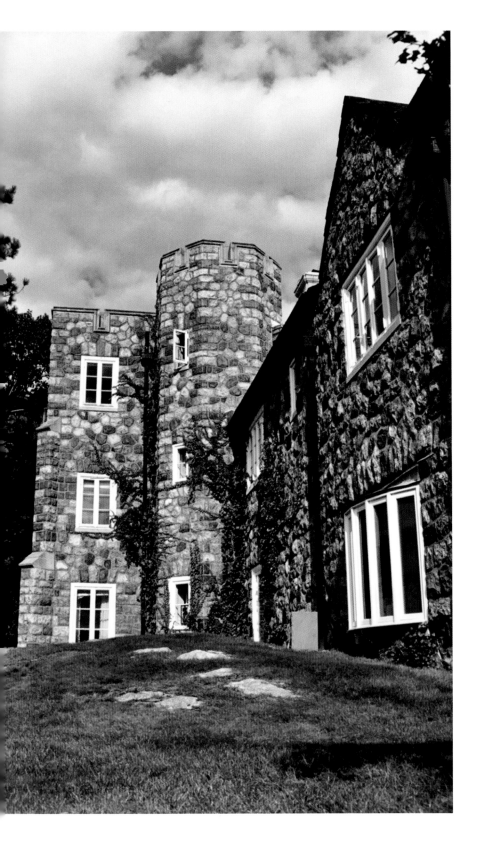

me that Cat Rock received its name from numerous sightings of wildcats in the 1700s. "My great-grandfather, Frederick Henry Osborn," he continues, "and my great-grandmother, Margaret Schieffelin Osborn, began construction on Cat Rock in 1919. My kids are the seventh generation of Osborns to live on this land."

Hank then leads me around back, past a handsome stone portico featuring sets of double columns, to the expansive west lawn, which is sheltered and shaded by huge, spreading trees. "My great-great-great grandfather," he tells me, "first spotted the land from the window of a Highland Falls asylum, where he was recovering from malaria." Hank gives an introspective smile, as though reminiscing about some particular point of pride. "He was William Henry Osborn, the first Osborn born in the United States, and he made a ton of money in the whaling industry." Hank points ahead of us, skimming his hand from left to right. "William bought thousands of acres in the Hudson Highlands."

The estate eventually shrunk to a hundred acres of rugged terrain, but the Osborn fortune multiplied through the decades. In 1919, Hank's great-great grandfather hired a former Princeton classmate to design and build Cat Rock, primarily as a weekend home. But his great-grandparents made it their permanent residence in the 1970s.

Today Hank and his family live in a separate house, elsewhere on the grounds, and support the castle's upkeep by renting it out for meticulously planned weddings and commercial photo shoots.

The castle itself contains twenty-eight rooms, fourteen of which are bedrooms. Stepping into the grand entrance hall, visitors enter another world. A large staircase leads up to the second floor and to the towers, and the entrance hall expands into a seven-hundred-square-foot living room, which opens through arched glass doors to the small, columned patio and the west lawn, with its wrought-iron-gated swimming pool and tennis court.

The interior staircases are dotted with portraits of Hank's ancestors. The large dining room displays photographs of the family's different residences over the years.

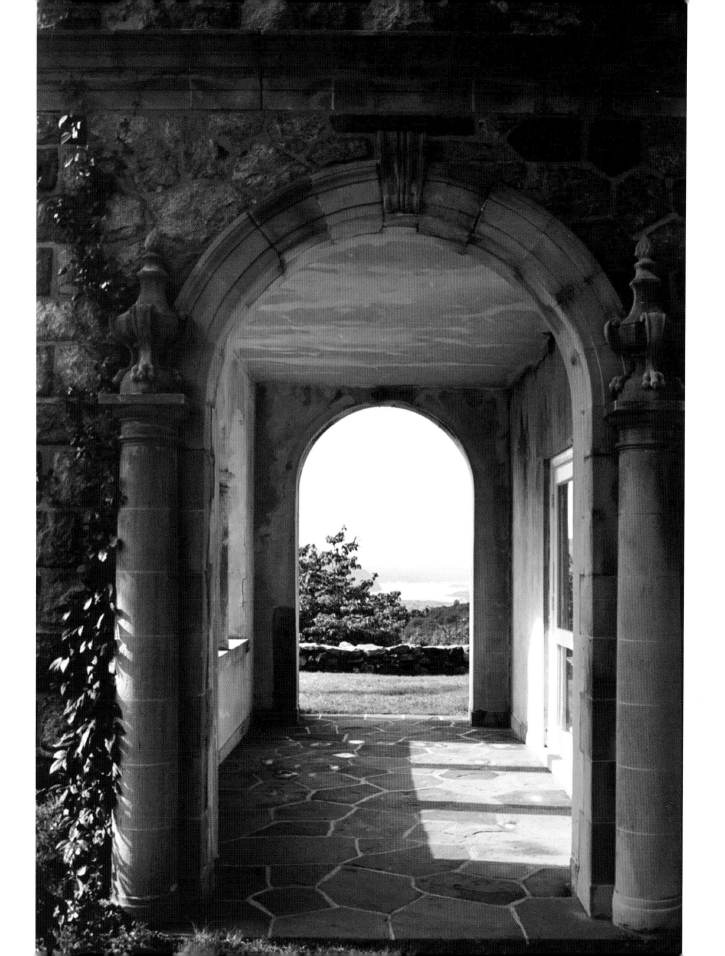

Hank's father—Frederick Henry Osborn III—later tells me that they keep the castle free of keepsakes so that wedding parties will feel as though the space, and their special evening, truly belongs to them. In the past, however, the rooms of Cat Rock were filled with luxury.

Back outside, it becomes apparent that Cat Rock—with its chiseled stone facades, square central tower, crenellated battlements, symmetrically carved arches, inspiring gardens, and delightful fenced-in swimming pool—was designed to provide a lifestyle of elegant comfort that is in harmony with nature. "It's our goal," explains Hank, "to make Cat Rock as green as can be—both literally and figuratively."

Indeed, the family has been strongly devoted to its environmental beliefs for six generations. The Osborns played a key role in founding the Palisades Interstate Parks Commission and the beloved Hudson River Sloop Clearwater, along with other organizations.

"We try our best to limit waste," says Hank, "to recycle, and to build from existing materials within reach." He bends down, picking a tomato from a small garden. "Cat Rock will be at its best," he concludes, "when it is totally self sustaining."

A noble goal, I tell myself. For now, Hank, you'll just have to settle for it being a spectacular triumph, where the present meets the past: a treasure of the Hudson Valley.

Cat Rock Castle itself is not open for visitors, but the estate grounds continue to host numerous weddings and other special events.

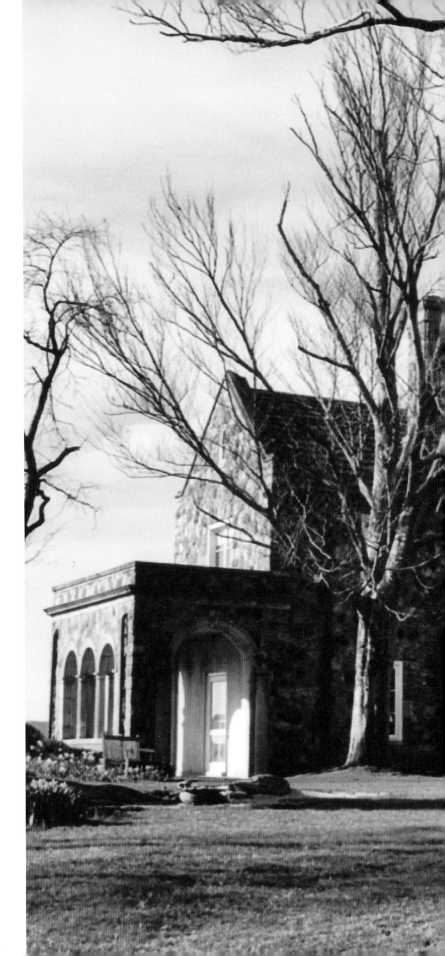

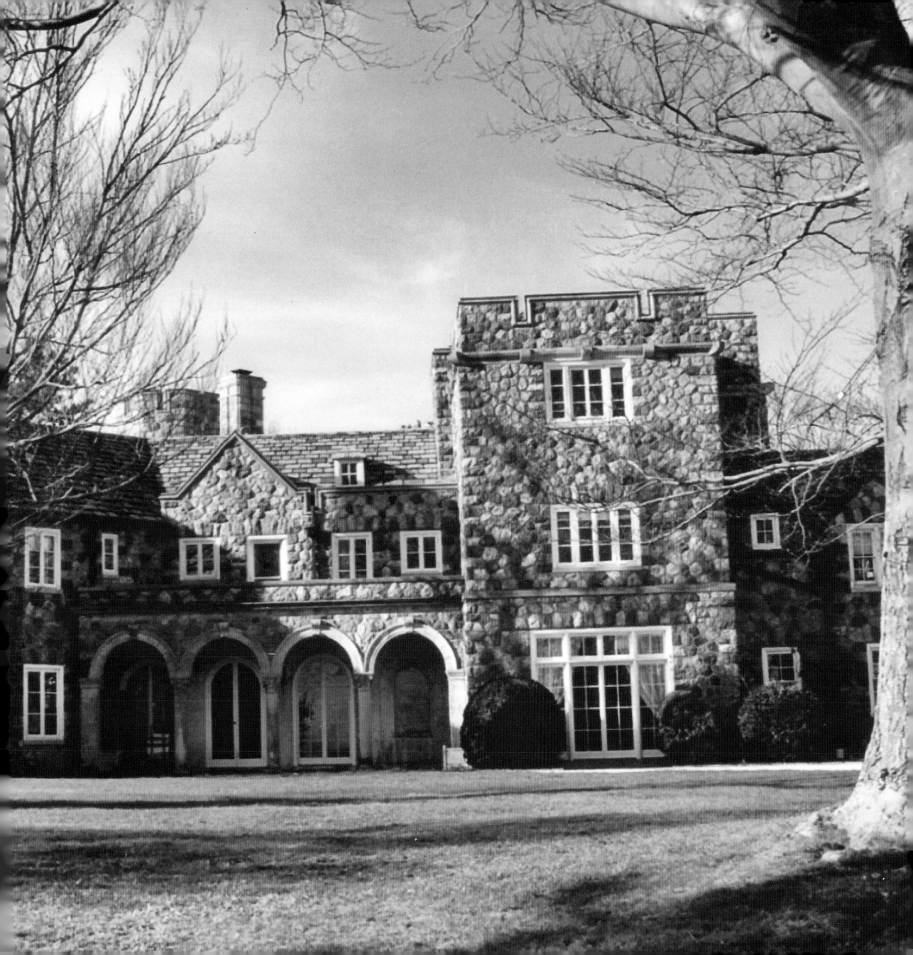

DOLCE TARRYTOWN HOUSE

Each time I head up East Sunnyside Lane in Tarrytown, I get a feeling of familiar comfort. Driving through the tall wrought-iron gates of Dolce Tarrytown House, I negotiate the long, sweeping entrance road and pull into the side parking lot adjacent to the west tennis courts. As I progress across the well-tended front lawn, I am greeted by the comical sight of "Mr. Goose" (as I like to call him)—the sometimes-resident Canada goose—combing the grass for bits of food. I am particularly impressed by the stretching stone patio wall and the semicircular terrace wall, with stone railing and balustrade pillars, that form the outdoor reception area. Behind them rises the stout central tower that defines Dolce Tarrytown House and imbues it with a sense of power.

In reality, Dolce is a combination of two estates whose histories are intertwined. The smaller mansion—a white, porticoed Georgian structure—was built by J. S. Cronise in 1840 and then sold, not long after, to a Mr. Abernathy. Nine years later, in 1849, Abernathy bought a second house, a stone mansion on a neighboring property that had been built by Franklin Couch. In 1859, he sold both mansions and their properties to Joseph Hartly, who, in 1889, sold the northern section of the estate, and its Georgian mansion, to John T. Terry. Eleven years passed, and Thomas M. King, a vice president of the Baltimore and Ohio Railroad, became the new owner—the same "King" whose name the north mansion bears today.

But Hartly kept possession of the stone mansion—now the Biddle House—until 1895, when it was sold to Herbert Squires. Ten years later, William R. Harris, the wealthy founder of the American Tobacco Company, took ownership. Harris spent the following seven years refurbishing the mansion. He used granite stone, taken from the local hills surrounding the house. The result was a grand structure that closely resembles today's castle.

But the Kings' and the Harrises' personal histories were further intertwined when Thomas King's son, Frederick,

married his neighbor's daughter, Sybil Harris. Frederick and Sybil lived in the King House until Sybil died in 1955.

Shortly after they had married, though, in 1911, Thomas King Sr. died, leaving Thomas Jr. to inherit the upper estate. In a strange twist of fate, Thomas Jr. was declared mentally incompetent by the local courts and ownership of the house was put in the hands of his brother and sisters. Five days later, in a second strange twist of fate, the King House was sold to Sybil, their sister-in-law, for the outlandish sum of one dollar. Sybil Harris-King now held control of both estates.

In 1921 Sybil sold the stone mansion to one of America's wealthiest women, Mary Duke Biddle, the only daughter of Benjamin Duke, who was partner in the Duke Tobacco Company and founder of Duke University. Mary held extravagant parties at her new home to please her husband, Anthony Drexel Biddle Jr., who was minister to Norway and later ambassador to Spain. One of Mary's "soirees" was said to have cost $25,000—a decadent amount of money for the time. Although she hated entertaining her husband's friends and business acquaintances, Mary continued holding social events at the stone mansion until 1933, when she and Anthony were divorced.

Although Mary remained at the estate, she no longer felt compelled to socialize or buy extravagant clothes to indulge her husband's sense of "keeping up with the Joneses." One year before their divorce in 1930, she held the record for largest amount for customs duty—$77,000.

Now, instead of importing shoes from Italy, evening gowns from Paris, and jewelry from London, she shipped in

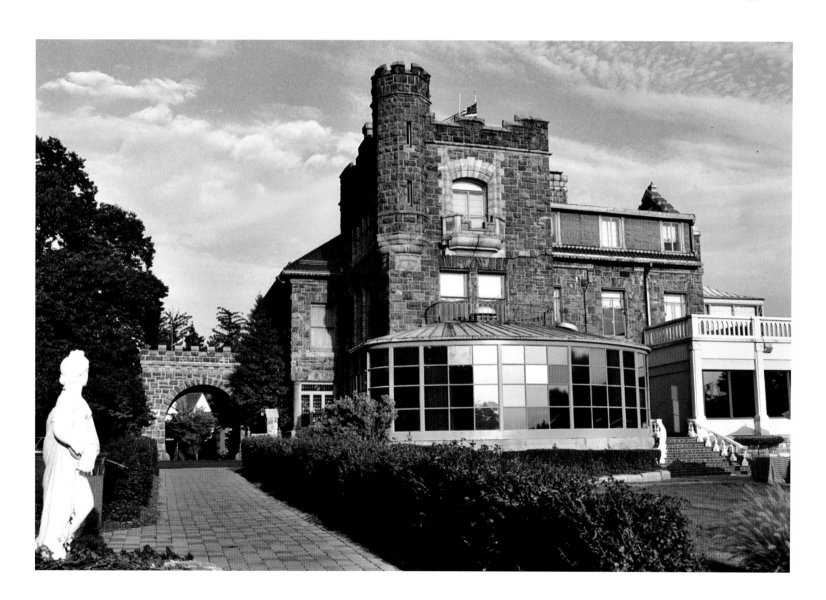

pink clay from France for her treasured indoor tennis court, orchids for her climate-controlled hothouses, and roses for her gardens. She then decorated the spacious lawns that separated the two mansions with carefully selected classical statues. The stone steps and pathways were bordered by flower gardens; the lawns were impeccably landscaped.

As is the case with many of the castles that I've photographed, Dolce was also the victim of fire: in 1956, a roaring blaze gutted and nearly totally destroyed Mary's imposing granite home. In the following four years, she was said to have spent upwards of a million dollars to rebuild and "re-glorify" her beloved house.

In 1959, she went one-step further to consolidate control over her private domain: she purchased the King House from the descendant of Frederick and Sybil King. Once more the two mansions and estates fell under the guidance of one owner.

The next year—1960—Mary suddenly died. The Biddle House was left to her son, Nicholas Duke Biddle, and the King House (now called "Uplands") went to her daughter, Mrs. Mary D. P. T. Seamans of Durham, North Carolina.

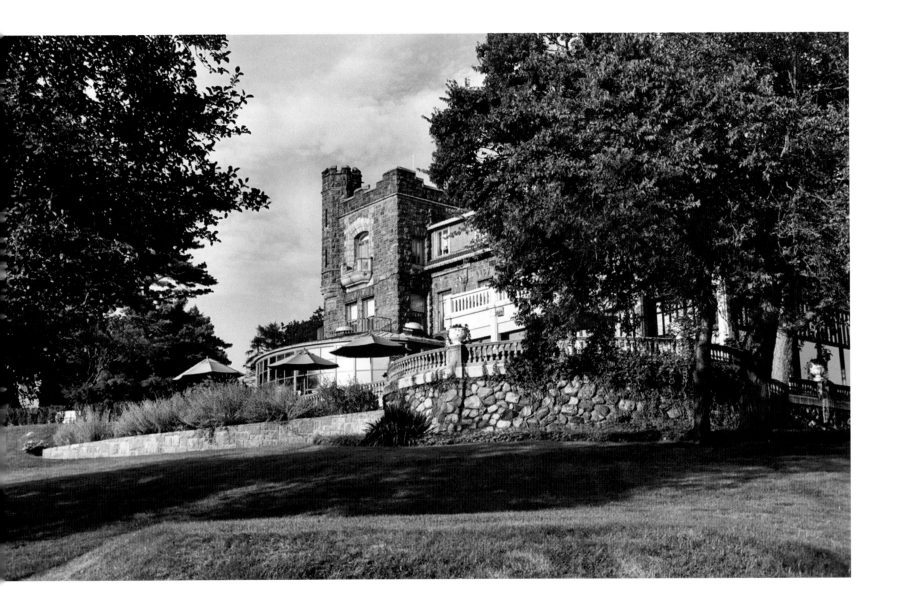

Three years later, in 1963, the African nation of Mali bought the house for its ambassadors to the United Nations. Twice a month, they held state dinners that were attended by a slew of diplomats.

The Mali government did not hold onto the two estates for long, though. It sold both properties to Robert Schwartz, a veteran journalist and the creator of the Motel on the Mountain in Suffern, New York. Schwartz's dream was to convert the two historic homes into a modern conference center for businesses.

In 1994, Dolce International did just that when it bought the property. Fifteen million dollars later, with all-new renovations and a greatly expanded structure, the transformed Dolce Tarrytown House was molded into a top-notch hotel and conference venue while retaining its strong historic character.

Although the curved solar porch room must be a warm and comforting place to sit, I found myself drawn to the perfectly crenellated stone arch entranceway that serves as a headpiece to the long red-brick walking path.

I turn from the stone arch and head down the path. Before me, the retreating sun takes the form of a diffuse orange ball as it glides on its path to the horizon. All is calm and quiet. Suddenly, I sense movement to my left. I swing my head and chuckle; "Mr. Goose!" I proclaim brightly. He ignores me and waddles toward the tennis courts, where three white-tailed deer have decided to hold a meeting.

Dolce Tarrytown House prepares for night. I have a feeling it will be a good one.

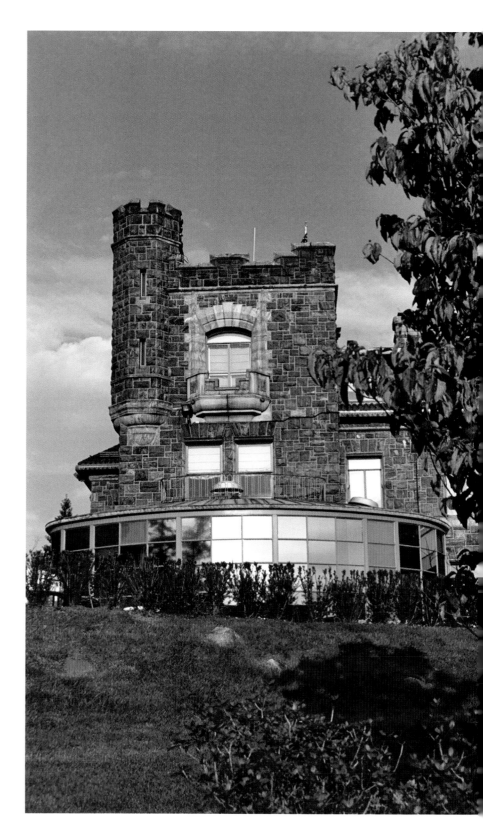

EMMA WILLARD SCHOOL

At the peak of Pawling Avenue in the city of Troy lies the Emma Willard School, a cultural jewel in what many might consider a run-down postindustrial city. This internationally renowned secondary school for girls—which now boasts students from twenty-two different countries—is the oldest of its kind in the United States, having been first constructed in 1821. Originally known as the Troy Female Seminary, the school was renamed in 1895 in honor of its founder, Emma Willard, who spearheaded a tradition of innovation in women's education in the early nineteenth century.

In 1910, the school moved from its location on Second Street to its present site on Pawling Avenue. Margaret Olivia Slocum, who graduated from the Troy Female Seminary and was the second wife of famed financier Russell Sage, donated the new campus to the school. She commissioned the highly respected architectural firm of M. F. Cummings and Son to build three spectacular buildings: Slocum Hall, christened with Margaret's maiden name; Sage Hall, named for her late husband; and the school gymnasium, which were all constructed in the Tudor Gothic style. These three buildings' grand, intricate, and at times otherworldly wealth of architectural features have earned Emma Willard the nickname "Hogwarts on the Hudson."

This flamboyant nom de plume surely seems well deserved, for when newcomers first drive along the wrought-iron fence and stone-pillar borders of the school, then swing up its inclined circular driveway, they are struck by Sage Hall's tall central tower, with its Notre Dame–inspired dragon gargoyles, silently beckoning to them. From time to time, freshman students have been heard to proclaim, "Oh my God—it's like Harry Potter!"

Harry Potter, indeed; the central tower at Sage Hall looms above the Troy landscape with a grace and intensity that speaks to the quality education offered to all those who come here to learn. The collection of stone buildings appear at once ancient yet accessible, immaculate without being sterile. Perfectly coiffed battlements, sprouting raised merlons, and chiseled crenels run along the expansive rooflines, while terra-+cotta chimney stacks stand in braces of three, in perfect condition—no easy task, considering there are several dozen of them adorning the building-tops.

It is easy to see why as many as five Hollywood feature films have been shot at Emma Willard. Security officer Dan Williams leads me to the small library at Sage Hall, where the movie *Scent of a Woman* (with Al Pacino) was filmed in 1992. "They changed a couple of things around in here," he explains with a hint of school pride. "They added this fireplace"—he points—"and rows of books, and a table or two."

I then learn that the critically acclaimed movies *Ironweed* (1988), *The Age of Innocence* (1993), *The Horse Whisperer* (1998), and *The Emperor's Club* (2002) were also filmed in and around the school, a legacy to its students not only of academic but of cultural-artistic tradition as well.

Newer buildings have kept faith with the Tudor Gothic style of the original architecture. Overbridge, the campus infirmary, was built in 1926. Kellas Hall, which closely mimics the exterior and solid dark wood interiors of Sage Hall—except that it features no gargoyles—was built in 1927. Weaver Hall was also constructed in the Tudor Gothic style, between 1936 and 1937.

Though William Lamb (associated with the architectural firm M. F. Cummings) was hired to assist with the overall construction of the original buildings, it was Abraham Mosley of England who was put in charge of all design details, such as gargoyles, interior work, doorways, and paneling. English and French artisans created their unique carvings under Mosley's

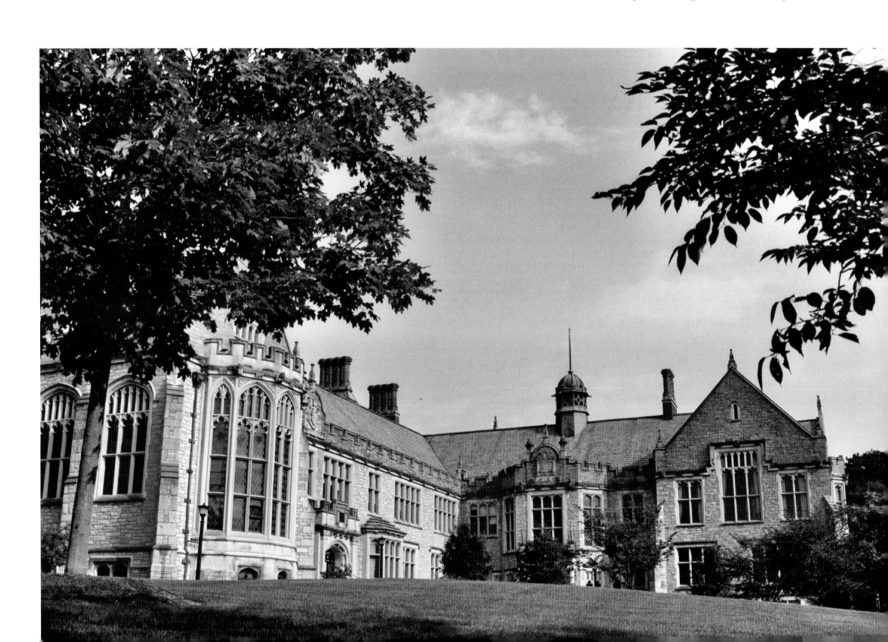

supervision. Both the eastern and western windows of the library (the current Lyon-Remington Hall) display the fine details of his consummate skills. The gargoyles, in fact, were carved right there, onsite, on the exterior stone walls. As in centuries gone by, political leaders of the time were paid tribute with a portrait in stone. The faces of U.S. presidents Theodore Roosevelt and William Howard Taft can be seen smiling from opposite corners of the gym (Alumnae Chapel). The gargoyles of Slocum Hall portray historical scholars, scientists, and philosophers such as Galileo, complete with telescope. Students carved of stone, clutching their prized parchments, adorn the school hall (Kiggins Auditorium). Two blithe monks converse over their teacups above the living room of the residence hall, and next to the driveway an automobile circa 1910 races along, guided by its determined driver in goggles and duster-coat.

Exterior doorways of the buildings are hand carved of the finest hardwoods and finished off with leaded-glass windows. The mantles in the Sage Hall living room and in the library are hand carved from solid mahogany and walnut, as is the extensive paneling in each of these buildings. The staircases in Slocum Hall are made of marble and slate, with hardwood banisters. Both the library and gymnasium feature cathedral-style leaded-glass windows that stretch two stories high. Yet the one feature that stands out in my mind about the Alumnae Chapel is its commanding tower with its huge wrought-iron clock of Roman numerals.

In the 1960s, the Maguire Art Building, the Dietel Library, and the Snell Music Wing were constructed in modern design, although their use of squares and half-circles as well as their stone building materials are meant to echo the earlier buildlings.

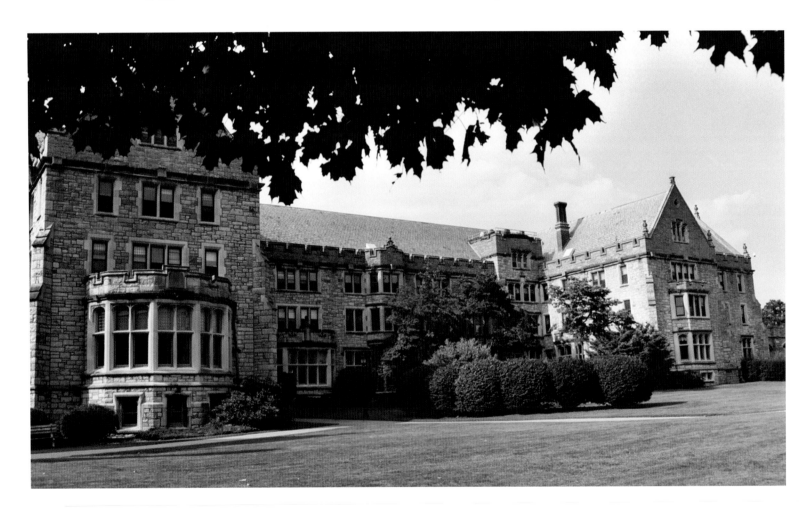

For my money, though, there is no contest: I strongly prefer the grandeur and eloquence of the original Tudor Gothic buildings. I feel thrust back to the early eighteenth century. Turning to walk to my van, I glance back at the gargoyle tower of Sage Hall and smile: "I could live here," I tell myself. "I could live here and never come out!"

Take that, Harry Potter!

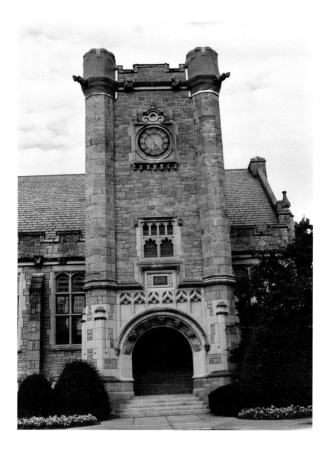

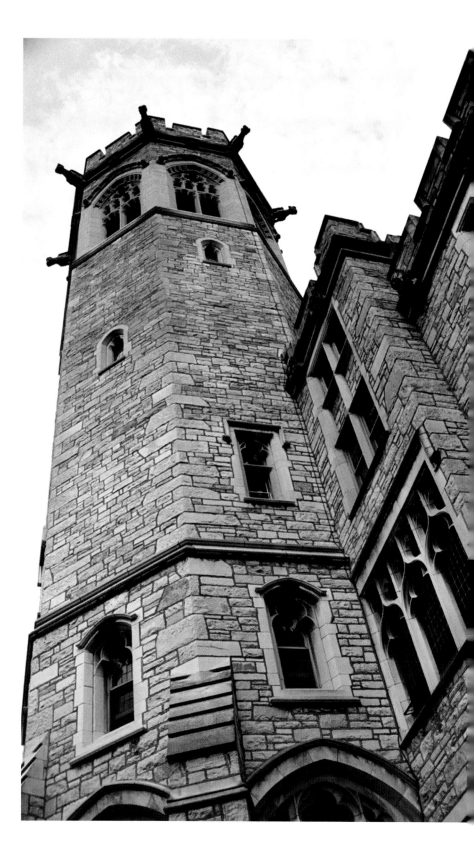

FREDERICK FERRIS THOMPSON MEMORIAL LIBRARY AT VASSAR COLLEGE

Huge, ornate, hulking yet elegant—these are just some of the words I would use to describe the Frederick Ferris Thompson Memorial Library at beautiful Vassar College, in Poughkeepsie, New York. Constructed in an architectural style known as "perpendicular Gothic," this domineering structure is built on a general plan of three wings formed about a central tower and, to my mind, has everything you would want or expect in a castle. The massive, square central tower is attended at its base by a collection of five smaller towers, which together form a single unit that is greater than the sum of its parts. Each tower features deeply chiseled merlons and crenels, with narrow, vertical "loopholed" windows on the two central octagonal towers, and three sets of gentle lancet-arched windows of highly decorative designs on the lower, square towers. Flanking the thick entrance door of rubbed hardwood, glass, and wrought-iron crown—below the equally intricate ceiling windows in the central hall—is a stone frieze featuring the seals of several colleges and universities: Cambridge, Oxford, Bryn Mawr, and Smith. On the right, above the outside door, the "Veritas" motto of Harvard can be seen. To the left is Yale's motto, "Lux et Veritas". Cornapo stained-glass was commissioned for the library windows from a studio in Birmingham, England, and installed in 1906.

I stand before the expanse of the library's east wing, staring at the sea-green tile rooflines, the spacious lancet arches of the windows, the fanciful spikes and spires atop the main tower. "This is one hell of a library," I tell my friend, Dr. Juan Montero—known as "Fin"—as he pulls some sandwiches from a travel bag.

"It *is* beautiful," Fin agrees, "but not quite as beautiful as most castles in Spain." Fin is from Spain's Galicia region.

About now, I'm starting to get a bizarre sense of déjà vu, having had similar conversations with our mutual Spanish friend, Lugh, about the Ward Manor Gatehouse. "It may not

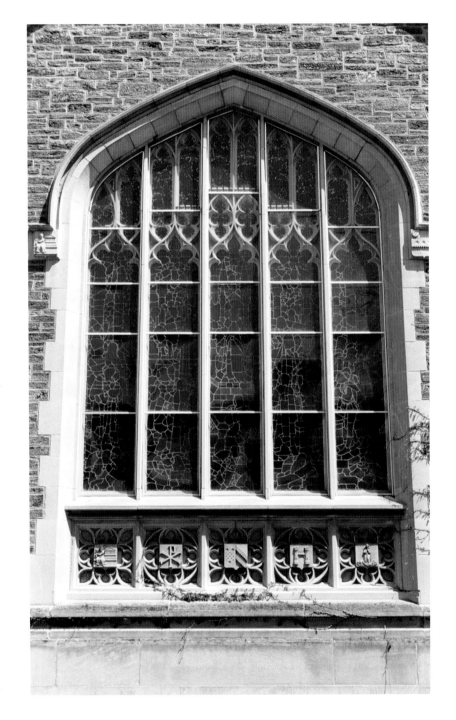

be as beautiful as some," I tell Fin, with a sly glance, "but it is certainly prettier than the rest."

We agree to disagree and wolf down the sandwiches. Five minutes later, I'm on my belly, stretched beneath the limbs of a fine shade-tree, framing the library's tall tower between the leaves.

When Vassar opened in 1865, the library was housed in a small room in the college's Main Hall. Then, in 1893, Frederick Ferris Thompson, a Vassar trustee, gave the college an extension to Main Hall that served as a library. In 1905, Mary Clark Thompson had the present building constructed as a memorial to her husband.

The library was enlarged in 1918, again with the support of Mary Thompson, and in 1924 she gave a bequest to the college that became an endowment to help support the upkeep of the building. From 1961 to 1964, the library's interior was renovated and modernized with the help of another trustee, Elizabeth Stillman Williams. From a modest collection of approximately 3,000 volumes, the library has grown to contain over 830,000 books and 3,500 serials, periodicals, and newspapers.

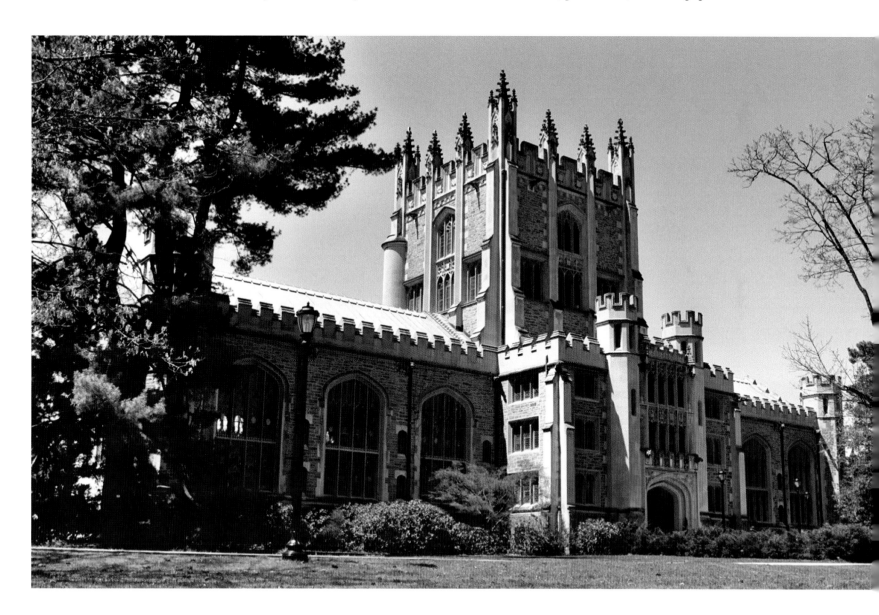

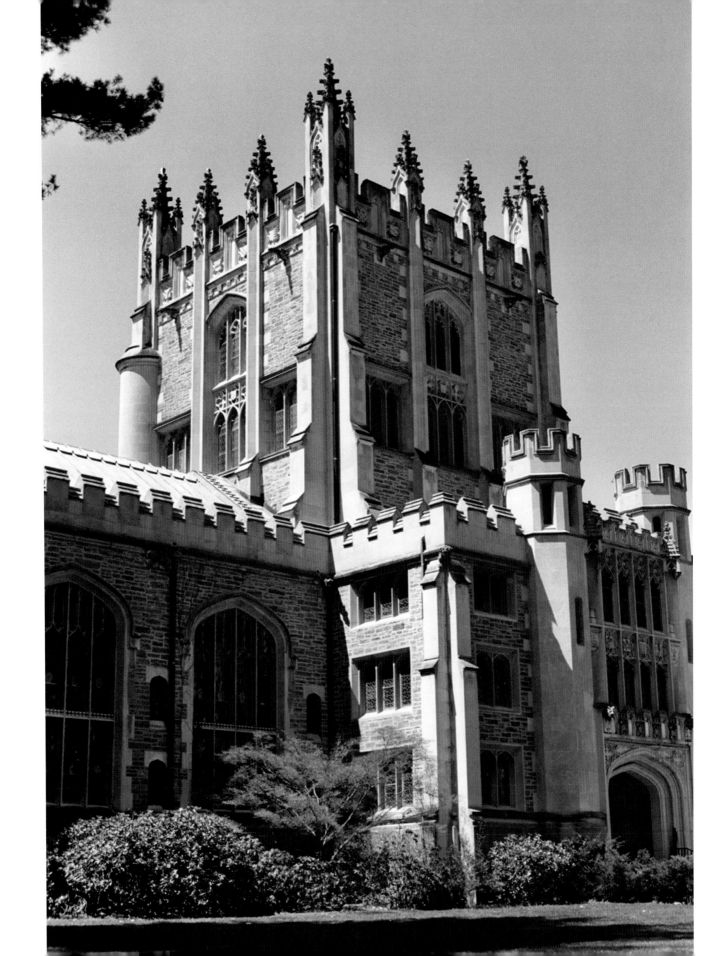

I get back to my feet, content that I've captured dramatic images of Vassar College's venerated library-castle. I turn in a circle, gazing around the expansive library lawn, and am stunned to see—just briefly, in the blink of an eye—a brilliant shaft of sunlight bursting through the main tower's upper central window. I turn quickly to Fin: "Did you see that?"

He stares at the tower, to the spot where the light has already faded. "I saw that."

I gesture toward the ornately framed window. "I told you this place is prettier than the rest of the castles in Spain."

A thin smile. "For the moment," he says. "For the moment."

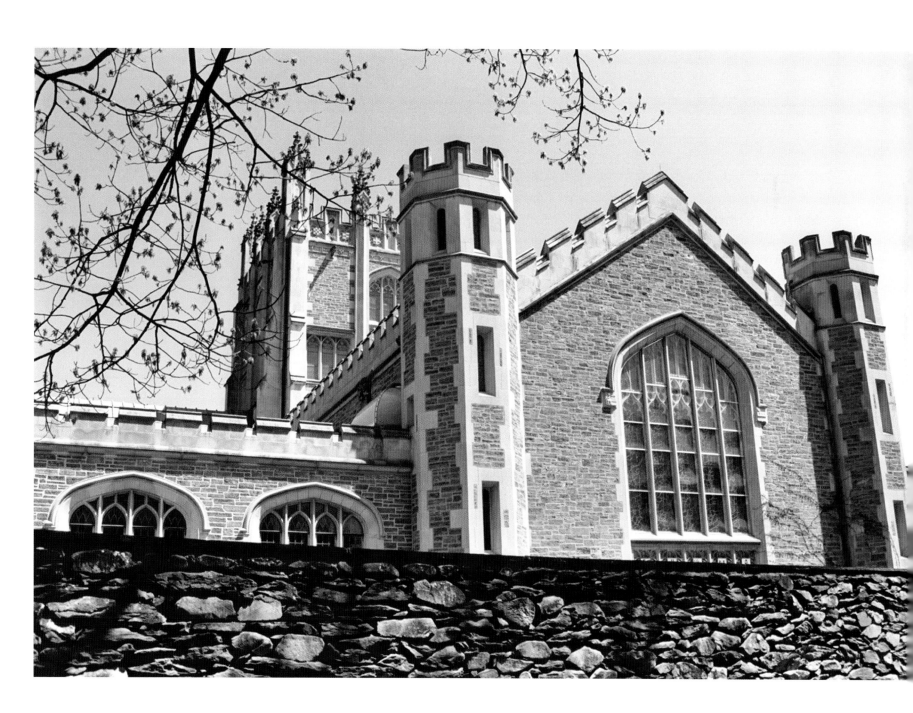

LYNDHURST

I stand with my back to the stark limestone tower of Lyndhurst, one of America's finest Gothic Revival mansions, and gaze across an expanse of lush, green meadows that roll like a tidal wave to the Hudson River below. This could be a scene plucked from the ancient myths of England, Ireland, or Wales, replete with warriors bathed in the glow of glistening armor.

Instead, this is Tarrytown, New York, located just several miles down Route 9 from the village of legend, Sleepy Hollow. Lyndhurst seems very much at home here, very much a part of the land that was once called the "Hudson Highlands," where a terrified schoolteacher named Ichabod Crane fled for his life from a malevolent headless horseman, and a wife-weary fellow named Rip Van Winkle fell into a deep, twenty-year sleep beneath an expansive oak tree.

Yet for all its Gothic majesty, Lyndhurst was designed as a country home for former New York City mayor William

Paulding by famed architect Alexander Jackson Davis in 1838. Despite its resplendent features, the public did not initially appreciate Davis's design, and Paulding's radical new home, which he called "Knoll," became known in some circles as "Paulding's Folly." It was the second owner, New York merchant George Merritt, who renamed the estate "Lyndenhurst," for the many linden trees he planted throughout the sixty-seven acre property, and who was responsible for doubling the

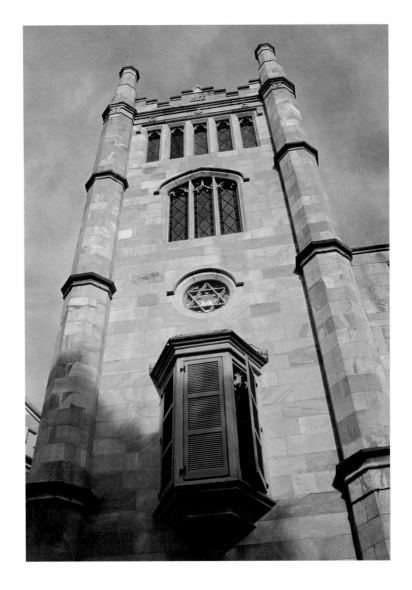

size of the mansion between 1864 and 1865. The trees add to an atmosphere that speaks to an intense, stoic power not found in many of the castles I have visited.

All is quiet beneath the golden cast of the late summer sun. In the distance, the Tappan Zee Bridge stretches like a gargantuan serpent across the width of the Hudson. I try to imagine the Lyndhurst landscape before such monuments to modern society were constructed. Known for its particularly asymmetrical silhouette of tall bay windows, rising-and-falling crenellated rooflines, stark angles, and faceted turrets, Lyndhurst has become known, particularly after its opening to the public in 1965, as one of the finest examples of Gothic Revival architecture in the country.

Within its thick walls of Hastings and Sing Sing limestone, the main floor boasts a superb entrance hall with vaulted ceiling sections, stone archways, and historic busts. The parlor room houses a star-shaped vaulted ceiling, a tea-service table, sofa and chairs, tall plants, ancestral paintings, and statues. But it is the dining room that is the "grande dame" of Lyndhurst's main floor, with its central chandelier, intricately carved wooden alcove awnings, and long dining table resplendent with silver plate setting and crystal glassware.

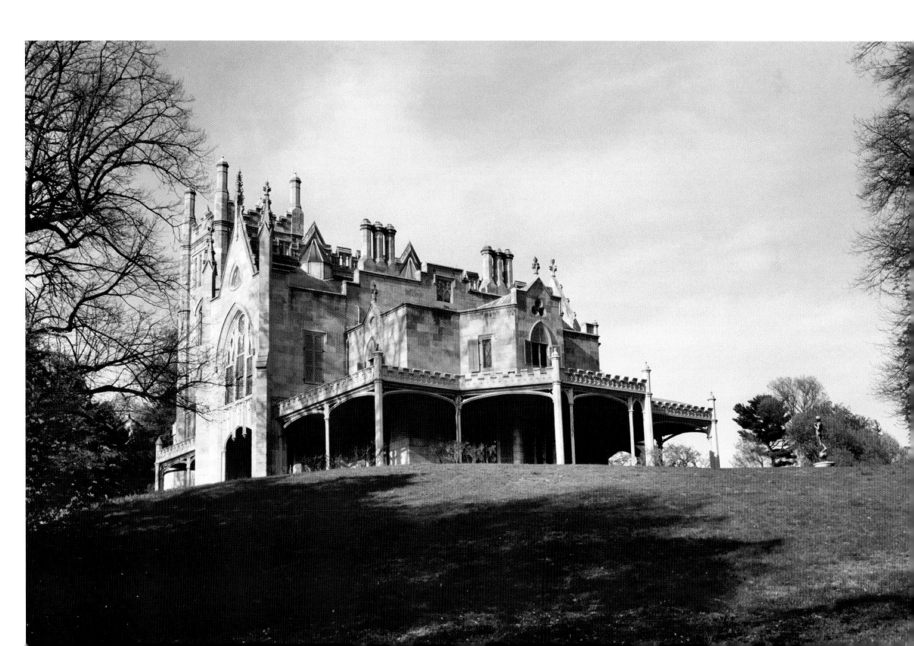

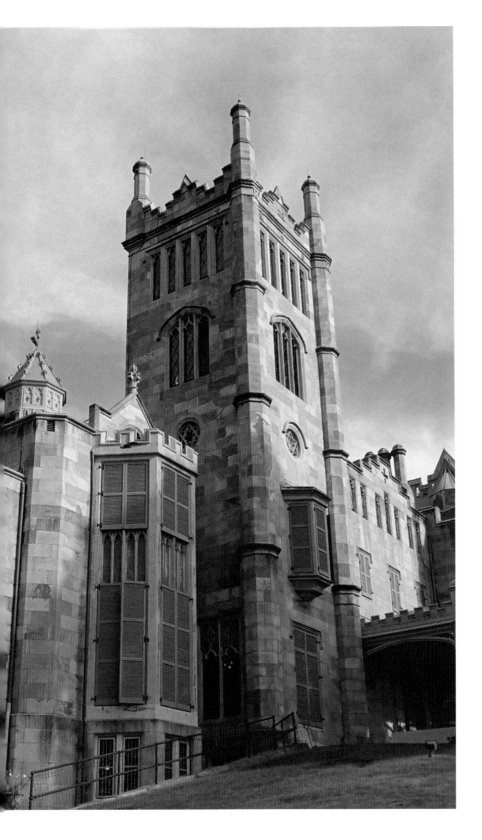

The high ceiling is constructed of a stout wooden cane-pattern, and an ornate bay window allows copious amounts of light to stream in from the head of the room. The furniture was also designed by Alexander Jackson Davis. "One of the fascinating things about the Davis-designed furniture," says current assistant director and curator of Lyndhurst Catherine Anders, "is that he used a lot of the same 'vocabulary' as the decorations on the outside. He'd reduce it in scale and apply it to his furniture." In a brilliant stroke of symmetry, Davis designed the backs of the chairs in the drawing room to match the wavelike wooden corbels of the roofline.

Upstairs, where the families lived in comfort and luxury, there are other fascinating rooms. The art gallery, which is bathed in white and highlighted in gold, still displays the artwork purchased for Lyndhurst by its third owner, railroad tycoon Jay Gould, which makes it a rare example of an intact nineteenth-century collection.

Gould poured thousands of dollars into Lyndhurst, which he had purchased as a summer home in 1880. He added a colossal cast-iron greenhouse made by the firm of Lord and Burnham in the Gothic style, the first steel-framed conservatory in the United States. And his "gardenesque" landscape was brought to life by the famed German horticulturist Ferdinand Mangold, who had originally been hired by the second owner, George Merritt.

After Gould's death in 1892, Lyndhurst was placed in the care of his daughter, Helen. When she died in 1938, the property passed to her sister Anna, Duchess of Tallyrand-Perigord. Upon Anna's death in 1961, the estate was bequeathed to the National Trust for Historic Preservation, who readied it for its grand opening to the public four years later. Since that time, Lyndhurst has served as host to many weddings and special events, including—I am told by a staff member—the filming of the revered children's classic *Annie*, starring Albert Finney, Carol Burnett, and Aileen Quinn.

I turn my back now on the Hudson River and the snaking roadway of the Tappan Zee Bridge. Lyndhurst Castle remains silent in the orange glow of the sunset light, except for the protestations and territorial mandates of bickering crows. I allow

my eyes to slowly wander up the limestone façade of the pristine central tower, now a deep hue of beige. If this had been an overcast day, the magnificent Gothic giant would have taken on a completely different personality, bathed in a wash of stoic gray, all dour and serious and full of historic purpose.

I stare past the bay window, some ten feet over my head, to the six-pointed star inset above it; then to the leaded-glass frames of the arched windows above that; and finally to the quartet of lean, facetted spires crowning the crenellated roof. A crow lands on the spire directly overhead, then launches itself south.

As with so many of the castles I have been fortunate to see, I tell myself: "I love this place. I find it hard to leave."

But if there is one consolation, one comfort I can hold on to as I head my van down the winding driveway, it is that Lyndhurst has stood the test of time against the elements. It has passed the test of greatness.

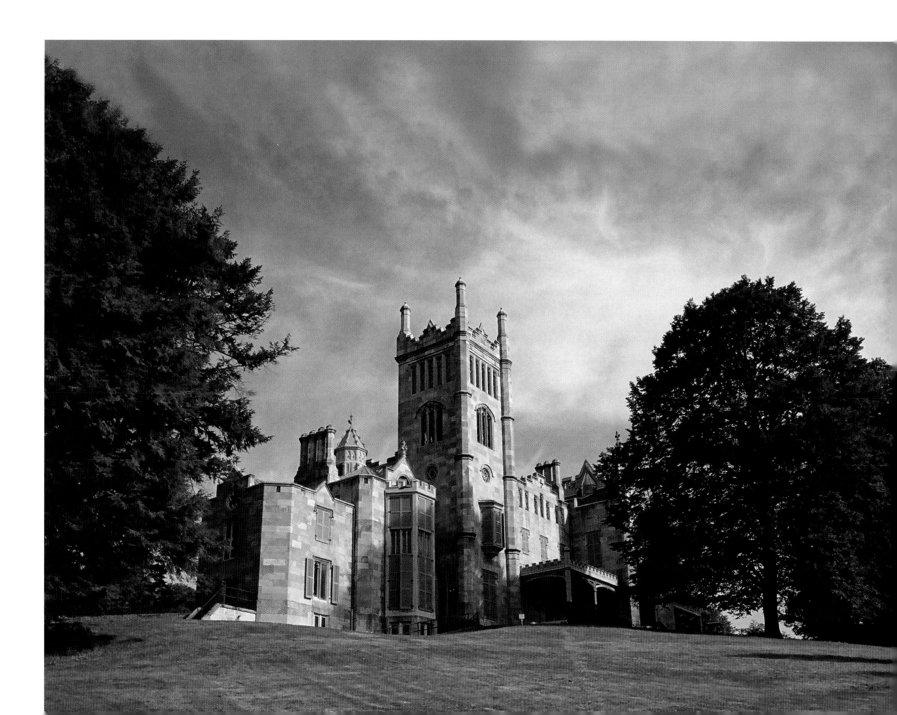

MOUNT ST. ALPHONSUS

After my visit to Castle Gould at Long Island's Sands Point Preserve, I did not think it was possible to find a structure as grand and powerful elsewhere in New York State. And then I come upon the Mount St. Alphonsus Retreat Center in the town of Esopus. Simply put, the place is massive.

My assistant Aleta and I arrive on a spectacular autumn afternoon and are met at the parking lot by Alfie, the center's adorable black Labrador retriever. It is a delight to be in the presence of such a blithe spirit, who proceeds to flop onto her back and push her paws up in the air at us, gently demanding a belly

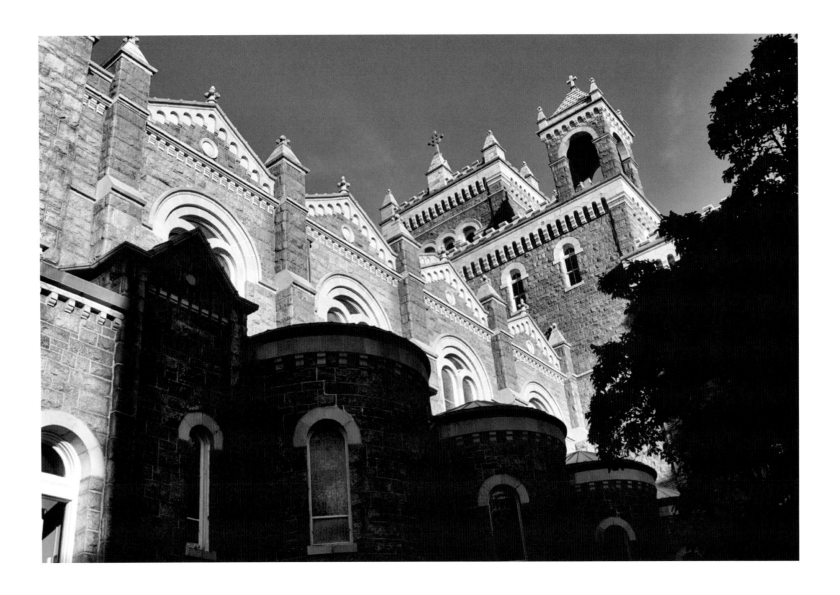

rub. After obliging her for a little bit, I set about my work. While I am fascinated by the curved apses of the chapel and the crenellated battlements at the rear of the Mount—the main building—I cannot wait to get around to the façade of the building, which faces the Hudson River, and begin firing away.

Built as a seminary for the Redemptorist Congregation, a Roman Catholic missionary order founded in the early eighteenth century by St. Alphonsus Liguori, construction on this 200,000-square-foot, 200-room goliath began in 1904. Three years later, what was once lush farmland—supporting cattle, pigs, chickens, horses, and crops such as corn, potatoes, and some of the best apples and grapes in the country—was now transformed into a spiritual sanctuary, a self-sufficient "heaven on earth" of contemplation and learning (even the Communion wine was made on site). Between 1907 and 1985, approximately thirteen hundred young men were ordained in the Mount's Romanesque chapel, which is graced by transcendent stained-glass windows, detailed statuary, and rich marble floors. By 1985, however, only sixteen seminarians remained in the house, and the scholastic program was transferred to Washington Theological Union in Washington, D.C. The building was turned into a Redemptorist-operated retreat center, but as a tribute to the students who used to attend classes and live at Mount St. Alphonsus, the lecture halls, a two-story library, and an auditorium remain intact.

Aleta signals to me from a near distance, pointing out an advantageous spot to photograph. I walk along the front façade of the building until I reach a stand of trees that borders the main walking path. Aleta was right, as the leaves of the dangling branches help frame the Mount's central castle tower. Alfie, the black Lab, decides to get in on the act and plops down next to me as I reposition myself on my belly to set up the next series of shots. I shoot the long, mammoth east face of the building, then concentrate on the corner juncture between the south and east faces, which remind me of the expansive wings of Castle Gould.

Originally, the property contained many buildings, including a functioning greenhouse, an observatory, and a convent, built in 1926 for the Sisters of St. Elizabeth, a German order whose nuns cooked and helped with laundry details at the Mount. A boat house and wharf on the river received supplies

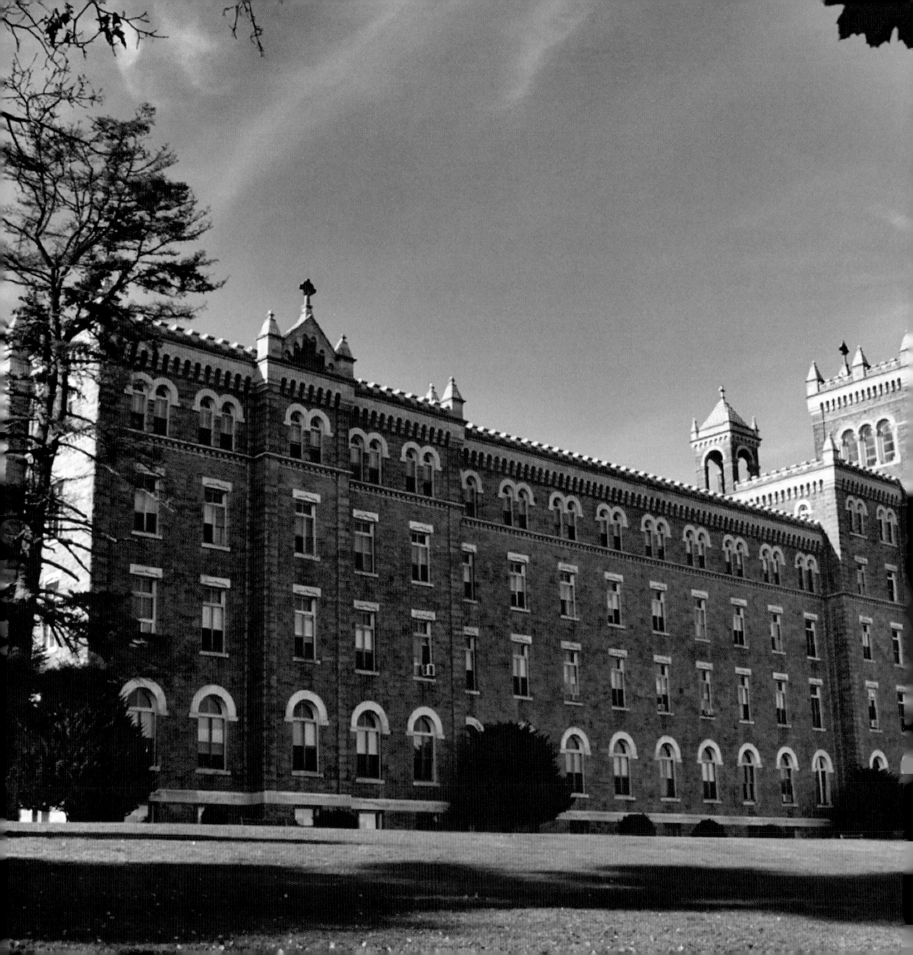

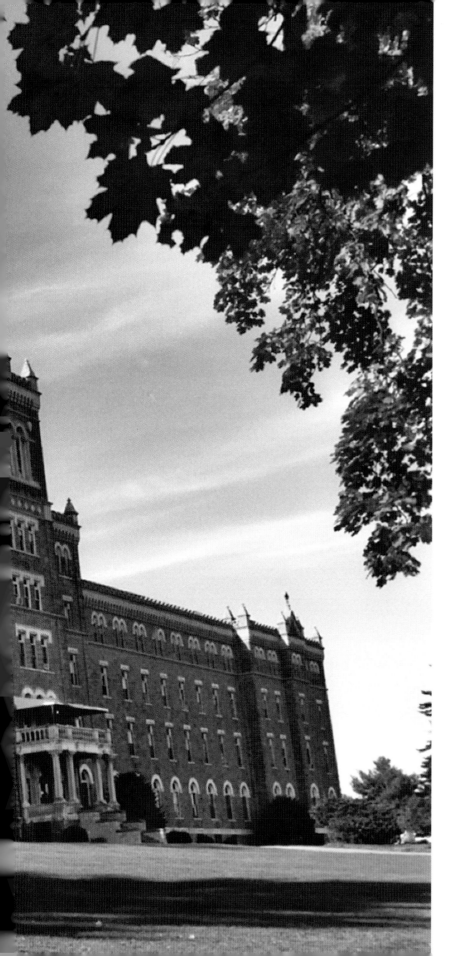

and housed the boats used by seminarians. In 1960 a convent was built for Redemptorist nuns, who still live on the property, and nearby is a cemetery for Redemptorist priests. Today, the Mount St. Alphonsus Retreat Center has grown to 412 acres along the Hudson River.

Aleta joins me as I get to my feet and head back to the van. Alfie brings up the rear, but as we enter the parking lot, she dashes away to greet a wedding party, bedecked in white gowns and crisp, black tuxedos—off to a new adventure, here amidst the peace and tranquility of the Hudson Valley.

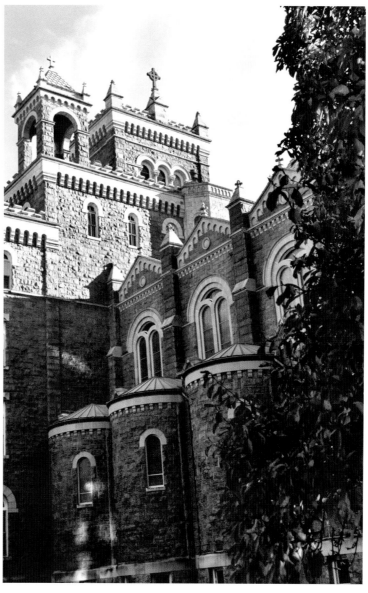

NEW YORK STATE CAPITOL

ig and sprawling, the New York State Capitol sits at the north end of Albany's Empire State Plaza. Lacking a large central tower or "keep," battlements of merlons and crenels, inner and outer courtyards or "baileys," and a heavy wrought-iron or wooden portcullis, it is decidedly not in the style of the classic Norman castle commonly featured in movies, television, and books. Instead, it is more reminiscent of French palaces or châteaus of the seventeenth century.

Inspired by the Hôtel de Ville (City Hall) in Paris, the building took thirty-two years and $25 million to complete. The outer shell is constructed of white granite from Hallowell, Maine, and the interior makes plentiful use of marble cut by state prisoners at Sing Sing. A full 220 feet tall at its highest point, the imposing structure is 400 feet long and 500 feet wide, and it is one of only ten U.S. state capitols that do not have a domed roof.

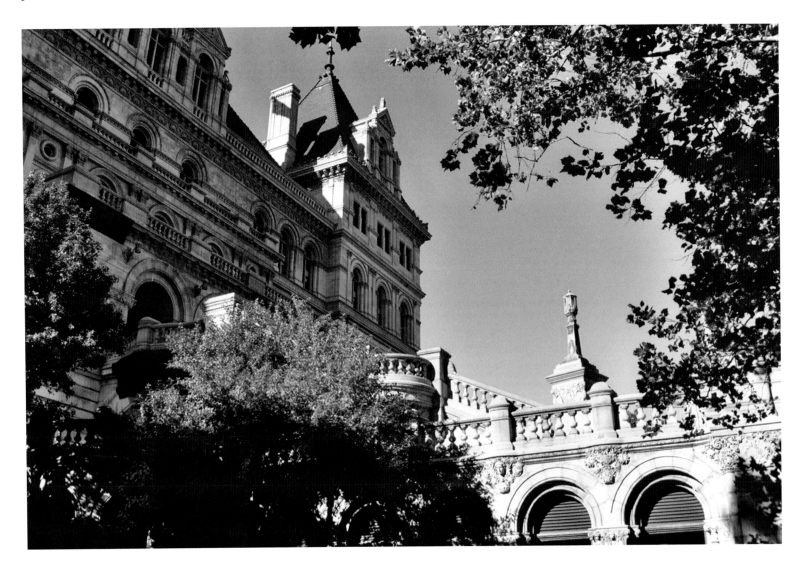

With its mixture of Romanesque and French and Italian Renaissance styles, the building has been dubbed the "Battle of the Styles" by some architectural historians, no doubt due to the fact that it was designed by three different teams of architects. The original architect, Thomas Fuller, who designed the Parliament buildings in Ottawa, Canada, was dismissed in 1876 because of cost overruns and was replaced by the architectural team of Leopold Eidlitz and Henry Hobson Richardson. They in turn were also dismissed, in 1883, also for cost overruns, and Isaac G. Perry was hired to complete the high-profile project. In the end, the price tag was double that of the United States Capitol.

The interior of the building is as lavish as its exterior, particularly the three carved-stone staircases. The Great Western Staircase, also known as the Million Dollar Staircase, was completed over a period of fourteen years. Containing 444 stairs and

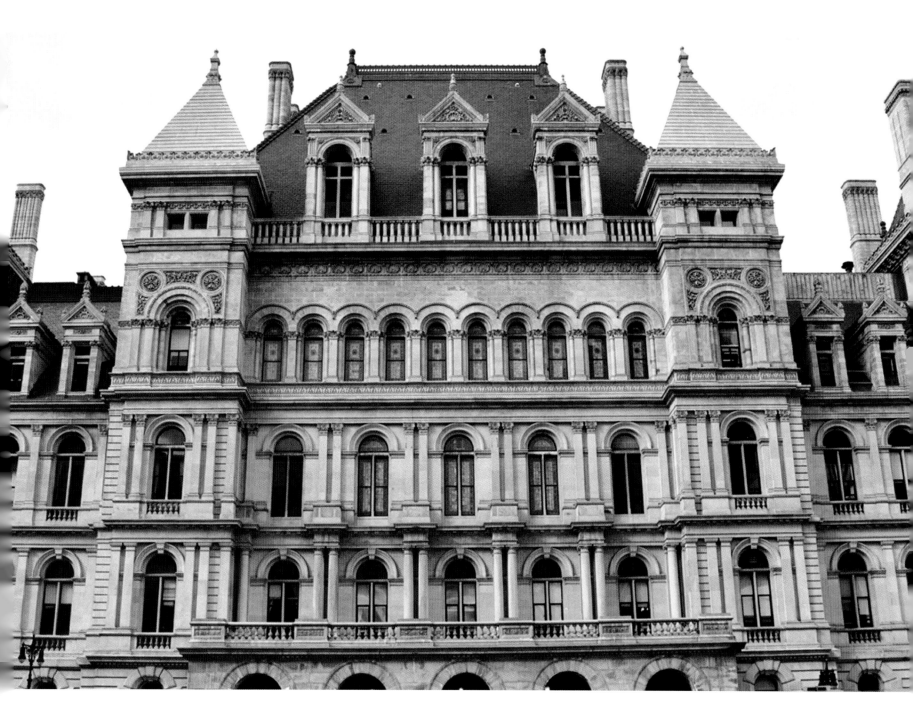

reaching a height of 119 feet, the staircase features the faces of seventy-seven prominent Americans hand-carved into the existing stone walls, as well as the faces of the friends and relatives of the stone-carvers. All told, more than five hundred stone-carvers were employed over the years, many of them from Italy, Scotland, and England. Climbing this staircase, with its arched supports and beautiful stonework, you truly feel as though you are in a vast European castle, but the faces of George Washington, Abraham Lincoln, and others remind you that you are actually in the United States.

Back outside, as I walk around the perimeter of the building, the overall effect is almost Disneyesque. The combination of white granite, slate-gray roof, and earth-red tile has a kind of joviality, while the sheer size of the structure lends it a gravitas that speaks to the vital task the building plays in the everyday operations of the state. Like SUNY Plaza, just down State Street, the Capitol serves as a reminder of where we've come from but also, and perhaps more importantly, where we are going—a signpost to a future filled with the promise of accomplishment.

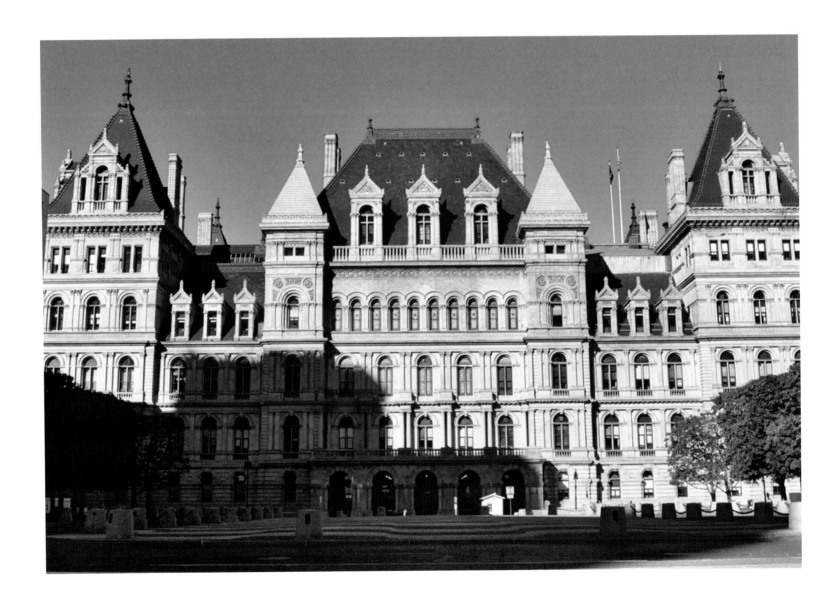

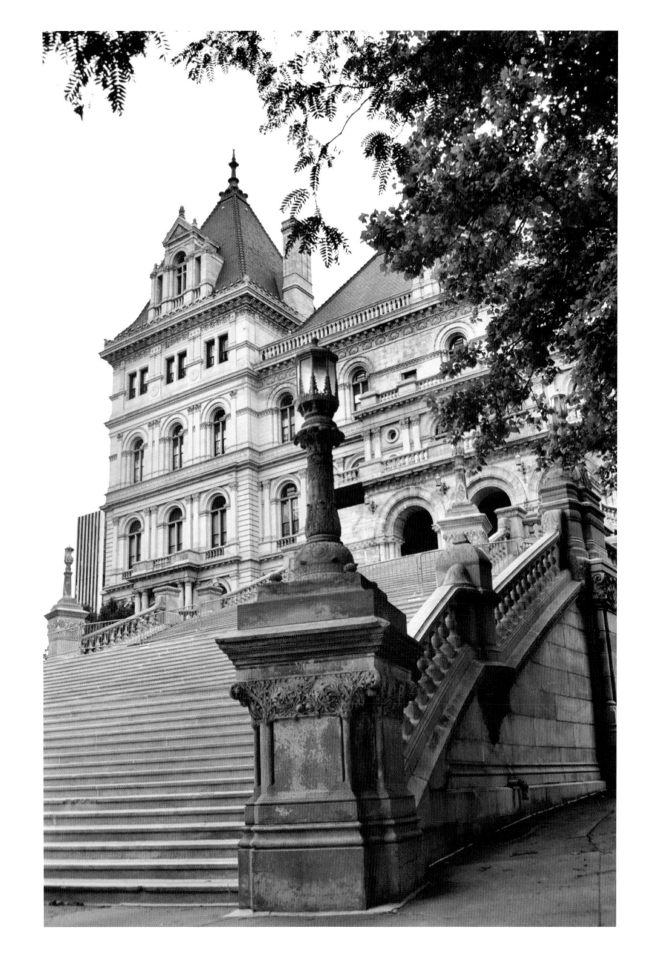

OLANA

Olana, Frederic Edwin Church's nineteenth-century Moorish castle, stands poised at the precipice of its grassy hill, a few miles south of the town of Hudson. It is a sentinel of sorts, undaunted and proud, keeping watch over the shores of the Hudson River in the near distance.

On this hot, dry afternoon in July, I find myself completely alone, not a soul in sight—perfect for photographing this magnificent structure. Among the sudden hissing of leaves that sway in the soft breeze sweeping up the castle-hill from the south, I get the sense that Olana itself is leaning forward, ever

so slightly, towards the river. But this is an illusion born of my own perception.

Is this the same breeze, I ask myself, that Church felt against his face in 1872, when he moved his wife, Isabel, and children into the second-story rooms as construction continued on the main floor? Is this the same breeze that rattled the canvas of the man who helped propel the Hudson River school of landscape painting to international fame?

Here before me is the living realization of Church's dream, a dream handed down to his family and, perhaps unknowingly,

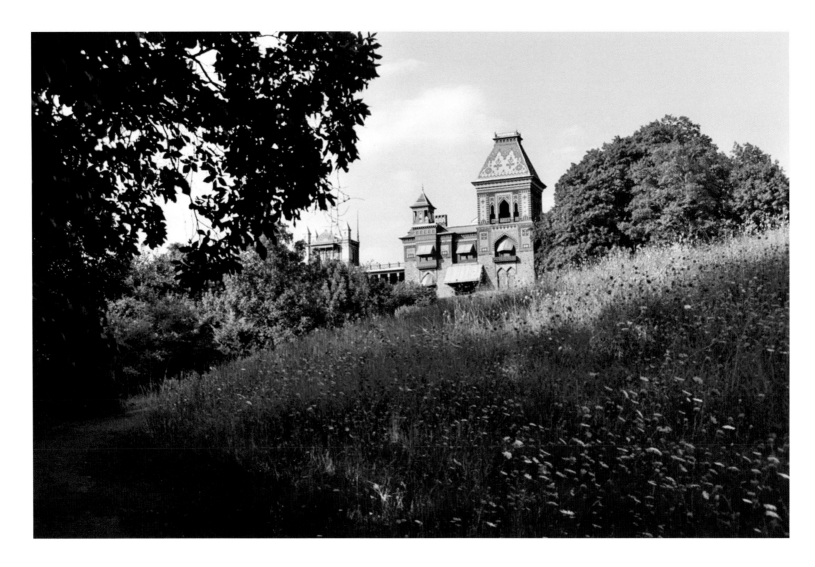

to the world—a place of peace, majesty, and reflection. Among the delicate, inlaid mosaic patterns of the squared main tower lies Frederic Church's message: that at Olana, two worlds—East and West—meet. "I like the houses," he wrote fellow artist Martin Johnson Heade, referring to the homes he was visiting on an eighteen-month tour of the Middle East. "They are so solid and capacious, and are decidedly effective." Upon his return to the United States, Church abandoned the plans he had for building a French villa on his Hudson Valley estate and instead began drawing up plans for a Moorish castle. Combining Islamic and Arabesque artistry with Western practicality, Olana features a central courtyard surrounded and protected by thick, fortresslike walls, while its interior rooms reflect the delicate designs of the different Moorish houses Church so admired in his travels.

I draw a deep breath, release a long sigh, and allow the force of gravity to guide my footsteps down the rolling meadow of the castle hill. Wildflowers explode in fans of yellow, white, and purple. Tall, thin weeds and stalks of green grab at my jeans.

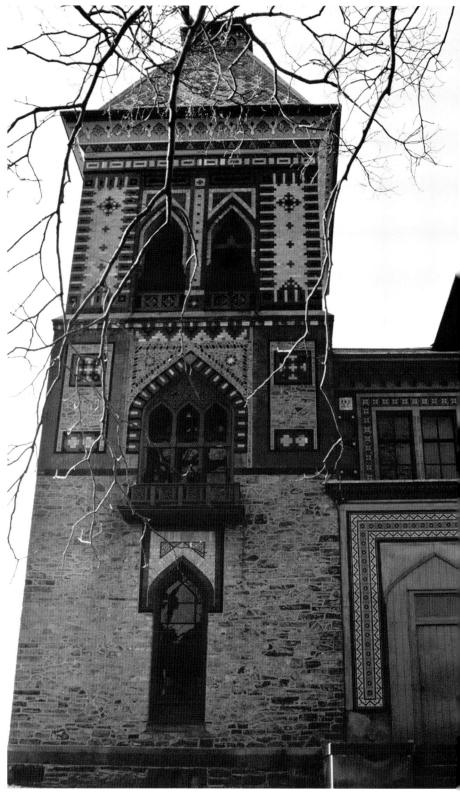

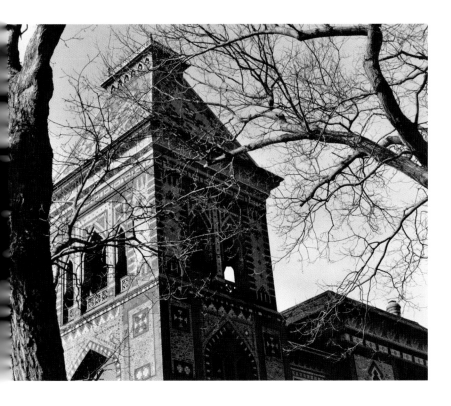

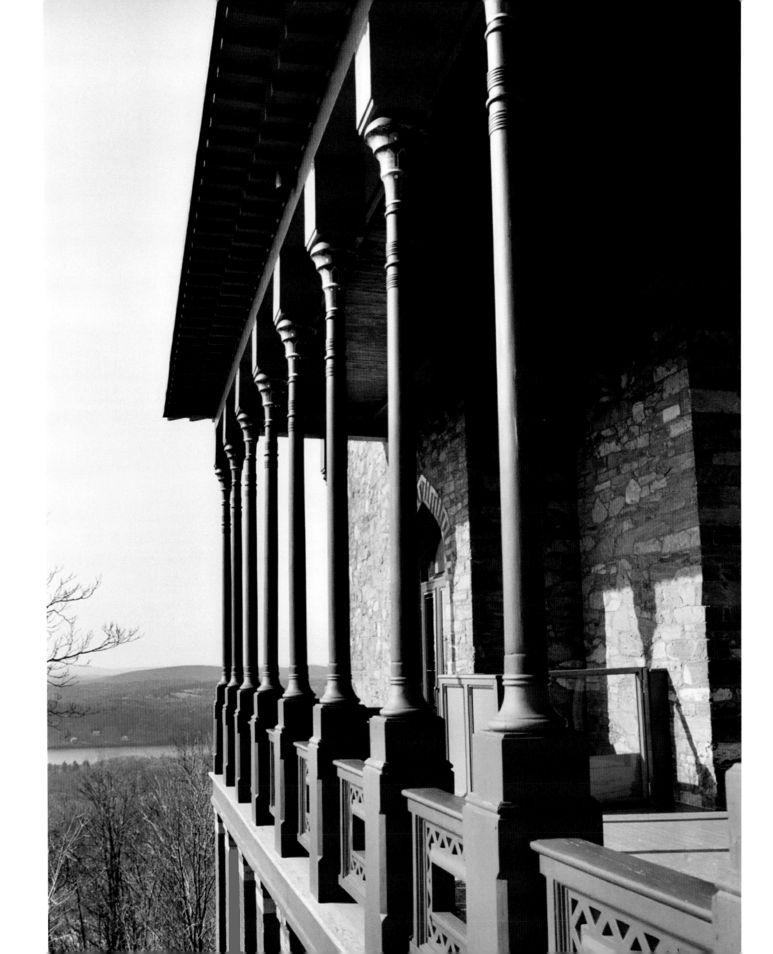

I turn and gaze longingly up at the castle. "There is history here," I tell myself, "personal history."

Conceived as a three-dimensional work of art and a gift of love for Church's young family, Olana took nearly thirty years to complete. Church employed the services of noted architect Calvert Vaux—who along with Frederick Law Olmstead designed Central Park in New York City—to help with the plans. Fashioned of stone and brick, the exterior façade is an Oriental shade of red and features polychrome stenciling in distinctive patterns that were designed by Church himself. This elaborate stenciling continues throughout the interior of the building, which looks exactly as it did during the artist's lifetime. Many of the exotic furnishings and art specimens were collected by

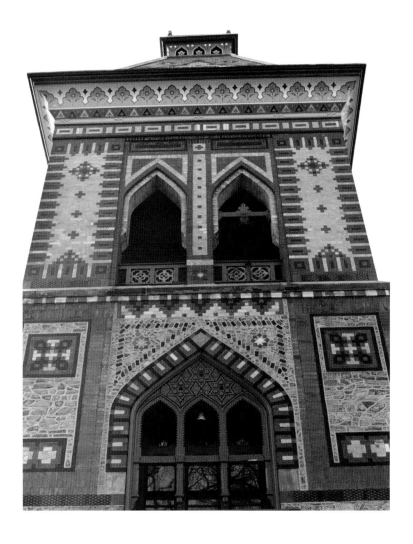

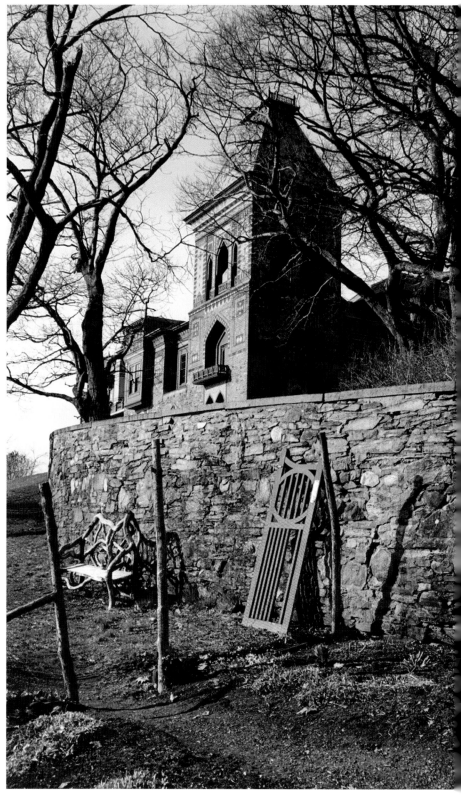

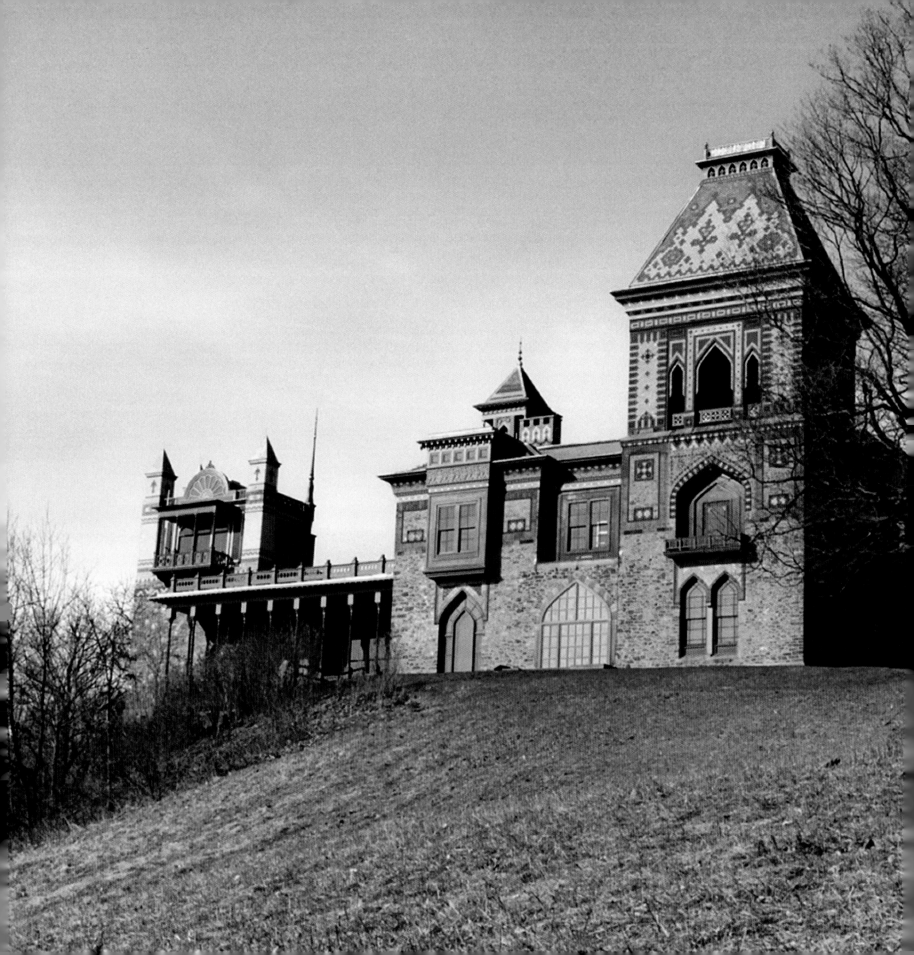

Church on his travels, and the castle also contains Church's last studio, which was built as an addition between 1888 and 1890.

Just over my shoulder is the view that inspired Church to choose this particular site for his Moorish castle. The densely foliated foreground opens to a view of the Hudson and, beyond that, the Catskill Mountains and the expansive reach of the sun-bathed horizon. I nod my head appreciatively. "Yes," I concede, "this is the way it should be—here, beneath the clouds—a view commensurate with heaven."

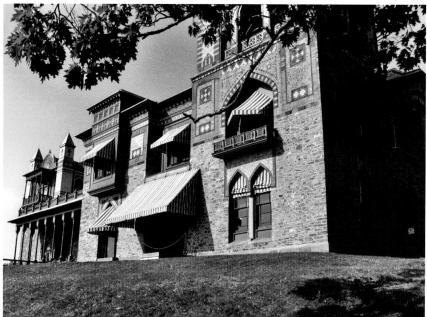

SKY TOP AT MOHONK MOUNTAIN HOUSE

Standing alone against the sprawling sky, Sky Top, the castle-tower at Mohonk Mountain House, rises high above Lake Mohonk in the Shawangunk Mountains. Constructed as a memorial to Albert Smiley, who purchased the land in 1869 and who, with his brother Alfred, founded this historic American resort hotel and the adjacent Mohonk Preserve, the tower can easily be seen from the New York State Thruway and the nearby town of New Paltz.

Most local residents would be surprised to learn, however, that the Sky Top tower we know today is in fact the fourth structure to rise three-hundred feet above the surface of the lake. In January, 1870, Alfred built an octagonal observatory, twenty feet tall and nearly nine feet in diameter, at the high point of the ridge. Constructed of hemlock and white pine lumber, it was held in place by three chains fastened to the stumps of trees, located near the base of the tower. Shortly after its completion, however, Alfred wrote to Albert that it had been destroyed by a severe wind, and so a second "Smiley Tower" was built between March and June of 1872. This time, Alfred wrote to Albert, "a violent storm of wind swept over the mountain—almost a hurricane—blowing down the scaffolding on one side, but the tower stood like a rock." Five years later, though, on May 19, 1877, a New Paltz newspaper reported that the Sky Top Observatory had burned down on Sunday afternoon, at about four o'clock. The cause of the blaze was never discovered.

In May 1878, work began on Smiley Tower number three. Construction was completed later that summer, but on June 1, 1909, it too caught fire, and since there was no immediate source of water nearby, the tower burned to the ground. Plans were made for a fourth tower and architect Francis F. Allen, of the Boston firm Allen and Collins, was finally given the go-ahead for a new stone tower, which was designed to complement a recent stone addition to Mohonk Mountain House itself. A cornerstone was put in place on August 30, 1921, and after two years of inten-

sive labor by scores of workmen, the tower was completed and dedicated on August 30, 1923. This time, steps were taken to prevent another devastating fire. A reservoir was eventually created at the base of the tower from the large cavity formed by the

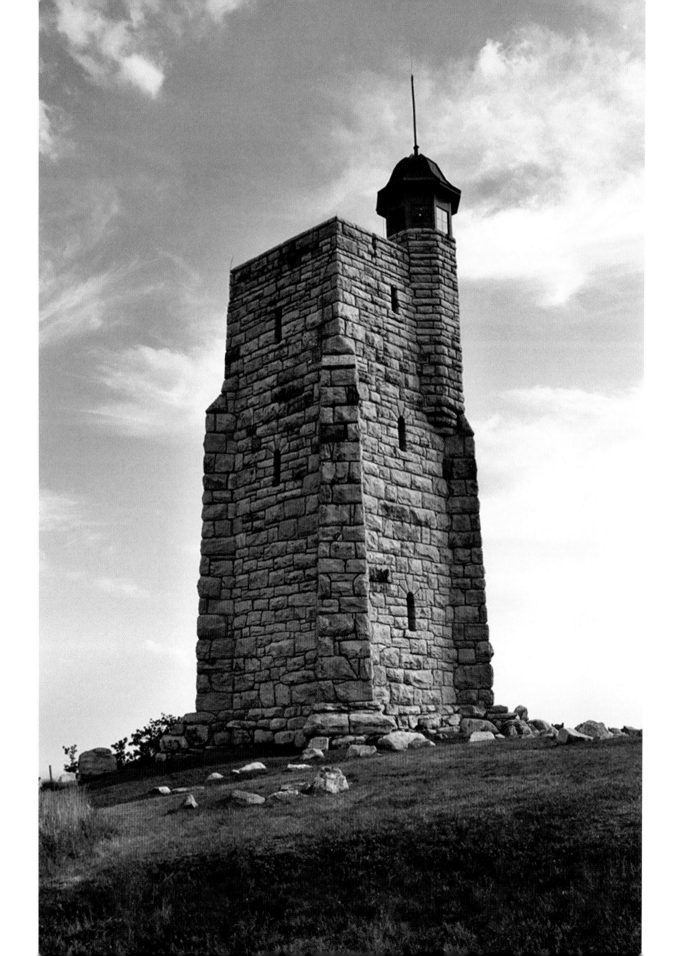

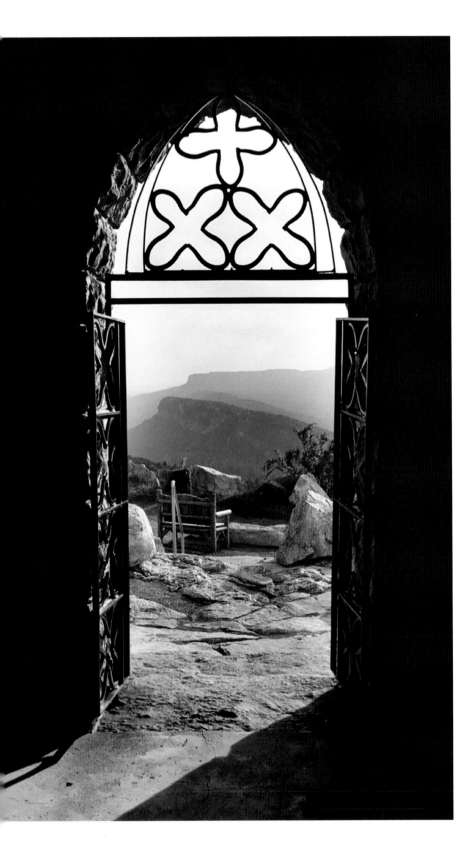

extensive stone quarrying at the site. The 1.3 million gallons of water held in reserve would well serve the purpose of "defending" Sky Top. The ground surrounding the tower was decorated with boulders taken from the quarry and positioned along the carriage road. The quarry reservoir still serves the vital function of protecting the castle-tower through Mohonk's sprinkler system, which was installed in the 1930s.

The tower is topped by a metal flagpole that rises eighteen feet from the roof, making its tip ninety-five feet above the ground. And though Sky Top is also protected by judiciously placed lightning rods, being present during an electrical storm is like being a willing participant in one of Baron von Frankenstein's scientific experiments.

I am walking doggedly along a dirt path that twists and curves upward at a constant 45-degree angle. I need only glance to my right, to the Mountain House and Lake Mohonk far below, and to the tiny people, like ants, beside the lake, to see how high I've climbed and to remember that I have a lifelong fear of heights.

Intrepid traveler that I am, I continue onward—up, up—until the carved-stone surface and squared edges of this medieval-style monument loom before me. There is not a soul in sight. I stand there for a moment to take in a view that dwarfs all others in the Hudson Valley. Then a newborn wind springs up from the south, which brings me to wonder: Is this the same wind that toppled the first two Smiley Towers?

I lie down in a patch of grass by the carriage road. The tower is a goliath above me. This one will not fall, I tell myself. This one will stay up.

STATE UNIVERSITY PLAZA

Also known as the Old D & H Railroad Building, State University Plaza now houses the State University of New York's central administration. A massive and expansive Gothic structure that dominates the eastside waterfront of New York's capital city, Albany, SUNY Plaza's soaring thirteen-story central tower was designed by prominent Albany architect Marcus T. Reynolds in 1912 as part of his campaign to clean up the "noxious wharves and warehouses" of Albany's disreputable waterfront.

The building itself is based on the seventeenth-century Nieuwerck Annex of the Cloth Guild Hall in Ypres, Belgium. Everything about this place says Old World Europe, from the multiarched foundation to the corner turret-towers with their aqua-green conical peaked roofs. Capping the central tower is an eight-foot-tall functioning weathervane in the shape of the Half Moon, the fabled ship that Henry Hudson sailed up the Hudson River in 1609.

This all makes perfect sense as I walk the length of its spiked, oddly crenellated and gabled wings. SUNY Plaza falls into the category of castle sites that I revisited numerous times: not because I *had* to get the dramatic images I wanted, but because I *wanted* to get them. There is a palpable sense of the exotic, of imperial grandeur, emanating from this architectural giant at the juncture of Broadway and State Streets. I feel compelled to return to its abundant spires, lancet-arched windows, and faceted, "chunky" south tower again and again, shooting every conceivable angle, turret, corner, arch, and roofline vignette I can find.

Standing smack in the center of Broadway, hoping that some cell phone–distracted motorist will not turn me into human guacamole, I line up my final shots. The deepening orange glow of the descending sun lends an almost surreal tint to the facade, throwing a sort of spotlight—an illumination that speaks to an offering from Heaven, or certainly something not of this Earth—on the west face of the tall tower.

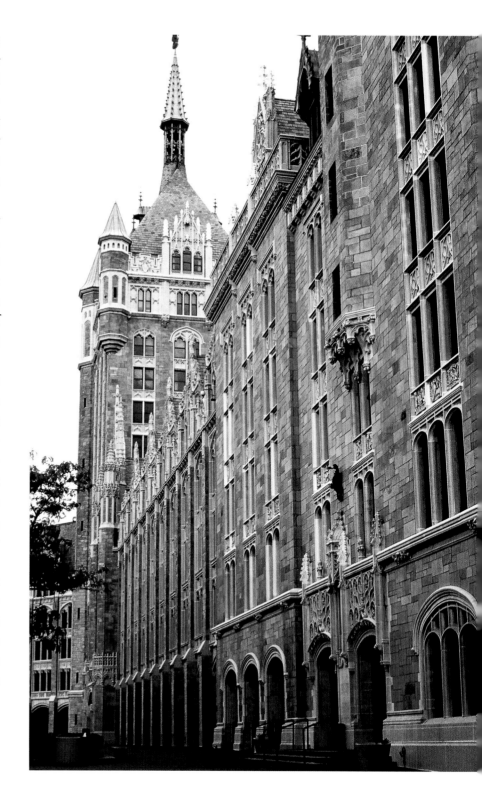

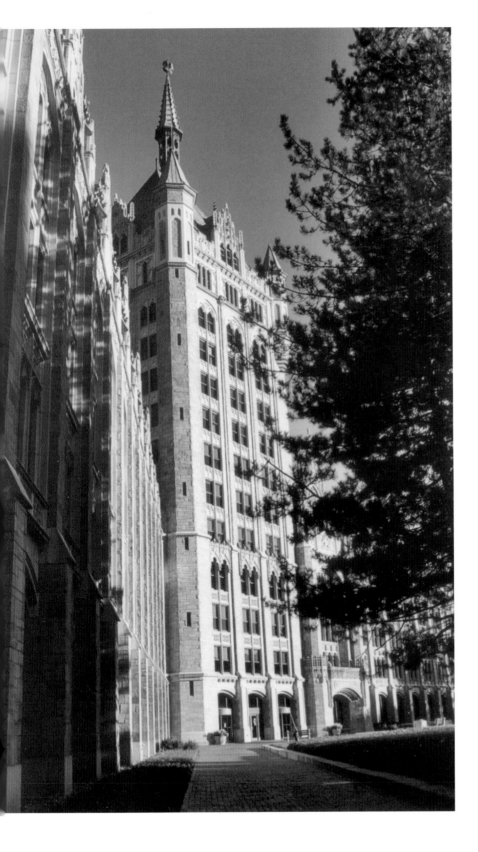

I shoot and shoot until the final frames of my Nikon FM10 camera are in the can. I think I've gotten the shots I wanted, and as I walk back to my van I touch my chest, my arms, my legs: I am intact; I have not become human guacamole as I feared. The van starts right up, and I drive away into the encroaching darkness. It is going to be a good night.

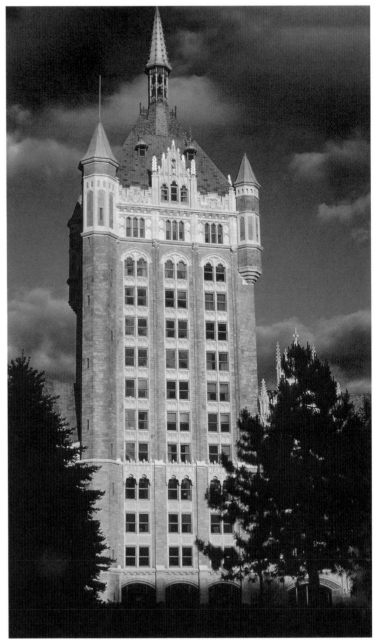

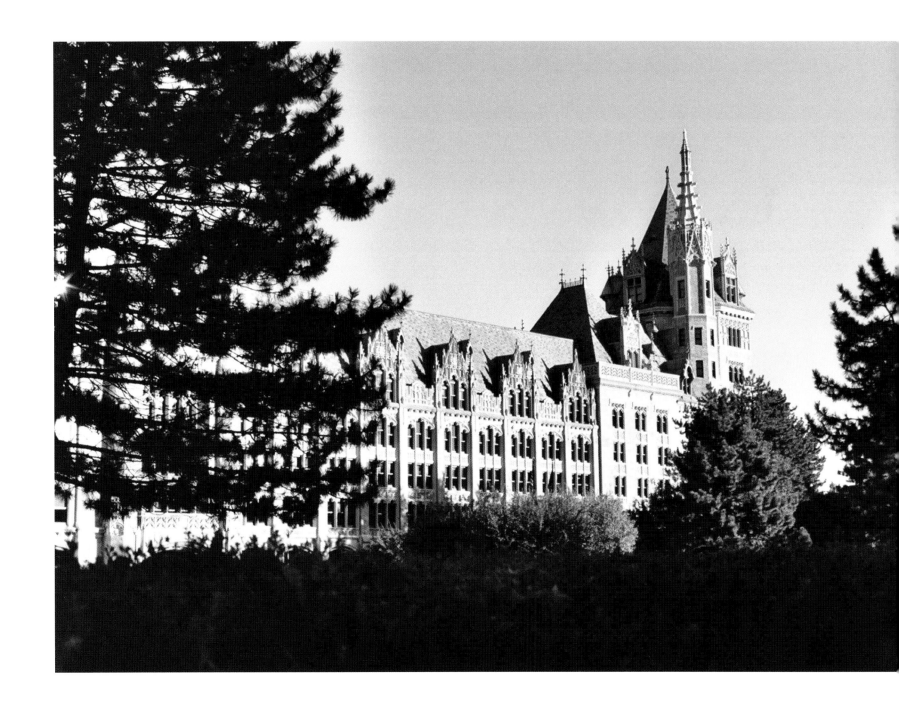

WARD MANOR GATEHOUSE

The exquisite gatehouse-castle that graces the north border of Bard College, in Annandale-on-Hudson, falls once again into the special personal category of one of those places I could move into tomorrow and never leave.

Constructed in 1918, it is a two-story, side-gabled Jacobean/Elizabethan building, composed of rough-faced ashlar-stone blocks surrounded by limestone trim. The front, or north face, is adorned with beautifully crenellated, twin octagonal towers that frame a highly artistic central gable, which features hooded casement windows, four-diamond-pattern panels, and a carved stone escutcheon in scrolled foliage.

Beneath the barred windows' capped bottom, a stout, portcullis-like entrance gate of wrought iron allows entrance to the residence area of the Manor Gatehouse. Together with the nicely balanced side-wings and roof of bright-ochre slate tiles, Ward Manor Gatehouse is a paragon of symmetry, tempered by strength and elegance.

As with Belvedere Castle, I find myself returning here again and again, but for an entirely different reason: I am so taken with the perfect aspect of this place that I find I want to capture it in various kinds of lighting, from crisp morning light to the orange glow of sunset, both of which offer deep shadows

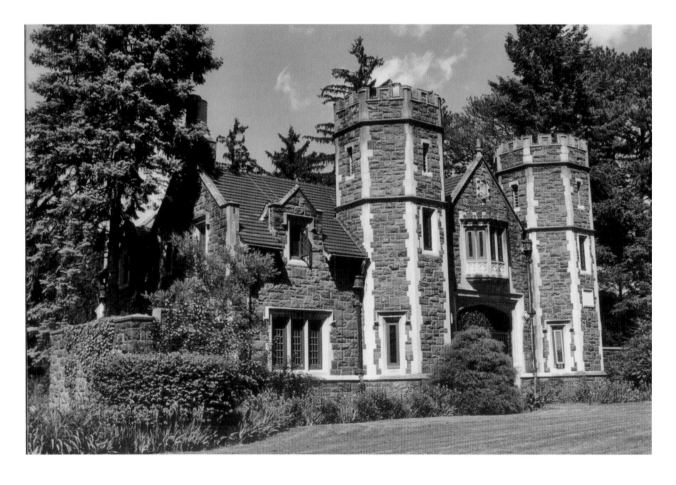

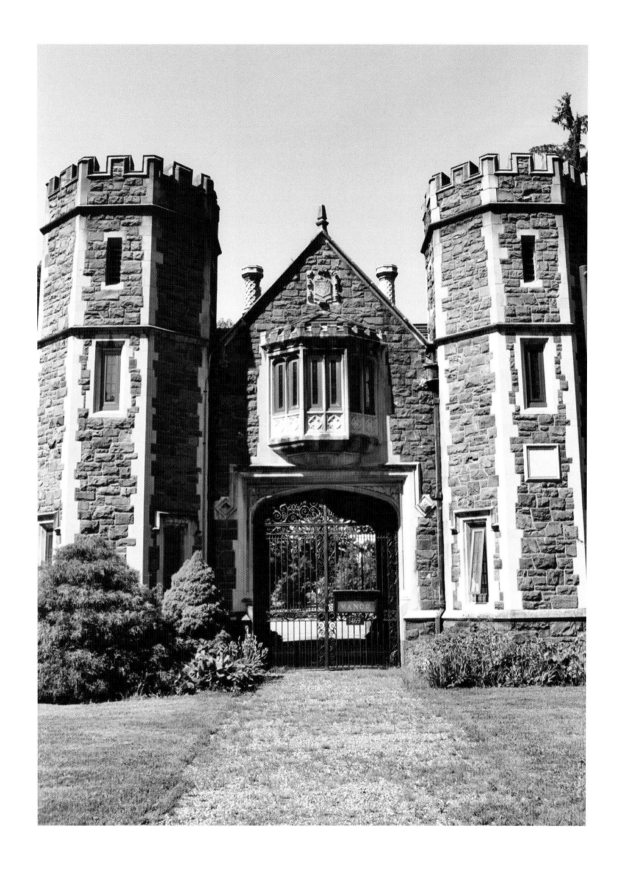

and stunning contrasts. I return for a fourth time, in July, just past noon, to capture the textured facades of ashlar in the bright, shadowless wash of midday.

On one visit, my friend Lugh assists for the afternoon. He marvels with me at the self-contained presence, projected not by the structure but by the manner in which it nestles into its setting of vivid blue sky and deep, verdant foliage (which includes a patch of ivy across a short stretch of the east curtain wall). "But," Lugh points out, raising his index finger toward the gatehouse, "beautiful though it may be, it is one-twentieth the size of castles in Spain."

"True," I say, "but small though it may be, it is much prettier than the castles in Spain. Just think of it as 'the little castle that could.'"

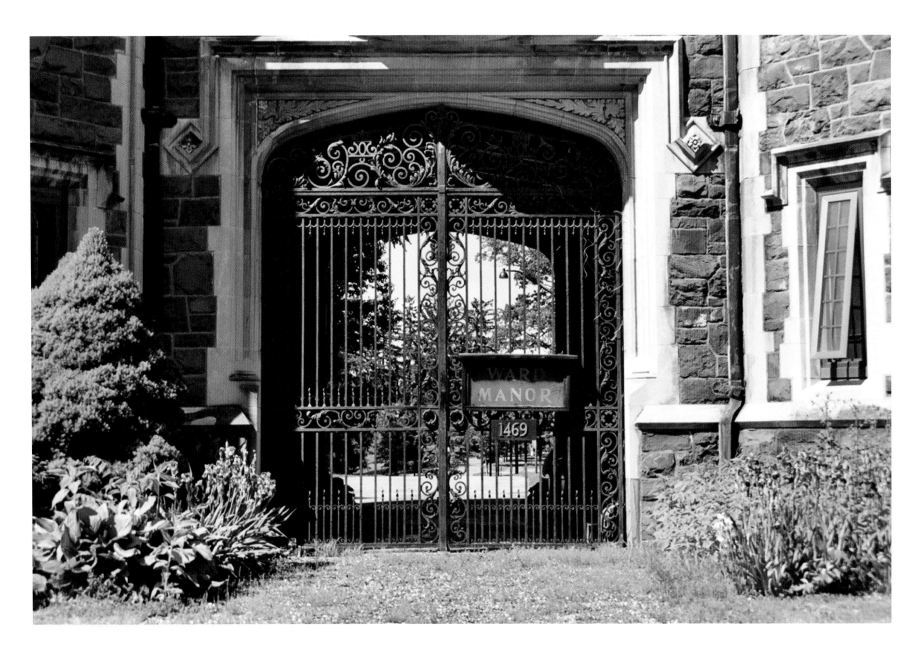

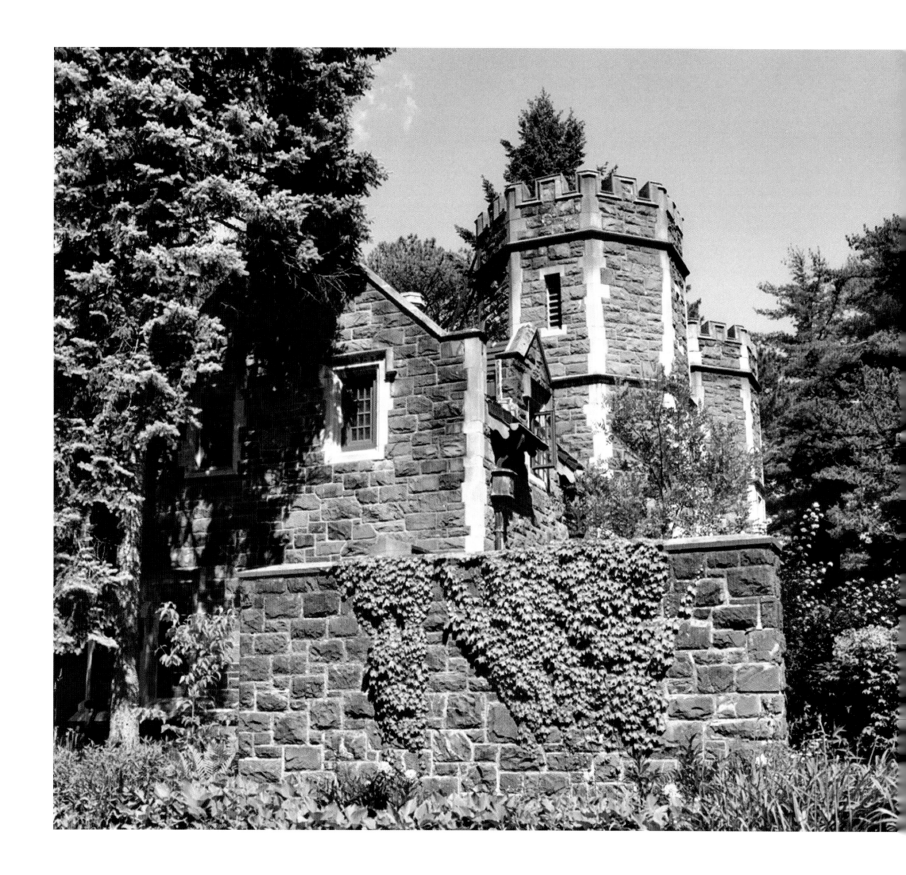

WING'S CASTLE

Tucked away in New York's wine country, near the peaceful town of Millbrook, is a living, breathing "Hansel and Gretel" castle. Wing's Castle is the forty-year brainchild and ongoing creation of Peter and Toni Wing, whom I have visited from time to time over the past decade.

Heading past Millbrook on Route 44, I eventually turn left onto Bangall Road, then hook another left at an intricately carved wooden sign sporting the castle's name. A short drive up the dirt-and-gravel path and I see Peter, just as I left him some six months ago, sitting atop his 1953 backhoe, which he lovingly calls "Henry." At the moment, he is transporting a writhen stone column across the southern driveway to its intended destination, the new bed and breakfast.

"Peter!" I call out to him, "Just how long have you been building this place?"

Peter cracks a broad, knowing smile, a smile that combines irony with a sense of satisfaction. "Oh, for about the last forty years or so . . ." He peers ahead of him, then back to me. "Toni tells me that Henry belongs in the Smithsonian."

To my mind, the whole place belongs in the Smithsonian. Wing's Castle is a marvel of innovation and artistic sensibility. And Peter is an artist in every sense of the word. Those of us lucky enough to take the house tour (between noon and 4:30 P.M. from early June through Labor Day weekend) are treated to Gothic spires, rough-hewn stone arches, a lengthy swimming pool that forms its own moat within a stone grotto, hidden passageways with private staircases that go to who-knows-where, and sculpted stone faces—angels, griffins, Sisyphus—staring out at you.

A full eighty percent of Wing's Castle is constructed from recycled materials that Peter has gathered from local railroad yards, factories, water towers, and any other source that yields fodder for his fertile imagination. "I'm the anti–Martha Stewart," he tells me, grinning proudly. "Well," he continues, "the dome of our small stone Buddha room, at the bed and breakfast, comes from the bottom of an old water tower that I turned upside-down. It looks like it's made of copper, but it is in fact battleship steel, held together with iron rivets." If this all sounds very industrial and "nuts-and-boltsy," fear not: there is enough elegant art to soothe the savage breast—from Peter's stained glass windows and carved stone Buddha to historic portraits, armor, swords, and handmade figurines that grace the main house.

In the past, visitors to Wing's Castle were greeted by the errant caws and squawks of "Crowsie O'Neill," Peter and Toni's pet crow, who always managed to give me a bit of a start when I turned the corner into the spacious kitchen. Sadly, Crowsie no longer sits upon her tall, T-shaped perch, but I can feel her bird-spirit taking wing through the eclectically furnished rooms, turning corners and sticking a landing on a couch, chair, or standing lamp. These days, however, a vision of brilliant azure and yellow rests upon another T-shaped perch. It is "Trudie," the blue macaw who greets guests coming through on the tour.

Forty years, I tell myself. Since 1969 . . . It's been forty years of their lives that Peter and Toni have given to building not only a home for themselves and their children, but also a miniature version of England's famed Stonehenge. From the vantage point of those standing stones, facing the western horizon, there is a spectacular view of the Shawangunk Mountains, and it's easy to see why they have kept at it for so long.

Like many of my castle subjects, Wing's Castle invites us to step back to a simpler time, a simpler version of ourselves. But this by no means suggests that Wing's Castle is for the unsophisticated or easily amused. Peter has not only gathered materials from his many recycled sources but has scoured the landscape for appropriate construction materials. "What kind of stone did you use for the main part of the castle?" I ask him. "You know, for the side that faces south?"

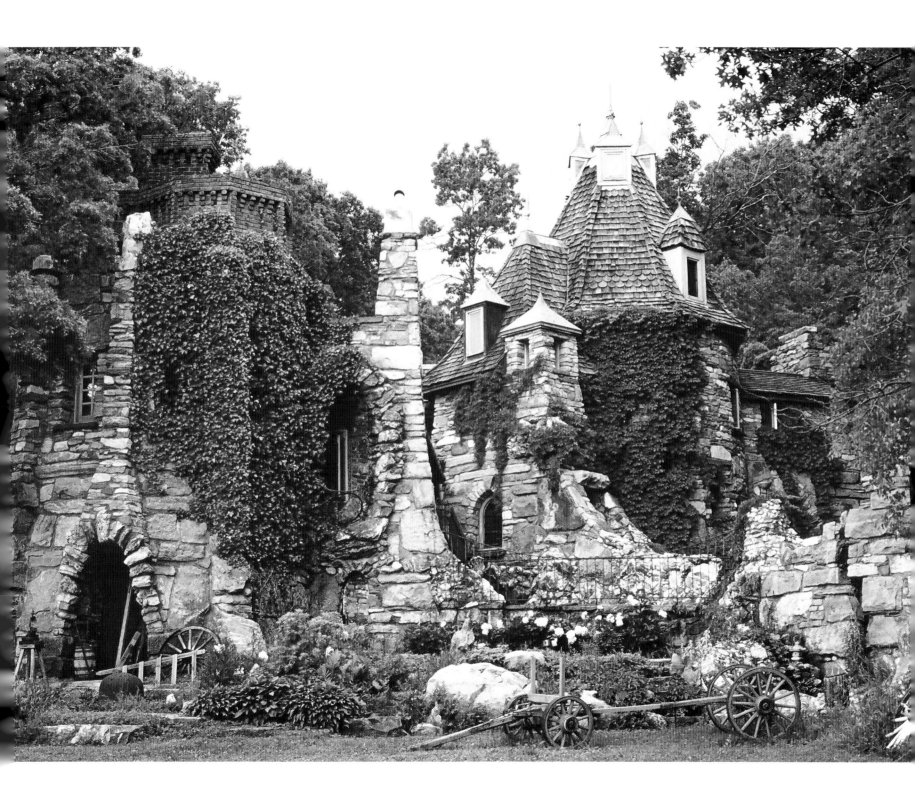

"Light bluestone," he replies. "In fact, fifty percent of the whole castle is constructed from light bluestone."

I nod my head. "The new bed and breakfast, too?"

"It's in there, too," says Peter.

"What about the rest of Wing's; what's that made of?"

Peter snorts a bit, and chuckles. "Oh, man. You name it, and I've used it." He pauses a moment to think. "We've got bluestone, sandstone, shale, slate, granite, limestone, brownstone, igneous rock . . . and more."

I turn around now and gaze north, up the high end of the gravel driveway. Ahead is the bed and breakfast. Henry the backhoe sits momentarily dormant outside the B&B's front façade. Not far to my right, I spy what looks like an Egyptian archaeological excavation. Writhen stone columns line a corridor that is littered with construction materials, long iron poles, hammers, drills, saws, and, most interestingly of all, several gravestones.

I learn from Peter that the columns are in fact concrete culverts that have been discarded from construction sites, and that their Greco-Roman-looking caps are sections of other culverts that he has masterfully cut and shaped. Together, they form a groined vault that will complete the partially covered path to the bed and breakfast.

"We are going to create a child-free zone," says Peter, referring to the bed and breakfast, which has been an eighteen-year labor of love. "I mean, the place is an attractive nuisance: just recently, one of my grandchildren got into the B&B, then climbed out the second floor window and into a tree."

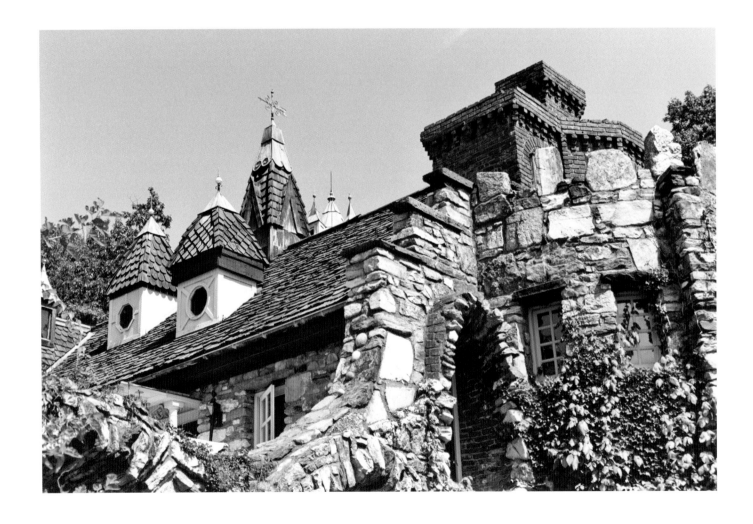

"Is he okay?" I ask, afraid to hear Peter's answer.

"Oh, yeah, he's okay," says Peter, "but he was up in that tree for awhile. It wasn't pretty."

"Therefore, your 'child-free zone.'"

Peter bobs his head. "Correct."

This anecdote aside, I am amazed yet horrified to discover that the historic gravestones lining the corridor—which date to the year 1821—were removed from private graveyards as eyesores when new homes were built on these properties. They were then dumped or stacked up like so much garbage on the tops of stone walls. Peter Wing's decision to rescue these historic markers represents an attempt to keep our past from slipping into oblivion.

"Things from the past exist today," Peter says, fervently. "I mean, I have a dinosaur footprint that is four hundred million years old—give or take twenty-five million years."

A big grin comes to my face. "You know Peter, I believe you do." In addition to forging a connection with the past, Wing's Castle allows us to be taken on a journey of adventure and discovery, reconnecting us with that best part of ourselves—the fanciful part—which these days is too often suppressed.

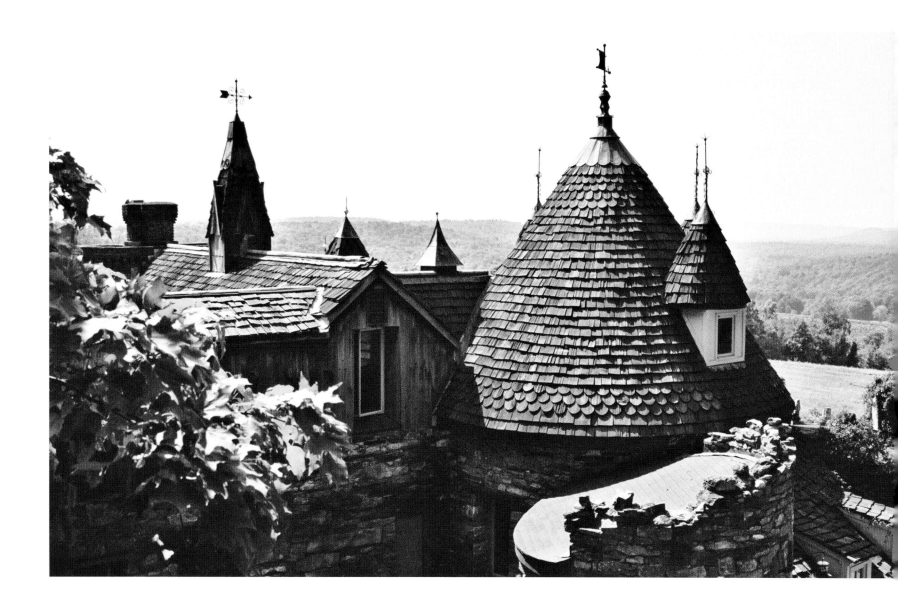

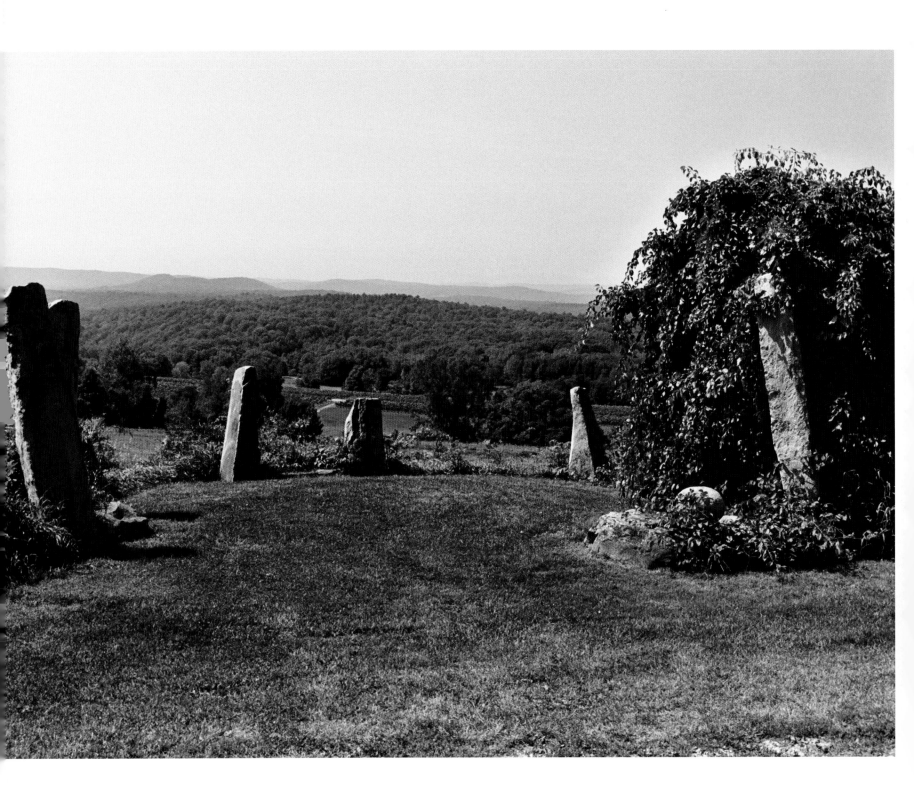

MOHAWK VALLEY

AMSTERDAM CASTLE

Now that I think of it, I would describe Amsterdam Castle—located in the Mohawk Valley city of the same name—as a comfortable fortress.

I arrive at the site with my assistant Aleta on a hot and humid August afternoon. Without my having to gesture or speak a word, she is off and out of sight, seeking the proprietor of the thirty-six-thousand-square-foot historic landmark and former National Guard armory turned bed and breakfast, while I—fending off the mosquito hordes—circle the perimeter of the four-towered goliath, searching the best photographic angle.

On my second circuit of the building, I see Aleta standing at the steps of the four-layered entrance area—with its arched brick and wrought-iron portcullis gate—waving insistently for me to come over. She introduces me to a stately, blonde-haired woman, Susan Phemister, owner along with her husband, Manfred, of Amsterdam Castle. Susan graciously bids us to enter, and I am immediately taken aback by the ten-thousand-square-foot gymnasium just inside the door, where the Phemister children are involved in a giggling, screeching round of dodgeball, closely monitored by Pumpkin, the family's golden retriever.

Susan then takes us on a delightful tour. Our first stop is the Kennedy Room, which can best be described as a place of humble grandeur. Warm, rich hardwoods and early twentieth-century lighting fixtures combine with tall, narrow windows to bring a joy and brightness to the space. Shelves of books and smaller activity tables provide for personal time, alone or with friends. Next we visit the Westlake Wing sitting room—very clean, very neat, very much the feel of a Victorian parlor room, with flowered wallpaper of blue, white, red, and green. Just through the side door is the exquisitely simple yet eminently cozy Westlake Wing bedroom, with its clean white walls and welcoming four-poster bed. Both the Officers Wing and the Officers Wing bedroom share the same attributes, with expensive area rugs over fine wood floors, except that here the walls are done in vertical stripe patterns that remind me of eighteenth-century colonial America. I, however, am sorely tempted to go over to the Billiard Room and shoot a few rounds of pool.

Built in 1894, Amsterdam Castle is one of the approximately 120 armories and arsenals built in New York State dur-

ing the eighteenth, nineteenth, and early twentieth centuries, nearly half of which are still in use by the National Guard. Decommissioned in 1995, it is the only armory that has been converted into a private home.

The fifty-room building features three cylindrical towers and one main tower of faceted construction. Along with the gymnasium and billiard room, it also boasts a rifle range and fallout shelter. The Phemister family purchased the castle and its property in 2005 and carried out extensive renovations and redecorations that were seen on the HGTV show *ReZoned*. They not only brought back the castle's luxurious Victorian décor, but Susan tells me they kept a strong eye toward creating environmentally sound rooms, using construction materials with low-VOC paints and repurposed wood. The eighteen-inch-thick brick walls help maintain a comfortable temperature indoors,

keeping the heat out in the summer and retaining it in the winter. This is fortunate, since the gymnasium can hold as many as a thousand people, making Amsterdam Castle the largest event-reception facility in the county. Recently, it has hosted a cheerleading camp, a dodgeball tournament, fundraising events, corporate board meetings, and the ABC-TV show *Wife Swap*.

Back outside, Aleta and I thank our gracious hosts for the tour of their historic home. As we head back to my van, Susan and Manfred take the opportunity to reposition a standing sign, while Pumpkin lies along the spacious, tumbling front lawn, gently panting as he flicks his paw to his face to shoo away the mosquitoes. I also begin swatting at the insect horde, which has begun to take out its wrath on me. I glance back at the handsome golden retriever, still pawing his face. "I can relate, Pumpkin. I can most definitely relate."

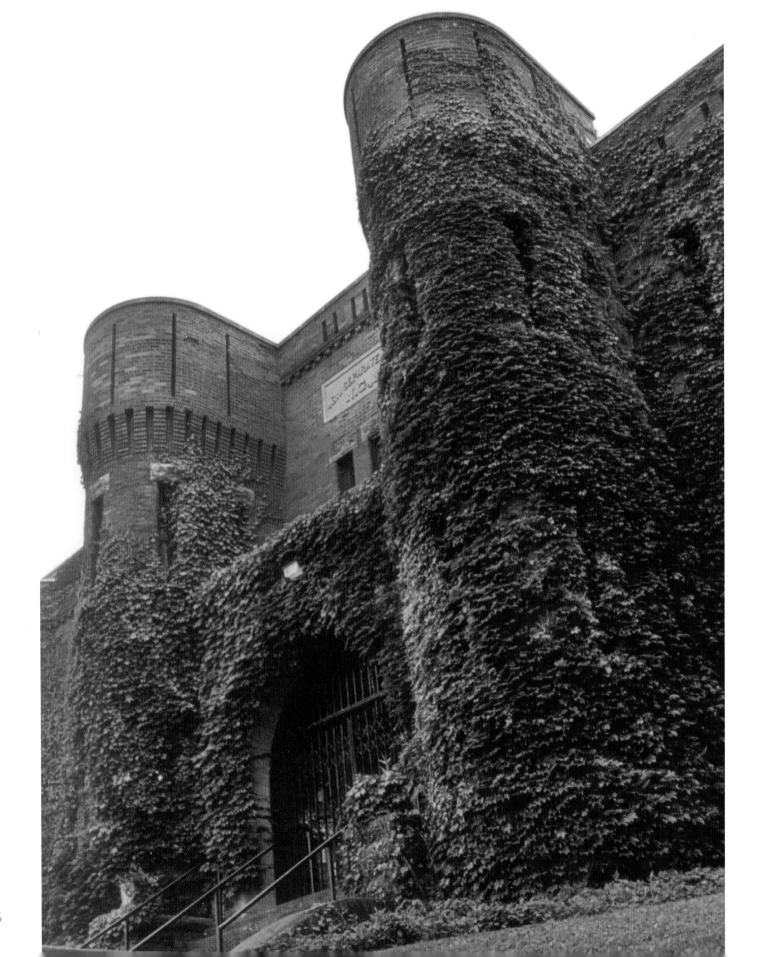

BEARDSLEE CASTLE

Just three miles west of St. Johnsville and six miles east of the town of Little Falls lies Beardslee Castle, perhaps best known for its ghostly visitors, not to mention its delicious cuisine. I am sitting with my friend James Casey on cushioned barstools in the downstairs dining room complex, aptly known as "The Dungeon." Beneath my elbows stretches a long, russet bar, covered entirely with thin copper sheeting. I order a Guinness from the attractive bartender, Holly. "So," I say, in a casual voice, "you got any good ghost stories?"

Holly does not so much as crack a smile. "I do."

This was not the response that I was expecting. "Such as?"

"Well," she says, leaning closer to the bar, "I was working here alone one night, getting things ready for the morning staff, when I heard a woman's high-heeled shoes coming loudly towards this room." She glances in the direction of the back dining room. "I heard her as clearly as I hear your voice, now. And then I'm thinking: there's no entrance door into the back room from the outside—how'd she get in there?"

I nod my head. "How did she?"

Holly shrugs her shoulders. "I didn't know. But her shoes—the heels—kept getting louder. So I took down a wine glass and waited for her to come around the corner, into the bar room."

"Did she?"

"The clicking heels stopped. They just went away. When I peeked into the back room—the dining room—it was empty; there was nobody there."

Holly's personal encounter is just one anecdote from Beardslee Castle's paranormal heritage. In the mid-1700s, a fortified homestead stood on the property where the castle is located today. During this volatile period of the French and Indian War, munitions were stored in tunnels along with black powder. Late one night, a band of Indians crept into the tunnels where the powder was stored. Local folklore has it that the torches they were carrying ignited the powder and blew them to pieces.

A number of psychic researchers claim that these Indians are the source of many of the apparitions and strange incidents at Beardslee Castle and throughout the Mohawk Valley.

But the castle itself, based on an Irish castle, was not constructed until 1860, when Augustus Beardslee (son of John, who established the settlement of Beardslee Mills in the last decade

of the eighteenth century) grew the family fortune by investing in the New York Central Railroad.

In 1879 Augustus's son, Guy, received a commission in the infantry assigned to Fort Niobrara in Nebraska, where the U.S. Army was setting up outposts to take over land from the Sioux. Guy resigned his army commission one year later and brought back a number of sacred Indian artifacts, including three full war bonnets, a collection of tomahawks, many knives, and other ceremonial items.

Researchers point to the presence of these ceremonial objects—felt to contain potent powers—as a second potential source for ghostly activity in and around the castle. Ironically, all of the Indian artifacts were destroyed in February of 1919. While Guy and his wife, Ethel Shriver Beardslee, were on vacation in Florida, an early morning fire broke out at the front of the castle. The entire structure was gutted, leaving only a border of stone walls.

Newspaper reports stated that a "mysterious man" was seen in the area several days before the blaze and that the fire was the result of arson, to cover up a large theft. Only the main floor of the castle was rebuilt, leaving the second floor without a roof and with railings spanning the window openings.

After the deaths of Guy and Ethel in 1937 and 1941, respectively, Ethel's sister, Gertrude Shriver, sold the estate to Adam Horn of St. Johnsville. Not long after, Horn sold it to "Pop" Christensen, also of St. Johnsville, who opened the grounds to the public in 1948 as "The Manor." Pop and his family moved into a small cottage they built beside the castle in what is now called the West Courtyard, and operated a restaurant in the main building. In his old age, Pop was diagnosed with a terminal illness, and the physical and emotional pain of his condition drove him to numerous suicide attempts. One fateful day he succeeded, hanging himself in what is now the side entrance foyer of the castle. Pop's daughter sold Beardslee Castle's furnishings several

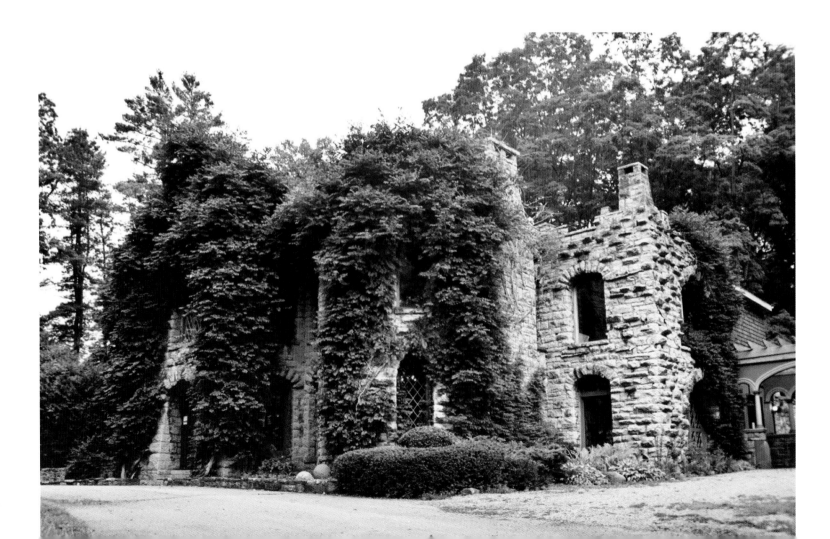

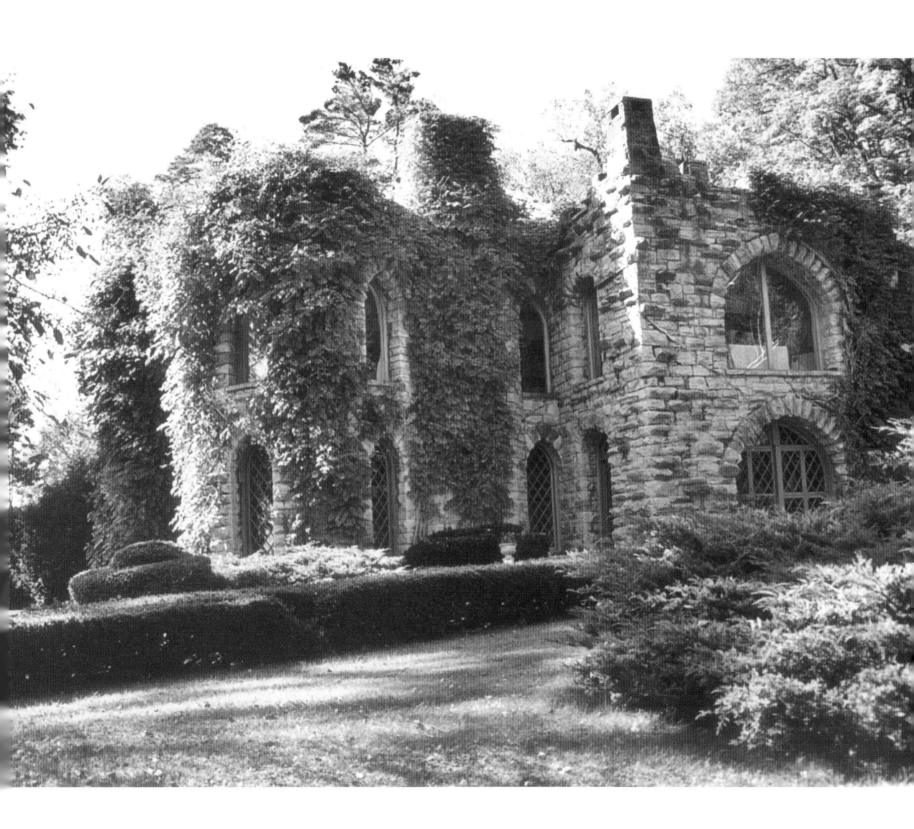

years later, then sold the building itself to John Dedla, a restaurant owner from Herkimer. John operated the business until 1976, when he sold it to Joe Casillo, owner of The Lakehouse in Richfield Springs. It was Joe who changed the name to "Beardslee Manor" and finished the basement as a pub, The Dungeon, in 1977. He rebuilt the roof and reconstructed the second floor a few years later, in 1982. The following year, Joe hired a professional ghost hunter—Norm Gauthier—who spent a night at the castle and recorded faint voices on tape before a group of over forty skeptical reporters. Although this ghostly reputation led to a boom in business, both the castle and the quality of the food were neglected. When a second fire broke out early on the morning of August 30, 1989 and destroyed most of the kitchen, the castle was abandoned and left to deteriorate.

But in February 1994, the structure was reopened for business as "Beardslee Castle" following an eighteen-month restoration by new owner and chef Randall Brown. The oak parquet floors were brought back to their original appearance, and 140 years of dirt and soot were cleaned from the Gothic arches and original stonework. The wood-paneled ceilings were also restored, and the second floor banquet room now boasts floor-to-ceiling plate-glass windows that provide a panoramic view of the Mohawk Valley. The kitchen was completely refurbished to provide service for all three floors.

After I wolf down a sublime roast-beef sandwich, Holly the bartender hands me a history of Beardslee Castle. In it I find the story of Abigail, the woman in white, who is said to have been a bride that died the night before her wedding (several weddings did take place at the castle when it was a private residence). Many customers have reported seeing the figure of a woman, dressed in what seems to be a wedding gown with a high collar and bottom sleeves, walking the grounds and sitting or standing on the other side of the plate-glass windows, looking out.

Maybe, I tell myself, just maybe it was the clicking heels of Abigail's shoes that Holly heard so clearly that night in The Dungeon's bar room.

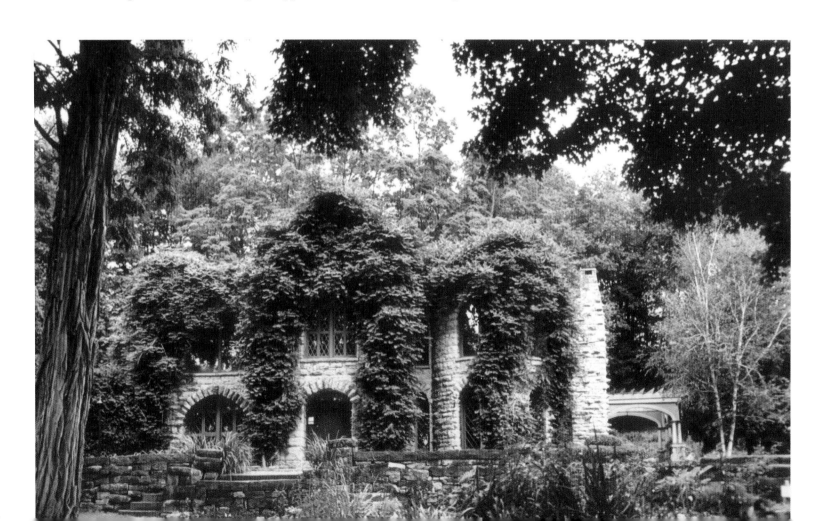

ADIRONDACKS AND NORTH COUNTRY

NEW YORK STATE MILITARY MUSEUM

Between the years 1879 and 1919, most armories built in New York reflected the influence of medieval military architecture of the twelfth to fifteenth centuries: castellated towers with deeply etched merlons and crenels, tall narrow windows, raised and battered masonry foundations, and massive portcullises and sally ports through which troops could march in formation. These were not merely decorative features. In a time of growing conflict between capital and labor, these armories were designed as imposing symbols of military and governmental strength and were meant to be defensible structures during periods of civil unrest.

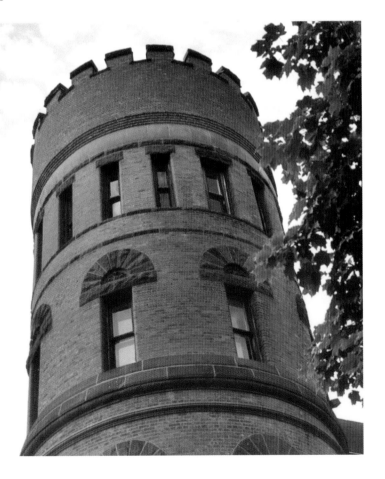

Although the cornerstone for the Saratoga Springs Armory—as the New York State Military Museum used to be known—was laid in late December 1889, it was not truly completed until 1906, when the conical roof of its main tower, designed by architect Isaac Perry, was replaced with a classic merlon-and-crenel parapet. Like many of the armories designed by Perry, the building features finely crafted and intricate details such as the carved stone face of a lion atop the southwest corner of the structure.

Originally built to house the Twenty-Second Separate Company, which later became Company L of Second (later 105th) Infantry Regiment, the armory is now home to the New York State Military Museum and Veterans Research Center. Its mission is to preserve, interpret, and disseminate the history and records of New York's military forces and veterans. The museum houses over ten thousand artifacts dating from the Revolutionary War to Desert Storm, including weapons, uniforms, artillery pieces, and artwork. The museum also owns the largest collection of state battle flags in the United States and the largest collection of Civil War flags in the world.

The Veterans Research Center is home to over two thousand volumes of military and state history, as well as over six thousand photographs, unit history files, broadsides, scrapbooks, letters, and maps. The research center takes specific pride in its New York State Veteran Oral History Program, which collects, transcribes, and archives the stories and reflections of New York's veterans.

In addition to offering a fine example of medieval castle architecture, complete with moat, Saratoga's New York State Military Museum gives individuals and families a chance to look at and experience an important part of New York's history.

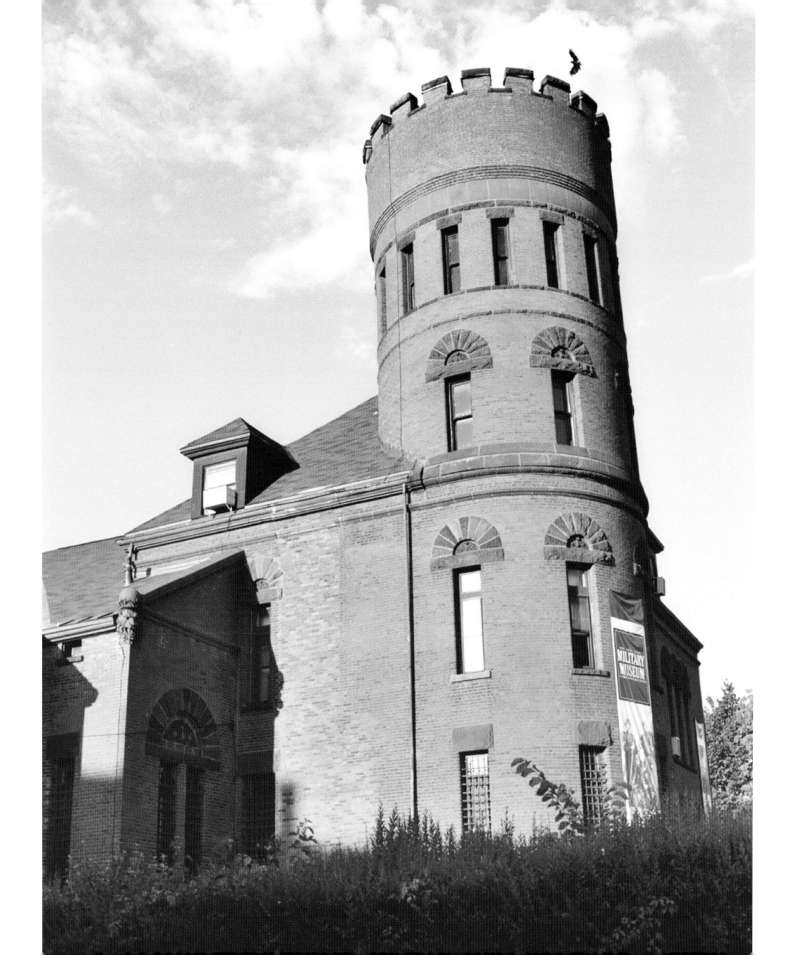

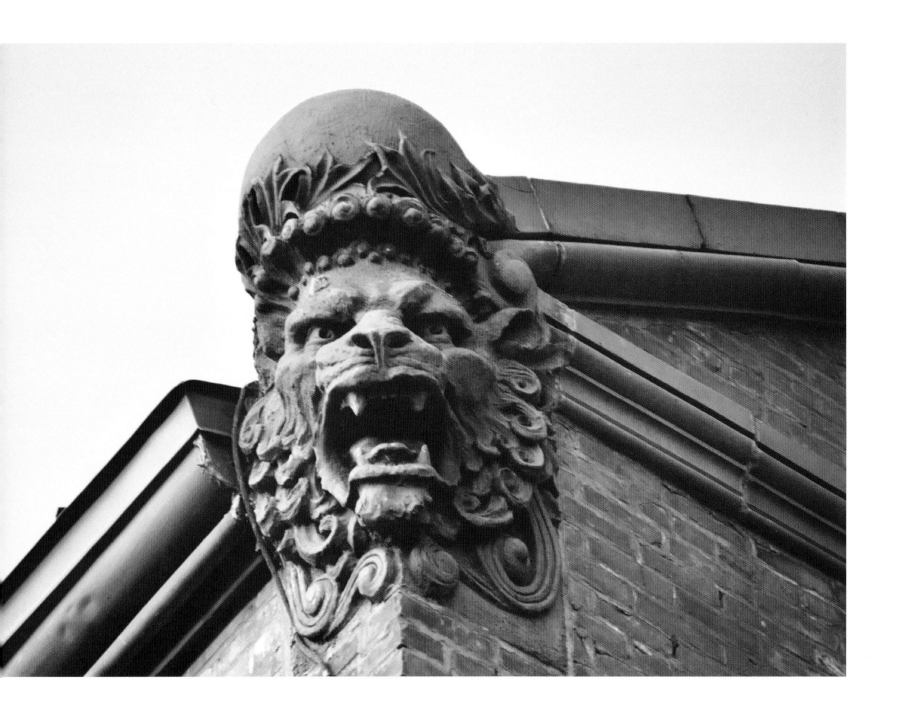

SINGER CASTLE

Singer Castle, tucked away on Dark Island in a remote channel of Chippewa Bay in New York's Thousand Islands, holds special meaning for me. First, it is the castle farthest from my residence in the Catskills. Second, I am be-ing accompanied and assisted by my good friend Alfonso Moral "Lugh" Cervantes, a native of Madrid and a direct descendant of the famed Miguel de Cervantes, author of the literary master-piece *Don Quixote*.

Lugh and I leave the Catskills on a cool, crisp, ultimately sunny October morning. Our drive takes us north to Albany, then west to Syracuse, then north again to Alexandria Bay, the town nearest to our destination—all told, a five-and-a-half-hour journey. When we arrive, I place a phone call to Tom Weldon, Singer Castle's general manager, who informs me that he will send a boat to take us across the bay at six-thirty in the morn-ing. It must be explained here that the word *boat* is more or less a quaint euphemism, for what finally arrives, amongst the wind and rain and chopping waves, forty minutes late, is an old wood-en craft not much longer and wider than a Volkswagen Beetle. This does not inspire much confidence in me, particularly be-cause I cannot swim.

So when Lugh (who can swim perfectly well, thank you very much) and I step into the boat and I manage to balance my posterior along the craft's narrow top rail, just inches above the waterline, I find myself holding on for dear life as we bob and jerk and jostle from side to side while the foaming, surging waves slap feverishly at the boat's bow. Although the ride prob-ably takes no more than twenty minutes, I cannot get there fast enough. Finally, the castle, with its russet-red tiled roofline of conical spires and stone towers, grows rapidly larger in my field of view, creating the optical illusion that we are not getting closer to it but that it is somehow moving closer to us.

After some skillful parallel maneuvers toward the island, our Beetle-sized boat pulls alongside the expansive South Boathouse, and I am most relieved to set foot on solid ground. Gazing up at the sheer massiveness of this island fortress loom-ing above its immediate surroundings like a colossus, my first impression is that it reminds me of a seventeenth-century

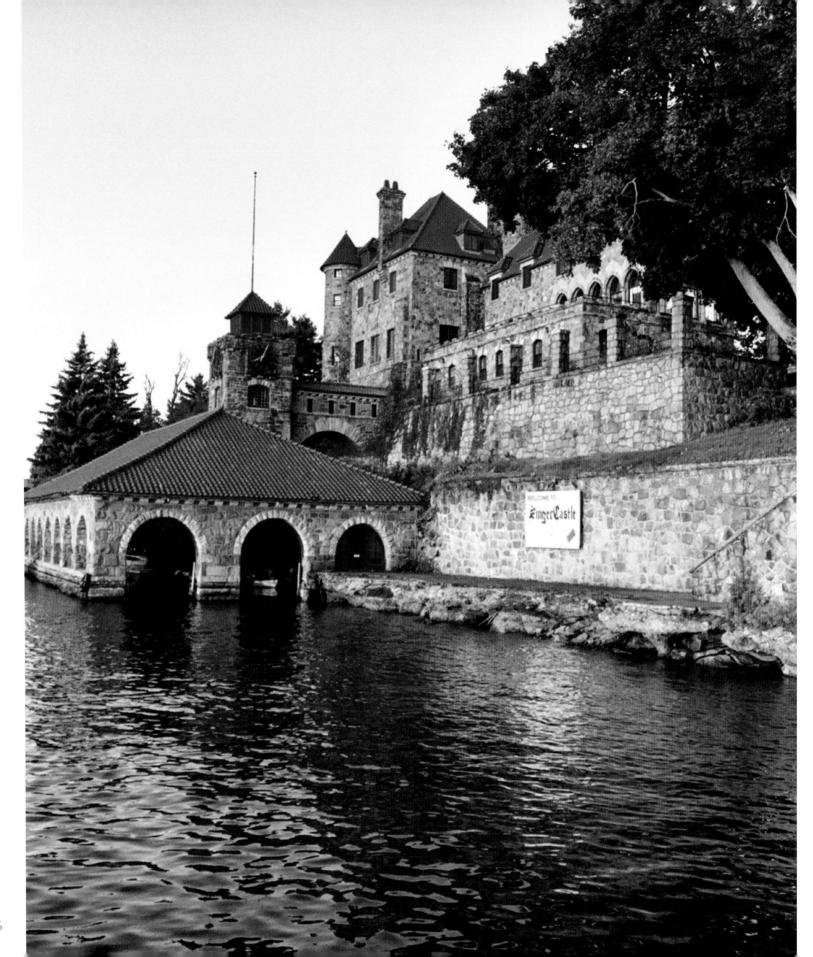

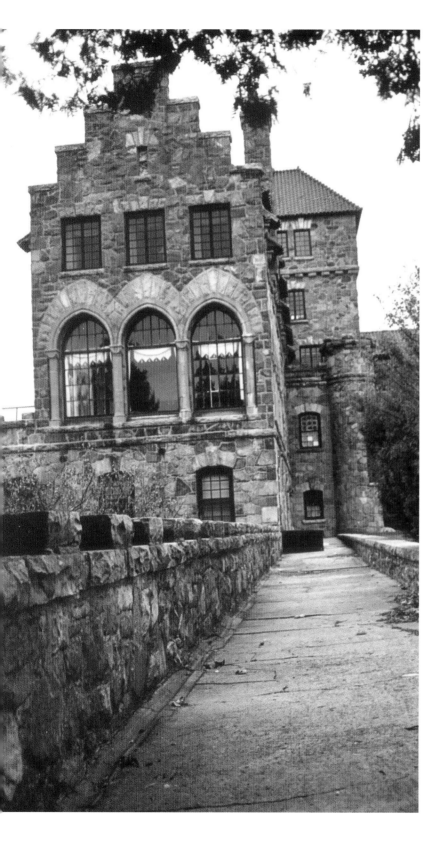

Dutch manor house—albeit a huge one—with its east-facing, stepped roofline.

Originally, Dark Island—also known as Bluff Island and Lone Star Island—was part of a thirty-five-mile string of islands that were purchased for three thousand dollars in 1845 by Azariah Walton of Alexandria Bay. After Azariah's son, Lyman, and an employee, Andrew Cornwall, used the land to harvest timber, it was sold to William H. Harrison Jr. in October 1891. Harrison then sold it to Frederick Gilbert Bourne of New York City on December 2, 1902, for the sum of five thousand dollars.

It was Frederick Bourne who commissioned Ernest Flagg, a New York City architect, to design a "castle–hunting lodge" on Dark Island, which would "not imitate any existing castle." Flagg had read Sir Walter Scott's classic work *Woodstock*, which is set in a hunting lodge–castle in Woodstock, near Oxford. He then incorporated the physical features of the castle described in the book (an actual castle that was torn down in the first quarter of the eighteenth century) to design Frederick Bourne's castle, thus adhering to Bourne's desire to imitate no existing building.

Construction began in the spring of 1903 and employed no fewer than one hundred stonemasons. Granite was taken from a quarry on nearby Oak Island, and sandstone was taken from a quarry in Hammond.

Bourne told his family only that he was building a hunting lodge on the St. Lawrence Seaway. Upon arriving, in the summer of 1904, they learned that their "hunting lodge" happened to include turrets, secret passageways, an underground tunnel, and an actual turret-dungeon. The castle was completed and fully occupied in the fall of 1905. Sometime before 1916, a clock was added to the front tower, the breakfast room on the second floor was extended, and a large bedroom and bathroom were added to the third floor.

The castle as a whole contains five stories, featuring twenty-eight rooms, ten fireplaces, and eight bathrooms. A spacious fourth-floor dormitory, with a vaulted ceiling and turreted bathroom, housed nine female servants. There were five servants' bedrooms located near the kitchen and four more on the ground level. Apart from the castle, the island also features two boat houses, a skiff house, and a bath house. The North Boathouse

held nine servants' quarters, a water pump, a diesel-powered generator, and a full furnace. Heat, water, and electricity were brought to the castle through its underground tunnel and were dispersed throughout its passageways.

Ironically, the Bourne Family only used the castle for several weeks of the year, in the summer and fall. But in 1916, Emma Bourne—Frederick's wife—died. Two years later, their son Howard passed away. When Frederick died in 1919, his estate, valued at $43 million, was left to his seven surviving children, and on June 12, 1919, Dark Island and all its attending buildings were sold for the sum of $389,000 to Marjorie Bourne of Oakdale, Long Island, and her sister, May Bourne Strassburger.

On the April 17, 1965, Dark Island changed hands once more and was sold to the Harold Martin Evangelistic Society—to Dr. Harold and his wife, Eloise—for $35,000. The Martins changed the name of the castle to Jorstadt and held religious services and retreats from May through October. But by the late 1980s, Eloise Martin's health kept her from the island and the castle, and the ministry was carried on by Harvey and Flo Jones. Two decades later, in 2002, the island was sold to Dark Island Tours for $1.8 million. The castle was renamed "Singer Castle on Dark Island" and has been open for guided tours, weddings, or overnight stays in the luxurious Royal Suite since 2003.

When Lugh and I bid farewell to Singer Castle, it is with regret. For me, the two days of intense photographing, of circling the castle on foot, again and again, and the gracious courtesy of manager Tom Weldon—which included an enthusiastic and highly informative tour by castle historian Judy Keeler—left me with a yearning to remain there, tucked away in that private, safe world, where the elements come to your doorstep . . . but never get in.

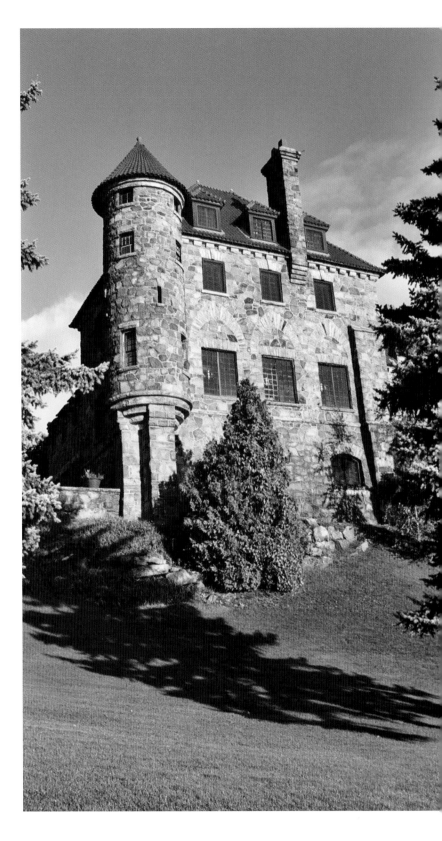

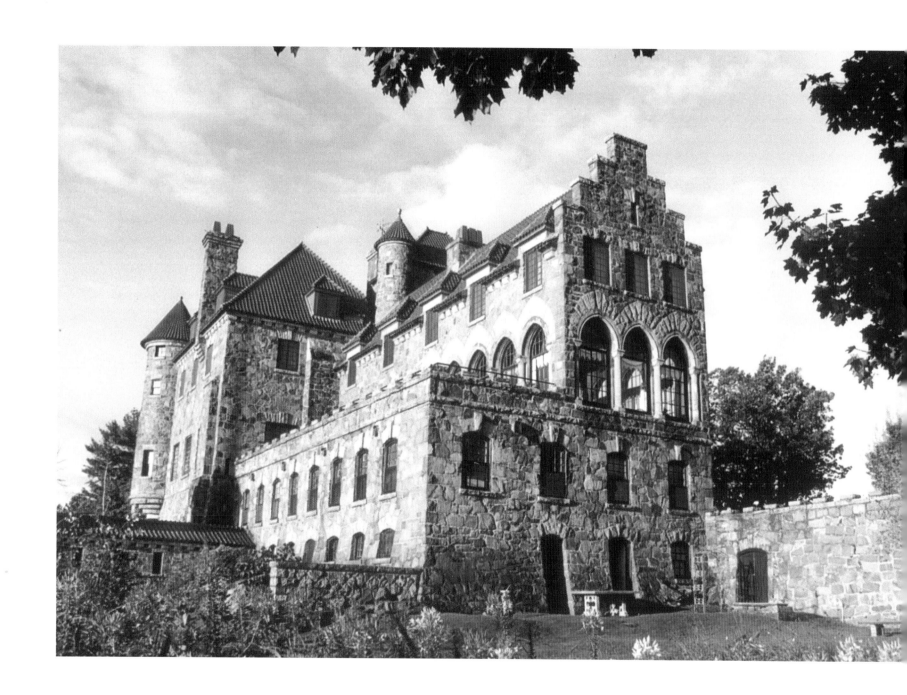

BOLDT CASTLE

I did not think it would be possible to find a castle in New York State as formidable as Singer Castle, but the day after finishing the shoot at Singer, my friend Lugh and I head across nearby Alexandria Bay to Heart Island. Again, we are in a local tour boat not much larger than a Volkswagen Beetle.

When we arrive at the castle's dock, just fifteen minutes or so from the mainland, I am hit by the sheer enormity of the structure. I soon learn, though, that Boldt Castle and its atten-dant buildings are a collection of six structures, a spectacular self-contained grouping of stone-and-tile spires, towers, battlements, and balconies, where flowers grow in rainbow clusters and the water gently laps against rocky shores.

While Lugh heads into the castle itself, I once again circle my subject on foot, sizing up the best angles and lighting. And though the main building is humbling in its grandness, I find myself utterly drawn to the picture-perfect Power House that sits at the water's edge, with its five spired towers arranged sym-metrically around its core. Very French, I tell myself. Very . . . fifteenth century.

I'm not far off, actually: Boldt Castle was envisioned as a full-scale Rhineland castle. Built by George C. Boldt, the multi-millionaire proprietor of the world famous Waldorf Astoria Hotel in New York City, it was meant as an expression of love for his wife, Louise. Work began in 1900, and for four summers the Boldt family lived in the Alster Tower while three hundred workers, including stonemasons, carpenters, and art-ists, began the process of making George's dream come true. Boldt's plans called for 120 rooms, with tunnel passageways, a self-sufficient powerhouse, Italian gardens, a drawbridge, and a dovecote. No expense was to be spared, and no refinement of detail was to be overlooked.

But George Boldt's dream of a special home for his family was not to be realized. In 1904, George telegraphed the island and commanded the workers to immediately stop all construc-tion. Louise had died, suddenly. George was too heartbroken to bear the thought of going back to the castle, let alone living there, without her. He never returned to the island again, and Boldt Castle stood against the elements—the wind, rain, ice, and snow—for seventy-three years, abandoned and vandalized, until 1977, when the Thousand Island Bridge Authority bought the property. Since then, millions of dollars have been spent to reha-bilitate, restore, and improve each structure.

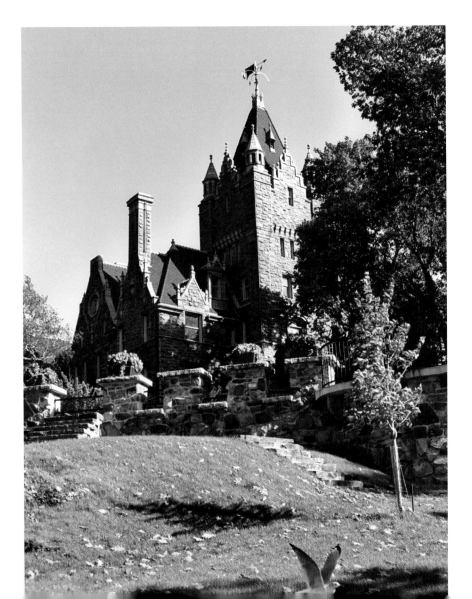

By the time I have photographed the castle, the Power House, and the Alster Tower, with its distinctly squared edges and deeply crenellated battlements, I have lost track of Lugh. Eventually, I find him standing in the high-arched doorway of the Hennery, or dovecote (dove house), trying to wedge his feet against the stone frame, halfway up its height.

The Hennery was the first structure built on the island. The bottom half of the tower contains an elevated water tank that supplied water to the other buildings on Heart Island. At its top lies the pigeon house, where fancy breeds of fowl were to be collected and raised. The rectangular Alster Tower, however, served an entirely different function. It was for all intents and purposes the playhouse of the Boldt Castle complex. Its design is reminiscent of a strategic defense tower found on the Alster River, in Germany. But this structure was intended for the entertainment of its guests. The Shell Room, named for the shape of its roof, was created for dancing. The basement contained a bowling alley, and there were plans to include a billiard room, library, bedrooms, café, grill, and kitchen on the upper floors. The Alster Tower was closed for many years because of its declining condition, but extensive renovations have been done and the tower is now open to the public.

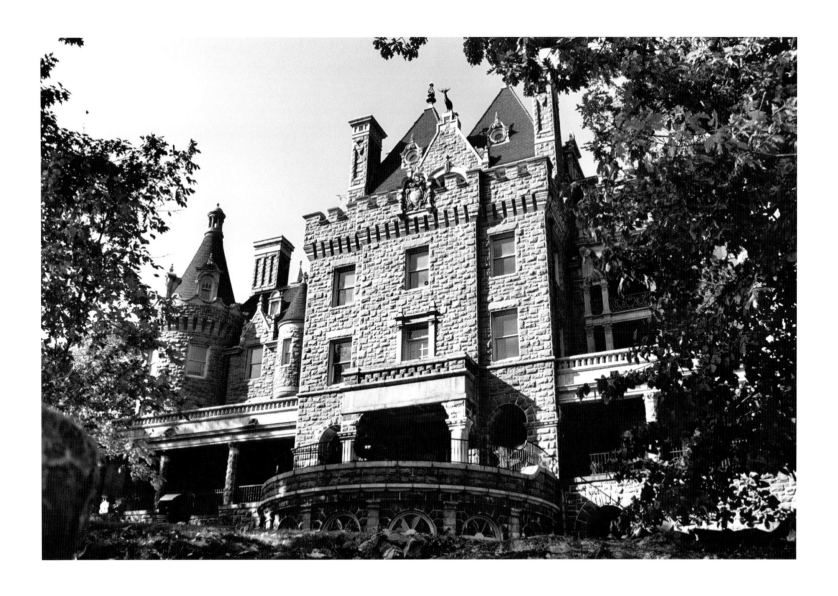

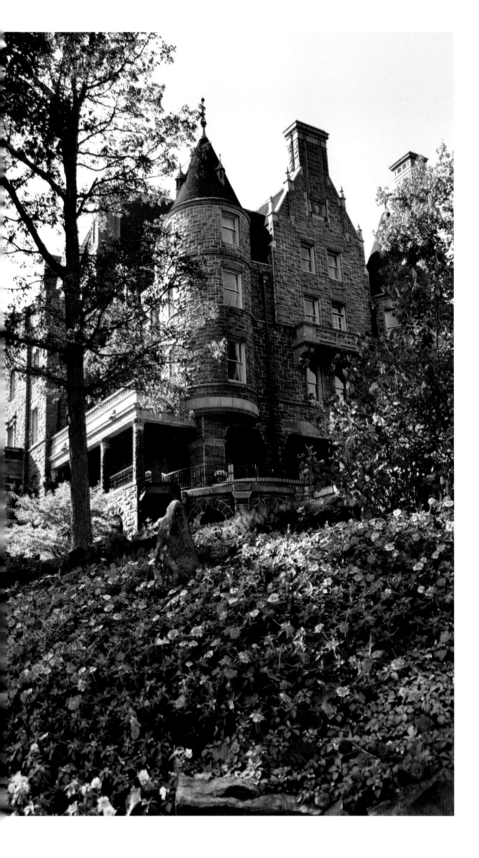

For me, though, the Power House's pull keeps drawing me back. Its cylindrical stone towers, capped off by spires, and the quaint, arched bridge of stone that connects it to the island, seem like a fairytale creation come to life. Inside its cool walls, photos and informational displays depict the lives of the people who lived on the Thousand Islands at the turn of the twentieth century. It also houses a steam engine that provides power for the entire island.

But among these historic buildings, the castle itself is by far the most spectacular. Inside, the first-floor exhibits are dedicated to the lives of George and Louise Boldt and to the development of the Thousand Islands as a tourist destination. Boldt Castle is accessible by water taxis, tour boats, and private boats, and it is available for self-guided tours from mid-May through mid-October. The five-acre island is completely handicapped accessible, with full restroom facilities, extensive docking space for private boats, several picnic areas, a gift shop, and a food-and-beverage concession.

As we hop into the water taxi to leave the island, I ask Lugh the question that's been on my mind: "If you had to choose one of the two castles as a favorite, which would it be, Singer or Boldt?"

"Well," he says hesitating briefly, "they're both great. Boldt is more magnificent, but Singer is more attractive, with nicer grounds."

As for me, I am enamored with them both. I agree with Lugh's assessment, but I could easily move into Boldt's Power House tomorrow. Either way, they should both be seen as icons of New York State history and enjoyed in all their architectural glory.

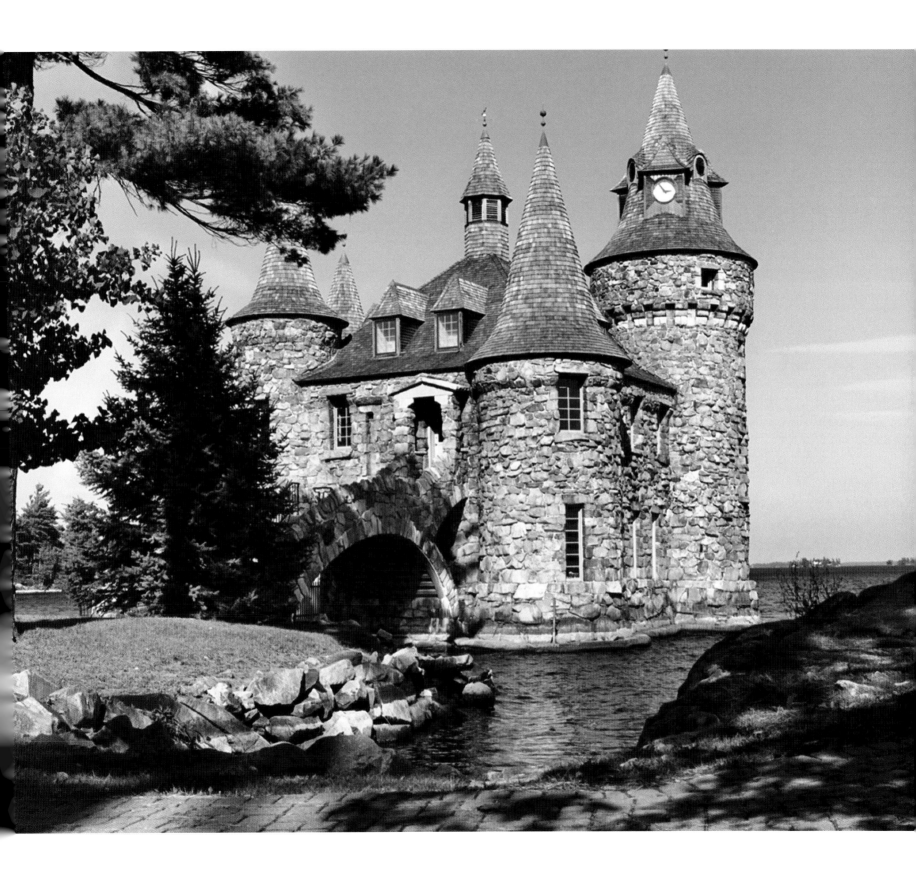

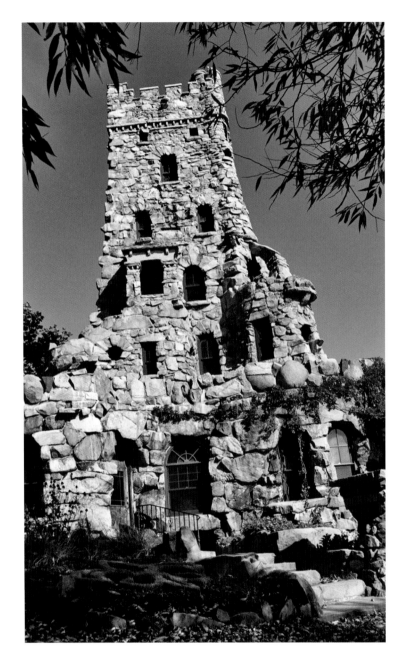

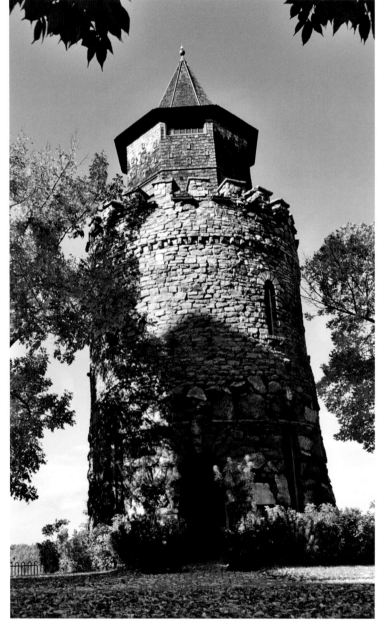

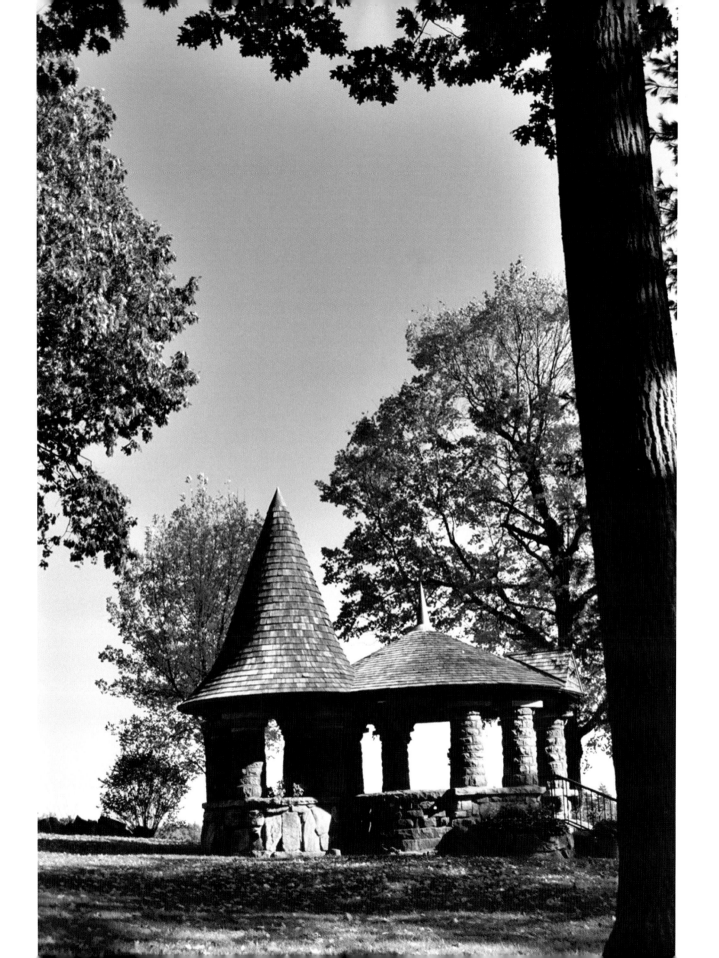

Ariel's Castle